P9-CCE-735

Edvard Munch

MASTER PRINTMAKER

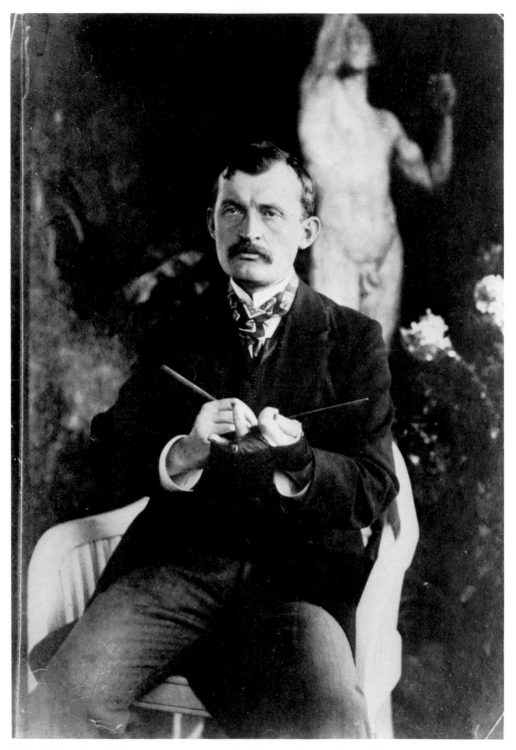

Edvard Munch working on copper plate in Max Linde's garden, 1902.
Photograph, Munch Museum.

Edvard Munch

MASTER PRINTMAKER

An examination of the artist's works and techniques based on the

PHILIP AND LYNN STRAUS COLLECTION

by Elizabeth Prelinger



W.W. NORTON & COMPANY / NEW YORK LONDON

In Association with

BUSCH-REISINGER MUSEUM, HARVARD UNIVERSITY

HOUSTON PUBLIC LIBRARY

R0148113520
FAR

Published simultaneously in Canada by George J. McLeod Limited,
Toronto.
Printed in Great Britain.
All Rights Reserved
First Edition

The text of this book is composed in Trump.
Composition by Zimmering & Zinn, Inc.
Manufacturing by Balding + Mansell.
Book design by Christine Aulicino

Locations of exhibitions of the Straus Collection:

NEUBERGER MUSEUM
STATE UNIVERSITY OF NEW YORK AT PURCHASE

HARVARD UNIVERSITY ART MUSEUMS

Library of Congress Cataloging in Publication Data

Prelinger, Elizabeth.
 Edvard Munch, master printmaker.

 Includes bibliographical references.
 1. Munch, Edvard, 1863-1944. 2. Straus, Philip—Art collections.
3. Straus, Lynn—Art collections. 4. Prints—Private collections—
United States.
NE694.M8P73 1983 769.92'4 83–13183

ISBN 0-393-01797-4

W. W. Norton & Company, Inc., 500 Fifth Avenue, New York, 10110
W. W. Norton & Company Ltd., 37 Great Russell Street, London WC1B 3NU

1 2 3 4 5 6 7 8 9 0

CONTENTS

Preface vii

Acknowledgments xi

Author's Acknowledgments xiii

Note on Captions xvii

Introduction 3

Chapter I
THE MASTER PRINTMAKER 5

Chapter II
THE INTAGLIO PRINT 11
 DRYPOINT 11
 ETCHING 22
 MEZZOTINT 31

Chapter III
THE LITHOGRAPH 35

Chapter IV
THE WOODCUT 61

Chapter V
COLOR PRINTING 71
 BY HAND AND *À LA POUPÉE* 71
 THE COLOR LITHOGRAPH 74
 THE COLOR WOODCUT 80

Chapter VI
MIXED MEDIA 101

Chapter VII
IMAGES REWORKED 113

Color Plates 131
Definitions of Techniques & Terms 147
Chronology 151
Notes 155

PREFACE

Edvard Munch has become for American audiences one of the most celebrated artists of the last hundred years. The recent proliferation of publications and exhibitions devoted to Munch have stimulated a new appreciation of his remarkable achievement.

The growth of Munch's fame in the United States may seem particularly noteworthy, since as a painter he is so sparsely represented in our public collections. To be sure, there are important paintings by Munch in major American museums, but if one compares his relatively meager representation with that of other classic moderns, such as Cezanne and Monet, Matisse and Picasso, or Klee and Kandinsky, the esteem Munch enjoys in the United States might seem astonishing. Thanks to distinguished public and private collections of Munch's graphic art, one can still discover the essential artist in this country—in his prints. It has thus been possible for Americans to experience the eloquence and power of Munch's major images, such as *The Lonely Ones*, *The Scream*, and *The Kiss*. It is an honor and a privilege to present one of those collections to the public with this exhibition, *Edvard Munch: Master Printmaker*.

The initial impact of Munch's work has been the artist's imagery. His intense and idiosyncratic pictorial treatment of sexuality and anxiety, sickness and death, evokes a particularly responsive chord among present-day audiences. The scholarly and critical literature on Munch has from the beginning generally shared this focus on the artist's images and the per-

sonal experiences that shaped them. It has been no different with the major exhibitions.

Munch is indisputably a master in his exploration of subjective experience, and is of seminal importance for this tendency in twentieth-century art. But he is equally important as a printmaker, as a major figure in the renaissance of graphic art that occurred at the end of the last century.

He was a boldly innovative and resourceful technician, a brilliant craftsman who expanded the range of the print media in which he worked. Along with Gauguin and Vallotton, he contributed to the revival of the woodcut as a major graphic medium; and, perhaps more than any of his contemporaries, he demonstrated the potential of the color print, which he explored with inexhaustible invention in both the woodcut and the lithograph and in prints combining both techniques. For Munch, technique was always a major agent of expression; its choice and utilization were never a matter of mere habit or routine. Indeed, in those innumerable prints in which he explored technical variations of a preexisting motif, the major creative effort was on the technical plane.

Connoisseurs of Munch's prints have long savored the technical subtleties and rich effects of individual impressions. But surprisingly, the development of this mastery has never been systematically explored. The present exhibition and catalogue, with their focus on technique and materials, are devoted to filling this gap.

The core of this exhibition, *Edvard Munch: Master Printmaker*, is the collection of Philip and Lynn Straus. With over eighty prints, the Straus collection is one of the most distinguished, public or private, in the world. It represents the full range of Munch's graphic achievement in all media, both chronologically and technically, and is especially rich in color prints. Moreover, because it also includes variants of specific motifs, such as *The Vampire* and *The Lonely Ones*, this collection is ideal for demonstrating an essential aspect of the artist's creative process: his repeated reworking of certain motifs in one or more graphic media.

The collection grew out of Lynn Straus's first trip to Norway in 1948, and her chance discovery of that country's greatest artist. During a return trip, both of the Strauses became captivated and finally, on the occasion of their twentieth wedding anniversary in 1969, they acquired their first Munch print, *Salomé*. Mr. and Mrs. Straus have always been interested in contemporary American art and have collected works by such diverse artists as Calder, Nevelson, Burchfield, Stella, and Johns. But more and more, their preoccupation in recent years has been Edvard Munch.

The Straus Collection continues to grow. After this catalogue had gone into production, Mr. and Mrs. Straus made a courageous and significant acquisition for the Harvard University art collections: the twelve extant prints from Munch's highly experimental, projected cycle "The Mirror," exhibited at his large retrospective exhibition at Christiania

(Oslo) in 1897, and one of only two known copies of the poster for that exhibition. It is a rare opportunity to be able to study this unique group of prints, which is central to an understanding of Munch's artistic development.

It is especially appropriate and pleasing that Harvard should have the privilege of exhibiting this outstanding collection of one of its alumni. For *Edvard Munch: Master Printmaker* has further significance for the University. The late Professor Frederick Deknatel, who taught in Harvard's Department of Fine Arts from 1932 to 1973, was the founding father of Munch studies in the United States. He organized the first American retrospective for the Museum of Modern Art in 1950, a show subsequently seen in nine cities, and his catalogue of that exhibition, the first substantial English-language monograph on Munch, has today become a classic. It is our hope that the present exhibition and its catalogue will contribute to the further appreciation of Edvard Munch in this country, thereby continuing the tradition begun over three decades ago at Harvard.

ACKNOWLEDGMENTS

As we acknowledge those who contributed to the realization of this project, it should be obvious that our greatest debt of gratitude is to Philip and Lynn Straus for their enthusiastic and unstinting generosity, manifested in countless ways, large and small, over the past two years; and for their willingness to part with their distinguished collection for nearly six months. By no means the least of the rewards of this exhibition, for me and all of those who have worked with them, has been their friendship.

No serious exhibition or publication devoted to the art of Edvard Munch could succeed without the cooperation of Munch-museet (the Munch Museum) in Oslo, with its incomparable holdings of paintings, drawings and prints by Munch as well as its wealth of archival material. Dr. Alf Bøe, its Director, has enthusiastically supported this undertaking from the beginning. He placed the incomparable resources of his institution at Elizabeth Prelinger's disposal during the research phase of this project, and generously agreed to lend four wood blocks and one copper plate to the exhibition, thereby enhancing its pedagogical as well as aesthetic dimensions.

Werner Walbröl, Exective Director of the German-American Chamber of Commerce in New York, generously lent his time to the search for a corporate sponsor.

Special thanks are due to Elizabeth Prelinger for her catalogue text which, I am confident, will prove to be a major contribution to our understanding of Munch's technical processes and thereby promote a richer

appreciation of his artistic achievement. She began working on this project as an intern in the Busch-Reisinger Museum; it has been a joy to observe her as she has developed rapidly into a Munch connoisseur par excellence. She has asked for a separate space in this catalogue to thank those who have helped her in its preparation; I, however, wish here to express my particular appreciation to two staff members of the Harvard University Art Museums who have offered special assistance in this regard. Peter Walsh, Publications and Public Relations Officer, played a crucial advisory role in the conception of the catalogue, guided it through the initial planning stages, served as liaison with the publisher and edited the manuscript. In all of these functions his contribution was invaluable. Marjorie B. Cohn, in addition to performing her normal tasks as Senior Paper Conservator, generously offered expert advice on matters both technical and editorial.

Gratitude is also due to the administrative and support staffs of the Harvard University Art Museums for their role in the realization of this exhibition. Seymour Slive, Director of the Harvard University Art Museums through June 1982, first conceived of the exhibition, raised the start-up funds for it, and remained engaged in the project through all of its subsequent stages. His successor, John M. Rosenfield, offered unfailing moral support and sage counsel on every aspect of planning and execution, and deftly guided the project through its most critical phases. Robert Rotner, Associate Director, and Lisa Flanagan, Financial Officer for the Art Museums, provided expert assistance on administrative and financial matters, respectively. Philip Parsons, Assistant Director for Operations, contributed sound advice on all questions related to installation and security. James Cuno, Assistant Curator of Prints at the Fogg Art Museum, served as overall coordinator of the exhibition during the final stages of planning. James Sharaf, Assistant General Counsel to Harvard University, generously offered his services on all legal and contractual matters.

Thanks are also due to the following staff members of the Harvard Art Museums: to William Robinson, Acting Assistant Director for Curatorial Affairs; to the Registrar, Jane Montgomery and her assistants Maureen Donovan and Andrea Notman; to Craigen Bowen of the Conservation Laboratories; and to Rick Stafford, for photography. Emilie Dana of the Busch-Reisinger acted as my liaison with all of the various departments, a critical function in any enterprise of this magnitude. It is not possible to name all of those staff members who have given generously of their time and professional skills, but I wish here to express my sincere appreciation for their contributions.

We are pleased to be sharing this exhibition with the Roy Neuberger Art Museum at the State University of New York, Purchase, and are grateful to its Director, Suzanne Delehanty, for her friendly cooperation.

Charles W. Haxthausen
Curator
Busch-Reisinger Museum

AUTHOR'S ACKNOWLEDGMENTS

The manuscript for this study was prepared with the help of many individuals. It is a pleasure to acknowledge them here with thanks.

Above all, I would like to thank Phil and Lynn Straus. Almost two years ago, Phil and Lynn introduced me to Munch through their wonderful collection and have since provided me with every opportunity to study this extraordinary man and his work. Thanks to them I have been able to visit the Munch Museum twice to find new information unavailable elsewhere, and they have been patient with my repeated study trips to their home. But perhaps most importantly, this project could not have been completed without their continuous friendship. It is impossible to detail the many incidences of their support and faith, but it has buoyed me throughout and made this both an incomparable experience as well as the starting point for further work. I hope that the inadequacy of these words can be made up for slightly in the grateful and affectionate dedication of *Edvard Munch: Master Printmaker* to them.

At Harvard, a few people deserve special mention. Seymour Slive, Gleason Professor of Fine Arts, was especially involved in the early stage of the project, and, as usual, is one of my guiding spirits.

Professor Charles W. Haxthausen, Curator of the Busch-Reisinger Museum, has been the best kind of advisor, in many ways the muse of the manuscript. Its focus evolved from frequent discussions with him and reflects throughout his participation and commitment. He has also overseen the planning of the exhibition and his remarkable, tireless optimism has been a constant source of encouragement.

The contributions of Peter Walsh, Publications and Public Relations Officer, have been vital to the project. He provided excellent editorial and organizational suggestions, in addition to arranging our collaboration with the publisher and acting as liaison between different departments within the Fogg. His sense of humor made complications easier to overcome.

Marjorie Cohn, Conservator of Works on Paper at the Fogg, shared with me her remarkable knowledge of prints, paper, and graphic techniques. She helped shape the manuscript's format and edited it not once, but twice. I am deeply grateful for her invaluable enthusiasm, generosity, and expertise in all facets of this endeavor.

This study could not have been written without the participation of two colleagues and friends at the Munch Museum in Oslo: Gerd Woll, Curator of Prints and Drawings, and Ingebjørg Gunnarson, Museum Assistant. It is possible only to sketch the extent of their role. Over the month that I spent in Oslo, they provided constant assistance, allowing me easy access to the riches of their collections. The research became an occasion to exchange ideas and I benefitted enormously from their extensive knowledge of Munch and generosity in sharing it. Many of my conclusions developed from our collaboration. They did everything from expediting the making of photographs and slides to extending me hospitality; I can only begin to thank them here.

Also at the Munch Museum, I would like to mention Dr. Alf Bøe, Director; Arne Eggum, Chief Curator; Jan Thurmann-Moe, Conservator of Paintings; and Sissel Biørnstad, Librarian. In Oslo, Kåre Berntsen and Marit Werenskiold. Trond Aslaksby made special contributions with his knowledge of the history of Norwegian art and especially with his scholarship on Hans Heyerdahl, an artist greatly admired by Munch. In Bergen, I thank Jan Askeland, Director of the Rasmus Meyer Collection and the Bergen Billedgalleri.

Members of almost every department at the Busch-Reisinger and the Fogg have been of help to me. At the Busch I would like to thank Emmy Dana, Dagmar Kohring, Amy Schrom, Reggie Brulotte, Joe MacDonald, and Sara Button for their friendship, indulgence, and participation in countless details of the project. At the Fogg, Professor Timothy J. Clark made important editorial comments. Rick Stafford photographed the Straus Collection and went out of his way to make up prints on short order. Anne Maheux, Conservation Intern in 1981–82, helped with the cataloguing and conditioning of the Collection. Craigen Bowen, also of the Conservation Laboratory, answered continual queries.

I am grateful to members of the Fogg Library who have aided me at different times over the last two years. Mr. Wolfgang Freitag has helped with the subtleties of the German language, which Munch did not always use with accuracy; and James Hodgson acquired important books for my research. With great affection, I thank Richard Simpson for allowing me

special privileges that have helped immeasurably in finishing the manuscript; Abby Smith has also supported my efforts.

At the Museum of Fine Arts, Boston, I thank Barbara Shapiro, Assistant Curator of Prints, Drawings, and Photographs, for allowing me special access to the Munch prints during the renovation of their storage areas.

Indispensable to the production of the manuscript has been Scott O. Bradner, Technical Associate and Senior Preceptor in Psychology. With his staff, and unfailing patience (and humor), he helped me conquer the mysteries of the word processor, finish the writing, and join the modern era.

I also am pleased to extend thanks to a special group of friends whose involvement has meant so much. First, to Mr. and Mrs. Charles C. Cunningham, Jr., whose friendship I treasure. Among many other things, I thank them for their introduction to Mollie Jenckes and Knut Ra and their family, who welcomed me to Oslo for the first time and who made my stay one of the happiest and most interesting times I have had. I am grateful to Mrs. Sarah G. Epstein and Lionel Epstein for showing me their collection of Munch's graphic work and sharing their knowledge. Nelson Blitz, of New York, also shared his expertise and his own excellent collection.

It has been a great pleasure to work with James Mairs and Jeremy Townsend, both of W.W. Norton & Company, Inc. Seeing the book finally come together under their imaginative direction has been a wonderful experience and their understanding of the many facets involved in its production has been much appreciated.

Finally, I would like to thank my whole family for their encouragement and to mention a few friends whose contributions on a personal level have meant a great deal. They are Eunice Williams, Cynthia Schneider, Martha Hickey, Gary Tinterow, Arlene Bernstein, and, most importantly, Steve Messner.

E.A.P.

NOTE ON CAPTIONS

All measurements are in centimeters (followed by inches in parentheses). Height precedes width. Intaglio print dimensions measure the plate; lithographic and woodcut print dimensions measure the image area. The given date refers to the date of execution of the plate, stone, or block. The date of the impression may be indicated by inscription.

The reference code S., followed by a number (sometimes a Roman numeral indicating state and/or a letter indicating particular version), refers to the listing in Gustav Schiefler's catalogue raisonné, *Verzeichnis des graphischen Werks Edvard Munchs bis 1906* (Berlin, 1907); and *Edvard Munch. Das graphische Werk 1906–1926* (Berlin, 1927). Both volumes were reprinted by J. W. Cappelens Forlag, Oslo, 1974.

The references beginning with W., followed by a number, refer to Sigurd Willoch's catalogue raisonné of the intaglio prints, *Edvard Munchs raderinger* (Munch-museets, skrifter 2. Oslo, 1950).

All plates and color plates are from the Straus collection. Figures refer to prints from the Munch Museum, Oslo.

When more than one medium is listed, they are listed in the order of predominance in the print.

Lithographs and woodcuts are made from one stone or block unless otherwise indicated.

All signatures, dates, and inscriptions are on the recto unless otherwise indicated. All signatures, dates, and inscriptions indicated are by the artist, his sister, Inger, or by printers.

Museum seals and collectors' marks have been noted; several of the latter are indicated by L., followed by a number, referring to Lugt, *Les marques de collections de dessins & d'estampes* (Amsterdam, 1921; supplement La Haye, 1956). OKK refers to Oslo Kommunes Kunstsamlinger (Art Collection of the City of Oslo) abbreviation for works of art in the collection of Munch-museet.

The wood types have been discerned from the Munch Museum records.

Edvard Munch

MASTER PRINTMAKER

INTRODUCTION

EDVARD MUNCH IS one of the rare artists to be as well known for his prints as for his paintings. In his variety of methods and in the brilliant technical discoveries that characterize a body of some eight hundred prints, he significantly altered contemporary notions of graphic art.

Munch's graphic production not only constitutes a large percentage of his oeuvre, but it is that area where he was most innovative and influential. Although he continually reworked the same set of powerful, archetypal images both as paintings and as prints, ultimately it was in graphic, rather than painted form that certain of his central themes found their most potent expression.

Not until the age of thirty, ten years after he began painting, did Munch make his first print. He took to the task with astonishing ease and within a few years he had created master works in every medium: intaglio, lithography, and the woodcut. Since the search for the most eloquent pictorial realization of his idea was always his first priority, he worked without the constraint of traditional procedures, and his constant experimentation led him to expand dramatically the expressive possibilities of each technique.

Munch's graphic work does not, therefore, always permit easy delineation by medium. His use of each was often so unconventional that a number of his prints do not represent "pure" examples of a particular type: either he employed means in one medium that traditionally belong to another, such as using engraving tools on a lithographic stone, or he

actually combined media such as lithography and the woodcut. Given Munch's endless fascination with such new methods, no study of the print variations could hope to be definitive, but can only point the way to further discoveries.

Munch's experimentation raises the important issue of the link between idea and realization in a work of art, and one reason for his especial importance in our understanding of this link is the fact that the ways in which it was forged can be traced so clearly in his graphic oeuvre. The printmaking techniques that Munch developed when he needed a new way to express a theme are for that very reason inextricably bound to the subjects they bring to form, even more because the best form for his idea was not always preordained in his mind. The link was achieved as the result of careful and extensive investigation, thereby becoming in a sense an active *process* rather than a *fait accompli.* Part of this process is revealed in the fact that, in his search for forms, he sometimes imitated or approximated in one medium the effects of another. Second, he went beyond merely imitating these effects to actually reworking a subject in different media. So although his ideas about the pictorial needs of a motif suggested certain technical procedures, these procedures in turn acquired a creative momentum of their own and themselves came to suggest new meanings as well as new forms. Therefore, for any given subject there is not necessarily one definitive version, even within a particular graphic medium, but a variety, each expressing a valid pictorial solution.

For this reason, indispensable to a complete understanding of Munch's creative thought is the knowledge of his graphic techniques. Detailed examination of his working methods has too often, however, been disregarded or treated simply as a means to the creation of his arresting imagery. This study explores those innovative technical processes by which Munch realized his themes graphically, evolving new forms and meanings. It is based upon examples from the Philip and Lynn Straus collection, which provides an excellent selection for discussion since the prints represent the many facets of Munch's printmaking career, and because the individual impressions are of outstanding quality.

A technical consideration of these prints reveals another dimension of Munch entirely different from the tormented figure so often depicted by scholars. While the events of a sad life provided the material for Munch's often gloomy imagery, nevertheless shining through his graphic work is an undiluted joy in experimentation and creation. Each exploratory impression records another insight gained in the restless search for new ways to strengthen an image, heighten its impact, intensify its communication through colors and forms. It is Munch the passionate technician who emerges in these remarkable works of art.

I
THE MASTER PRINTMAKER

"I AM IN A PRETTY GOOD working mood—I have begun to etch in order possibly later to publish a little collection—etchings..."[1]

In this letter from Berlin, written on November 14, 1894 to his beloved aunt Karen Bjølstad, Edvard Munch made his first mention of working in the graphic arts. At the age of thirty, he had been painting for ten years and was beginning to achieve a degree of notoriety, if not fame. He had been living in Berlin since November of 1892 when the Verein Berliner Künstler had invited him to exhibit his paintings in a one-man show, but it was forceably closed after one week by an outraged group of conservative artists. The uproar did him more good than harm, spreading his name throughout the country and eliciting other invitations to exhibit. And, although he eventually grew tired and frustrated with Berlin, nevertheless in the Bohemian circle that gathered at the café Zum schwarzen Ferkel, he found understanding and congenial companions.

In contrast to Norway, where there was little interest in printmaking, Germany and France were centers of the graphic arts. Although at mid-century, prints had been limited primarily to illustrative or reproductive usages, they were now in the process of achieving the status of original works of art, conceived in and exclusively for a graphic medium. As the 1880s drew to a close, societies of "painter-engravers" assembled to promote the recognition of graphic art. Publishers printed fine portfolios for a new generation of contemporary print collectors and limited editions began to be signed and numbered.

Many artists were active printmakers and could have served as inspiration for Munch. In Germany, Max Klinger's intaglio prints not only provided models for subjects, such as the *Dead Mother and Child*, but his virtuosic handling of line, as well as tonal processes, presented a standard for work in this medium. In France, there were the often pornographic prints of the Belgian Félicien Rops, the bold color lithographs of Toulouse–Lautrec, the Swiss Félix Vallotton's woodcuts, and the complex and nuanced woodblock prints of Paul Gauguin.[2] Munch may in fact have come to know the work of these and many other artists well, for he frequented the same printing shops: Clot and Lemercier in Paris; Sabo, Angerer, and Felsing in Berlin.

We do not know what inspired Munch to pick up the drypoint needle for the first time. Perhaps it was the simple question of survival during particularly impoverished days in Berlin at the end of 1894, when his paintings were not selling.[3] Harry, Count Kessler, art connoisseur and chronicler of his times, noted that in November 1894, Munch was seen wandering around the city, hungry and homeless.[4] By making prints, Munch had the chance to sell large numbers and earn more than he could from the sale of his paintings.

But it is not likely that economics were the central impulse. The critic Julius Meier–Graefe, who in 1895 published Munch's first portfolio of prints, wrote ironically: "If I were not aware of the utter lack of an economic viewpoint in Munch, I would hold his recent interest in graphics for opportune slyness."[5]

We do know that Munch intended that the early engravings and etchings, which are largely graphic reprisals of painted themes, would, as multiples, reach a wider audience. One of his early stated intentions was to translate a series of paintings entitled "Love" into prints,[6] and his sense of mission to share his themes was expressed in one of his best–known statements: "Taken as a whole, art comes with a person's urge to communicate to another—all means are equally good."[7]

Further, although Munch wanted to share his experiences, he was almost pathologically unable to part with his paintings. They were the children he never had, and he often conversed with them as he worked, castigating, even punishing them physically by exposing them to the weather and to bird droppings (the so-called "horse-cure") if they refused to turn out the way he wanted. As multiples, prints were easier to relinquish.

Perhaps most important, though, was the artist's incessant thirst for experimentation. Munch's "means" were no longer restricted to oil and canvas; in a burst of creativity he investigated every graphic medium: intaglio, lithography, and the woodcut.

One tends to associate the intaglio technique with Munch's printmaking debut—he made seven, possibly eight intaglio prints in 1894—but once he began, he was eager to experiment with every method. That year he also made his first lithograph, *The Young Model*.[8]

Munch enjoyed his first success as a printmaker the next year. His production jumped to twenty-one intaglio prints and eight lithographs.[9] He exhibited graphic work for the first time, in Berlin. The French art periodical *La Revue Blanche* published *The Scream* along with a poem by the artist. And the so-called Meier-Graefe portfolio appeared.

A. Julius Meier-Graefe (1867–1915), who was to emerge as the major German art critic of his generation, was a twenty-eight-year-old former engineering student when he fell under the spell of Munch's art.[10] He wrote an essay for the first book on Munch's work, which was edited by the Polish writer Stanislaw Przybyszewski in 1894. In June 1895, as a tribute to the talent of his admired Norwegian friend, Meier-Graefe assembled into a portfolio eight intaglio prints, all but one based on paintings.

From February 1896 to the spring of 1897 Munch lived in Paris. He had already visited the city several times and during one sojourn attended classes at the studio of Léon Bonnat, who praised his drawing. The advances that he made in his work were stimulated by the intense, creative atmosphere and Munch's focus broadened considerably.

In the space of that one year in Paris Munch learned the art of the mezzotint, the woodcut, and created his first color prints. He produced five mezzotints, which figure among his rarest prints; twelve other kinds of intaglio prints, both in color and black and white; twenty-three lithographs; and five woodcuts. At the same time, unfazed by the commercial failure of the Meier-Graefe portfolio, he planned a new one to be composed of lithographs and woodcuts. This time he envisioned a thematic series entitled "The Mirror" to be based upon the images that comprised the "Frieze of Life," a group of paintings depicting his monumental visions of love and death. Munch announced the series upon his return to Norway from Paris in 1897. He assembled the prints, pasted them onto cardboard, and on one single occasion exhibited them together; but they were never published. The large part of "The Mirror" consists of works made in Paris during his stay from 1896 to 1897, but it also includes several important lithographs from the Berlin period.[11]

The concept for "The Mirror" seems to have been of extraordinary importance to Munch. Not only does it include all his most important ideas and images, but these works represent the starting point as well as the development of Munch's technique in two media that were new to him. Nowhere else than in these newly discovered impressions, crudely and seemingly hastily mounted on cardboard, does one feel closer to the creative process of the artist. The prints crackle with inspirations; intrigued by the new methods, Munch seized crayon, ink, needles and knives to mark stone and wood with his images of human love, fear, and death. While most of the motifs derive from paintings of previous years, they have been infused with a new life in their graphic form.

Though never completed or published, the portfolio was crucial for Munch in that the prints stand as the definitive statement of his experi-

ence in Paris: the fruit of rich influences, knowledge, and experience gained from friends, art, literature, printers, and the atmosphere of the cultural capital of Europe. And in many cases, the impressions exhibited in 1897 contain the germs of the experiments, particularly with color, that came to fruition in the years to follow.

Munch spent the next several years traveling extensively, exhibiting, and working. In 1899 he made thirteen or fourteen woodcuts, among them some of his most famous. The next crucial year in Munch's printmaking career was 1902.

It was a tumultuous year for Munch. The relationship with Tulla Larsen, his mistress of several years, ended with a gunshot wound to his left hand and with his emotional collapse. But it was also the year in which he returned to some of his major prints to rework them or to render the same themes in other media. The color versions of *Vampire* and *Madonna* date from this year, prints in which the artist combined lithography and the woodcut in a single impression, creating entirely new pictorial effects. A major print commission, as well as a lasting friendship, came to him when Dr. Max Linde of Lübeck asked him to prepare a portfolio of fourteen intaglio works and two lithographs depicting his family, palatial house, and surroundings. And it was in this year that Munch made the acquaintance of the magistrate and *amateur d'estampes* Gustav Schiefler, who became his patron and catalogued his graphic work.

Munch's frantic, peripatetic life continued. His graphic work was selling so well that in 1904, heedless of the doubts expressed by Linde and Schiefler, he contracted to the Berlin publisher Bruno Cassirer the exclusive rights to the sale of his prints in Germany.

Three years later, the first volume of Schiefler's catalogue appeared, listing two hundred and forty-seven prints made from 1894 to 1906. Accompanied by a laudatory essay, the book firmly established Munch as an important printmaker.

Munch collapsed in the fall of 1908, exhausted by constant travel and unhealthy living. He entered a sanitorium in Copenhagen and, as his condition gradually improved, spent time at the zoo, making witty drawings of the animals on lithographically prepared zinc plates. During this time, he also made the lithographic series *Alpha and Omega*, which recounts the saga of a woman who betrays her lover by mating with all the animals on their island home. This was the year of the lithograph; Munch made sixty-six, including the many animal sketches.

After 1908 Munch no longer always worked directly on lithographic surfaces but made his images on paper for transfer, and for this reason the later lithographs seem less immediate.[12] Munch also seems to have lost interest in the intaglio technique by about 1915 or 1916. But the lithograph and the woodcut continued to fascinate him, and he made new images in these media until the end of his life, alternately finding one medium more congenial to his current intentions than another. By 1930 Munch was

making few new prints, and he limited himself mainly to handcoloring earlier impressions. Ragna Stang speculates that eye trouble, affecting him in 1930, forced him to restrict his activities for a while, although we know from accounts by friends that he never completely stopped making prints.[13]

A GREAT VIRTUE of the tools of graphic art is their constant freshness (barring wear over time). As Ernst Ludwig Kirchner, the master of German Expressionist printmaking and spiritual descendant of Munch wrote: "...creative work can be prolonged as long as one wishes without danger. It is extremely exciting to rework a picture again and again over a period of weeks or even months in order to achieve the ultimate in expression and form without any loss of freshness."[14] Munch exploited this property to the utmost in reprinting his early blocks and stones. It is not easy to pinpoint exactly when the reprintings or reworkings of block or stone occurred; sometimes impressions are dated, but not always. And, although some opinions hold that Munch's painted oeuvre declined in quality after about 1900, the graphic art maintained its intensity and level of creative innovation, partly because of reworkings, and partly because of the inherent potential in the graphic tools for further experimentation.

In the end, Munch's passion for the print led to a production of over 800 different images, pulled in tens of thousands of impressions; he left over 15,000 to the city of Oslo in his will. Although some are numbered, others of the same motif are not, so the total editions may never be precisely determined. Munch's original intention had been to deluge the world with his imagery, but he did not, on the other hand, want to flood the market. In 1929 he wrote, "It is impossible to publish any new prints, at least of the older works. The majority of them have been destroyed and the ones still in existence have been ravaged by old age. And besides, I decided long ago not to produce any new prints because I find that too many have already been published."[15]

Patron and biographer Rolf Stenersen found, however, that the vast numbers affected neither the popularity of Munch's graphic work, nor the selling price. In his intimate biography of the artist, in which anecdotes often seem to acquire fanciful embellishments, Stenersen recorded that "prior to World War I, Munch's works went primarily to German collectors and galleries. During the war, however...his market at home rose rapidly. In the years 1916 to 1920, it was not uncommon for Munch to receive thirty thousand *kroner* for a painting. His prints, of which he sold thousands, brought two or three hundred *kroner*, while those he decided to hold back soared to prices unheard of for graphic works. Thus, in 1920, a print of *Sick Girl* was sold for four thousand *kroner*."[16]

The question of print sales underlines Munch's ambivalence between commercial success and art for art's sake. He surely possessed a desire for

both. Although the effect of economic necessity on the young artist is less clear, Stenersen's description of Munch the salesman undoubtedly holds true for his later years. After the artist's death, Stenersen observed that "Munch found it beneath his dignity as an artist to carry on commercial activities. Consequently, he was always ill at ease when first approached about a sale. In reality, however, he possessed a well-developed sense of the value of money and ultimately became a master salesman. A person having succeeded in buying a picture from Munch was left with the unmistakable impression of having had a great favor bestowed upon him. Munch told the prospective buyer—and he was merely stating the truth—that he found it neither necessary nor to his liking to sell his works."[17]

Munch's esteem for his works was, however, always overshadowed by his never-ending fascination with new visual effects. Discussing the artist's cooking habits, Stenersen relates that: "[Munch's]...cooking was very simple—for dinner mostly bread and soup, or water, some vegetable, and a piece of fish. Not wanting to clean the fish, he would cut off the tail and cook that instead of the main part. If he couldn't lay his hands on a lid he might cover the pan with a print—once it was *Sick Girl*.

"'Watch out!' someone standing by shouted. 'Don't you realize it is *Sick Girl* you're using?'

"'So what?' he replied calmly. 'It doesn't cost me anything. In fact, it'll be interesting to see it steamed.'"[18]

This provocative indifference always vied with awareness and canny speculation. But there can be no doubt of Munch's regard for his graphic work. One may not say of Munch that, although he made master prints, his primary focus or achievement was his painted oeuvre. He is justly famous for both. Ernst Ludwig Kirchner wrote: "Nowhere can one get to know an artist better than in his prints,"[19] and in this way we come to know Edvard Munch, not just through his powerful imagery but by investigating his creative processes, the ways in which he brought his ideas to form.

II

THE INTAGLIO PRINT

As a PRINTMAKER Munch seems to have been largely self–taught. Several of his biographers indicate that he received lessons from Karl Köpping, a professor of graphics in Berlin, but no specifics are known of this alleged instruction.[1] An explicit reference to a printmaking lesson appears in the diary of Harry, Count Kessler. The entry for May 10, 1895 records that, after watching Munch balance the heavy stone on his easel, Kessler himself asked Joseph Sattler, a German printmaker, to show Munch how to make transfer lithographs, specifically to render the process less strenuous for his artist friend.[2] But in the main, Munch probably learned from studying master prints—Rembrandt in particular was an inspiration—and also contemporary work in progress at the various printer's shops.

DRYPOINT

On the face of it, the medium of the intaglio print, the first technique Munch tried, seems foreign to his artistic personality as it had emerged up until 1894. Munch's delicate, almost miniaturistic early drypoints and etchings printed in black and white, seem far removed from the exuberance and expressive color of his painted work.

Julius Meier–Graefe, in his introduction to the portfolio of eight intaglio prints he issued in 1895, observed with wonder (as well as irony),

11

that, without the brutality of the colors, one would believe oneself to be seeing "real, reasonable pictures," "definite works of art".[3] "Who would believe it...the same man, who is accustomed to working with a brush like a broom, here, in his subject matter, as well as technically, has mastered such a delicate manner."[4]

The language of the intaglio print is primarily line and it provides a novel challenge for the draftsman. Mistakes are not easily corrected, and the artist must also constantly be aware of the fact that, as with most print methods, the image will print in reverse. It was apparently Munch's superior draftsmanship that gave him immediate access to and success with the intaglio techniques; perhaps even impelled him to try them. In a German handbook of 1908 which describes the art of etching, the author characterized Munch as one of the "greatest living draftsmen."[5] Yet the artist seems never to have concentrated on creating drawings that were finished, complete statements like his prints and paintings. His use of paper and pencil was generally reserved for quick inspirations or compositional sketches for works in other media. Although his drawings exhibit lively and expressive qualities, it is clear that they did not hold the same interest for Munch. The nature of the materials, as well as the craft involved in creating the image on copper (or stone, or wood), enthralled him, along with the endless possibilities for pictorial experimentation.

The easy familiarity that Munch achieved with drypoint is shown by his practice, recounted by Schiefler, of carrying "a copper plate in his pocket, on to which he will etch some scene that particularly captures his imagination of the moment—a landscape, a waitress in a wine tavern, a couple of men playing cards, or a serious portrait."[6]

The initial use to which Munch put his new skill was the portrait: his first known intaglio print is a drypoint, probably taken from life, of the art critic Mengelberg (S. 1; W. 1).

In at least one instance, in 1905, Munch also used the intaglio method for taking a likeness that he would subsequently paint.[7] But the function of the intaglio print as preparatory study was unusual for Munch. Especially in the early years of printmaking, his working process was the opposite: he borrowed his graphic motifs from his paintings. In general, his preparatory sketches remain limited to drawings in pencil or ink.

The *Portrait of Dr. Asch* (Pl. 1) represents an example of finished portraiture from life. Munch drew the likeness of Asch in pure drypoint. At the life sitting, he filled in the head entirely, concentrating his energies, as well as the viewer's attention, on the doctor's face. Munch exploited the various properties of the technique, by contrasting the rich drypoint burr, which creates the dramatic moustache and the dark, penetratingly intelligent eyes, with the delicate scratching, which models the temple and outlines the tie. Uncomfortable, perhaps, with the seeming incompleteness of the first state, he then added details of the jacket, arm, and hand, as can be seen in the Straus impression, incising these elements with the

12

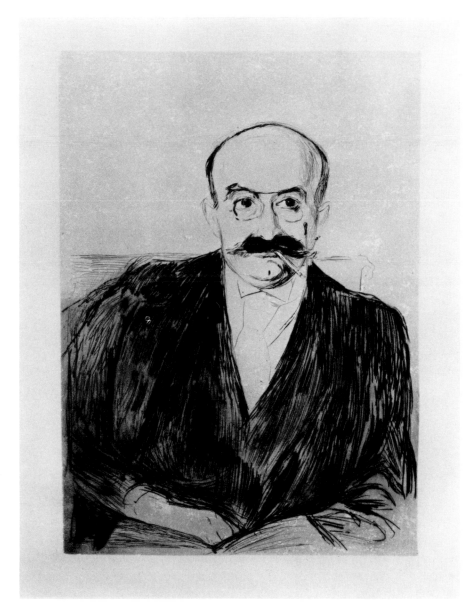

Pl. 1. *Portrait of Dr. Asch*, 1895.
S. 27 II/c; W. 27. Drypoint; buff wove paper. 26.4 x 18.8 (10⅜ x 7⅜).

power that the drypoint line can achieve, creating a sense of rhythm and delineating the man's bulk.[8]

Munch never ceased to make portraits in drypoint and etching, and in 1894 and 1895, before he became proficient in lithography and the woodcut, he also used the intaglio medium to render some of his most important painted motifs.

13

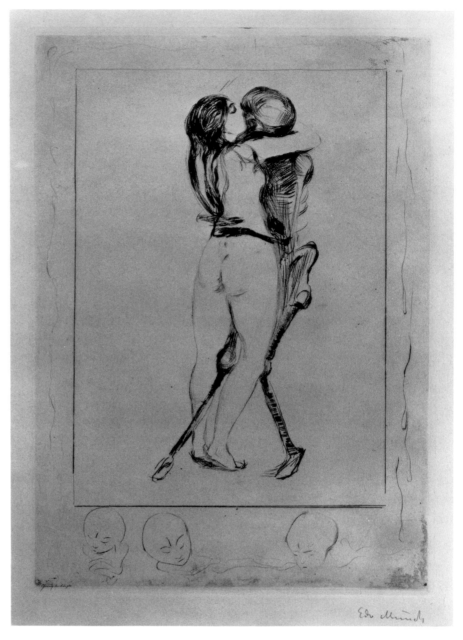

Pl. 2. *Death and the Maiden*, 1894.
S. 3 II/b; W. 3. Drypoint; buff wove paper. 30.4 x 21.6 (11¹⁵⁄₁₆ x 8½). Signed, graphite, lower right: "Edv Munch". Inscribed lower left, graphite, by the printer: "O Felsing Berlin gdr."

Death and the Maiden of 1894, (Pl. 2), the earliest work in the Straus collection, is based on a painting of the previous year. It represents Munch's first attempt to adapt a painted image to the copper plate; its elegant refinement differs dramatically from the rather clumsy treatment of the jacket in the Dr. Asch portrait. Although still only a beginner, Munch showed himself a master of the technique. The initial task for the artist, known for his expressive color, was to reduce the chromatic effects of the painting to simple value contrasts. Placing the image against a void he delineated the woman's body with a minimum of delicate, sketchy touches of the needle. Her sensuous form comes to life from the enclosed space which he molded from a few indications, such as the touches that model her buttocks. By contrast, the spiky figure of Death has been scratched vigorously into the plate with lines moving rapidly in all directions. The artist created a reverse illusion: although the figure of Death has been composed of many lines and represents a "solid" or "positive" shape, it is the figure of the maiden, an outlined void, which possesses the sense of animate volume.

The rich blurred lines peculiar to drypoint accent *Death and the Maiden* with terrifying connotations: burr stands out where the bones touch the maiden's body, as if the points of contact are literally electrifying. The strands of the woman's hair, always one of Munch's favorite motifs, crawl with these furry strokes.

Another element that recurs in other works is the decorative border. In designing the graphic version of *Death and the Maiden,* the artist omitted the color-streaked background of the painting of the same name, a background composed of red spermatozoa with two large embryos floating at the right. Instead, in the print, he ruled a simple line border around the figural design, and outside of that he drew a path of sperm, and, at the bottom, three fetuses, the elements previously incorporated into the central image of the painting.

The use of decorative borders that somehow illuminate the central image was not unusual at this time; Max Klinger was one of the most famous exponents of this device. In the case of this image, the spermatozoa are a serious allusion to the cycle of life and death and to what for Munch was the fearful cosmic mystery of sex. Nevertheless, his choice of these particular sexual symbols as embellishment was innovative, and even shocking.

Like *Death and the Maiden,* most of Munch's drypoints and etchings from the 1890s consist of reprises of his paintings. In changing his exercise of the intaglio method from spontaneous sketchmaking to translating his central images from canvas to copper, he altered his approach to the medium. He no longer used the needle as a substitute for a pencil, for he was no longer making drawings on metal. Instead, he introduced complicated tonal techniques in the interests of recreating his large, broadly handled, colorful (or tonal) oil pictures in portfolio-sized black and white

prints. Unlike the life portraits, which he would make throughout his life, and other intaglio images that postdate the 1890s, the early works which reproduce his "Frieze of Life" are not printed drawings but complex prints whose pictorial success depends heavily on the cultivation of subtle effects particular to the intaglio medium.

After the publication of the Meier-Graefe portfolio in which Munch experimented with tonal processes to recreate his paintings, the intaglio prints never again achieved the same degree of brilliance. Once he discovered the tonalism particular to lithography and the potential for simplification and color inherent in the woodcut (elements important for the graphic versions of his major motifs), he no longer needed the intaglio print for these purposes and his use of the technique became progressively less complex and innovative.

The eight prints that Meier-Graefe chose for the portfolio were: *Portrait of Dr. Max Asch*, discussed above; *The Day After; The Lonely Ones (Two People); Tête-à-Tête; Moonlight; Christiania-Bohême I; Girl in a Nightgown by the Window;* and *The Sick Child.*[9] The prints—all but the portrait based on paintings—show no particular thematic unity, as in the series "Love" or the "Frieze of Life" which Munch conceived himself, yet each examines a person or people in a setting, their reactions to each other or to the environment, and their own intense inner lives. The surroundings in turn reflect or somehow respond to the social or psychic activity of the people. Together, they aptly mirror some of Munch's most important concerns: the psyche of man and the perceptions he projects onto the physical world.[10]

Although the prints were listed in the table of contents of the portfolio as etchings *(Radierungen),* four in fact, were executed in pure drypoint, a fifth in a combination of etching and drypoint, a sixth in etching and aquatint, and a seventh and eighth in drypoint and aquatint. Each of the Meier-Graefe images exists also in a number of states. Such is the subtlety of Munch's experimentation that technique or state may not always be determined with certainty.[11] For example, Munch used the burnisher, usually employed to correct mistakes, to blend filigree-thin lines together, thus reproducing the impressionistic, tonal qualities of the paintings that served as sources for many of the intaglio images. Munch found that, by rubbing the burnishing tool across the incised surface of the plate, he could obtain blurred, atmospheric images suggestive of the handling of the painted prototypes. The results are reminiscent of, and sometimes confused with, the tonal qualities of aquatint, which appears in other prints.

Munch seems to have preferred to construct an image from dark to light, and this preference found its ultimate satisfaction with the woodcut. Among the prints of the Meier-Graefe portfolio, *The Day After* (Pl. 3) is the only one in which he worked in the opposite fashion, gradually building up the image in a series of increasingly darkened states to bring the graphic image close to the painting, which recalls the style of art nouveau in its

16

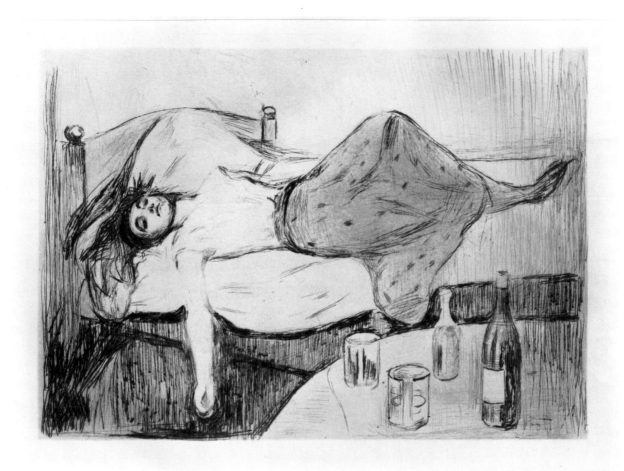

Pl. 3. *The Day After*, 1895.
S. 15 IV/c; W. 14. Etching, drypoint, aquatint; buff wove paper. 21 x 29.2 (8¼ x 11½).

curvilinearity and patterned flatness. For the print, the artist again closely followed the painting's composition; while the picture prints in reverse, it is unaffected formally and iconographically.

Girl in a Nightgown by the Window (Pl. 4) is an adaptation of the oil of 1891. Working in a painterly fashion on the copper, Munch explored the effect of light, how it diffuses over objects, illuminating and obscuring at the same time. The beams that fill the room flicker with such intensity that the unseen moon becomes the real subject of the scene, as it somehow lures the solitary child to the window.

In his search for atmospheric effects, Munch took impressions from five states of *Girl in a Nightgown by the Window*. Needle work and the roulette, a tool with a rotating jagged disk on the end, create the broken

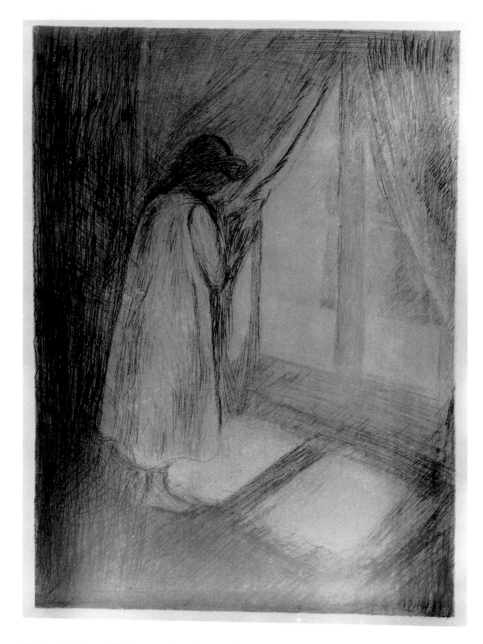

Pl. 4. *Girl in a Nightgown by the Window*, 1894.
S. 5 V/c; W. 5. Drypoint, roulette; buff wove paper. 21.9 x 15.8 (8⅝ x 6¼).

lines that suggest texture and contribute to the tonal blur. An advantage of
the intaglio technique here was the possibility of placing many minutely
incised lines next to each other which, when printed, would blend into a
tonal area, giving the print a painterly effect. The more vigorously incised
lines, where he left burr standing, also retained ink, adding to the blurry
effect, as well as creating the darker accents. The heavy use of the bur-
nisher also contributes to the shadowy quality of *Girl in a Nightgown by
the Window*, and finally, as may be seen in this impression, the plate was
expertly wiped, in this case by the Berlin printer Angerer, in order to leave a
thin layer of wash on the surface. When printed, a faint tone remained on
the paper. The picture becomes a study in tonal atmosphere translated
from color.

As in *Girl in a Nightgown by the Window*, the atmosphere of *Moon-
light* is melancholy, meditative, still. Lost in reverie, the slumped figure of
a man sits in a dark room, staring at the flowing river outside. Faint lights
in the water indicate a passing steamer. Intense moonlight passing through
the window silhouettes the cruciform window frame, echoed in the
shadow projected onto the illuminated floor.[12]

One of the remarkable successes of the drypoint of *Moonlight* is the
translation of this tonal quality from paint into the print. In creating this
image, the artist freely scratched in a network of lines, also burnishing
lightly and adding aquatint to create texture in the curtain at right. In an
early state (Fig. 5), dense vertical striations veil the entire image, falling
like dark, driving rain over the scene, causing material objects to blend and
lose their distinct character: they are important only as their suggested
form contributes to mood.

For the fifth, published state (Pl. 6), the artist, apparently not satisfied
with what he must have considered too haphazard a composition, went to
work with his burnisher, effectively "cleaning up" the picture. As in *Girl in
a Nightgown by the Window*, he greatly lightened certain areas, while
simultaneously refining details. The now heavily worked, clearly defined
table at left and curtain at right direct our glimpse into the private world of
the seated man. The middle corridor quivers with light and the rhythm of
the lines, faint and burnished, bold and dark. While the space is not very
deep, the tunnel view keeps us at a distance; the framing devices prevent us
from intruding upon an intimate moment of solitude.

In *The Sick Child*, also, Munch constructed the image in a series of
elaborated states. In an early state, before adding the landscape, he filled in
the background of the main image with dense horizontal striations. Only
in comparison with the Straus impression of the fifth state (Pl. 7) is it
evident to what extent the artist burnished the plate to lighten and model
things such as the blanket and change the orientation of the atmospheric
lines from horizontality to verticality. By burnishing and reworking,
Munch balanced the light and dark areas and accentuated the textures.
Further, in this impression is a striking example of selective plate wiping.

Fig. 5. *Moonlight.*
OKK 12–6. Off-white wove paper. Plate: 35.6 x
27.7), image: 31.8 x 25.7 (14 x 10⅝).

19

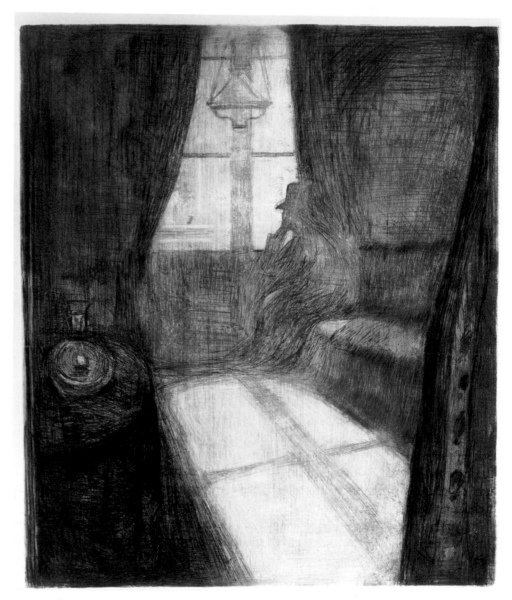

Pl. 6. *Moonlight*, 1895.
S. 13 II/c; W. 12. Drypoint, aquatint; buff wove paper. 35.5 x 26.8 (13$^{15}/_{16}$ x 10$^{11}/_{16}$).

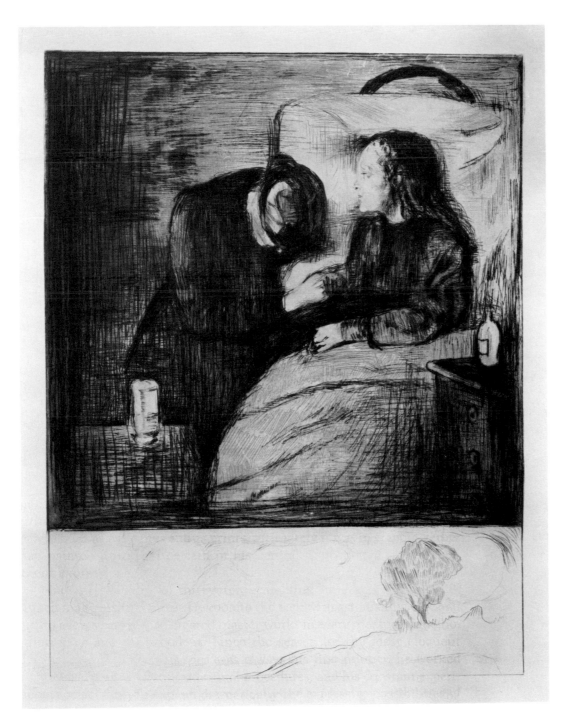

Pl. 7. *The Sick Child*, 1894.
S. 7 V/c; W. 7. Drypoint; buff wove paper. 38.6 x 29.2 (15³/₁₆ x 11½).

A plate tone in the upper area contributes to the coloristic effect of the black ink against the paper. The landscape below, however, has been wiped clean, contrasting the shadowy sadness of the sickroom with the brightness of the outdoors, an instance of technical virtuosity that enhances the meaning of the picture.

ETCHING

Etchings, especially in their first trial proofs, have the most direct hieroglyphs....Furthermore, there are plates which have been worked over repeatedly so that everything is highly finished and the smooth plate is transformed by repeated acid baths into a dramatic terrain of mountains and valleys. There are plates with etched lines 2 millimeters wide next to those with lines as fine as hair, plates with airily delicate aquatints and others with etched surfaces which look like cloisonné.

...Etching is a refined technique. Even the heaviest impression produces extremely delicate lines. They sit lightly raised upon the ground, which shimmers like velvet.[13]

The technique of etching, which Munch learned in 1895, allowed increased freedom of handling as well as additional coloristic effects possi-

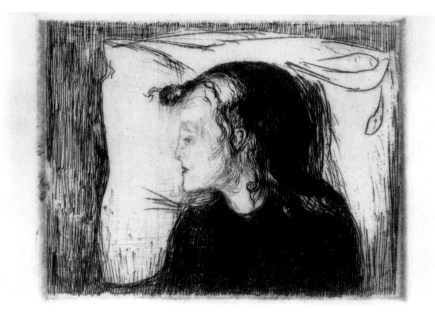

Pl. 8. *Head of the Sick Child*, 1896.
S. 60; W. 47. Etching; buff laid, thin Japan paper. 14 x 18.1 (5½ x 7⅛). Signed, graphite, lower right: "E. Munch".

Pl. 9. *Upper Body of a Naked Girl—The Maiden and the Heart*, 1896.
S. 48; W. 40. Etching, drypoint, in red; cream laid paper. 24.5 x 34.4 (9½ x 13½). Signed, pencil:
Inscribed, verso: "Meget sjeldet Plan er som Regel delt"

ble by progressive bitings of the plate. Although this did not prevent him
from also printing some motifs, such as *Head of the Sick Child* (Pl. 8, a
black and white impression) in color, nonetheless, when working in intag-
lio techniques, he consciously sought effects to suggest tonality and hue
while printing in black and white. Sometimes, as in *Maiden with a Heart*
(Pl. 9), to emphasize certain elements, he also either added color by hand or
perhaps applied it in the fashion of a monotype.

Munch chose the technique of etching for two prints included in the
Meier-Graefe portfolio, *Tête-à-Tête* and *Christiania-Bohême I*, perhaps
because there is not the same quietude that characterized the scenes
rendered in drypoint. The freer etched stroke allowed Munch looseness of
handling appropriate to subjects with more implied action. The etched
scenes are also larger than the drypoints, and the trend to larger format
continued as Munch moved on to lithographs and woodcuts.

23

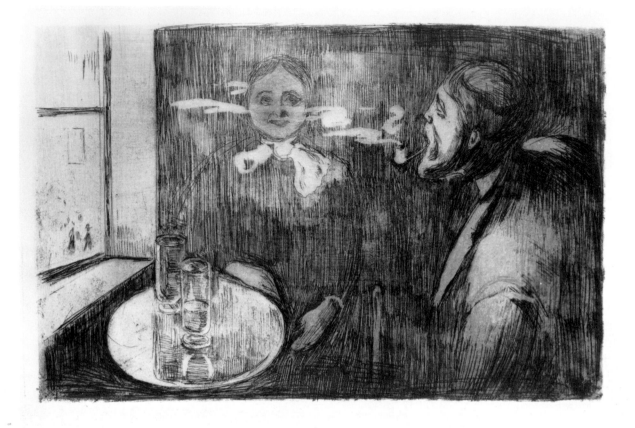

Pl. 10. *Tête-à-Tête*, 1895.
S. 12 III/c; W. 11. Etching, aquatint; cream wove paper. 22.1 x 32.7 (8⅝ x 12⅞).

Schiefler and Willoch disagreed on the technique of *Tête-à-Tête* (Pl. 10) in which Munch depicted an intimate conversation between the Norwegian painter Karl Jensen-Hjell and a lady, perhaps the artist's own sister Inger.[14] It is not clear whether it is aquatint or burnishing that creates the tonal surface which evokes the smoky room. In the area of the window, burnishing, and either some kind of stippling, or grainy material such as sandpaper embossed onto the surface of the plate probably produced the dotted effect that recalls the pits of aquatint.

An effect beautifully illustrated in *Tête-à-Tête* is the use of stopping-out. In order to create the white smoke wafting across the face of the woman, such an important element of the painting, the artist laid on an acid resistant substance to prevent these areas of the plate from being bitten. Although traces of etched lines from the earliest conception remain

in the white area, they were mostly burnished away in the transition to the subsequent state.

Confusion in the identification of techniques also occurs with *Christiania-Bohême I, Christiania-Bohême II* (Pl. 11, and Pl. 12 of copper plate) and the later intaglio prints in the Straus collection: *Two Girls with a Skeleton* (1896) (Pl. 13); *The Dead Mother and Child* (1901) (Pl. 14); and *Girls on the Jetty* (1903) (discussed in a later chapter). In each of the last four, in one of their intermediate states, a textured effect was created by aquatint and other graining techniques. The images appear pockmarked with irregular stipplings which betray traces of a sandpaperlike material,

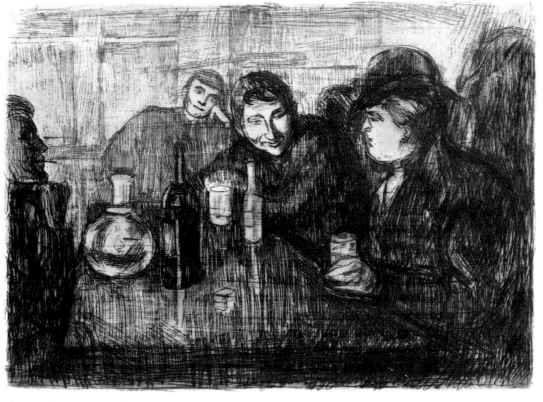

Pl. 11. *Christiania-Bohême I*, 1895.
S. 10 II/c; W. 9. Etching; buff wove paper. 21.9 x 29.8 (8⅝ x 11¾).

and it is not unlikely that Munch did run his plates through the press with sandpaper in order to emboss this texture. A stippled first state impression of *Two Girls and a Skeleton*, dated 1913, is even inscribed "Experiment," but it is impossible to deduce how the artist made this effect, which he subsequently erased. Also, if this date is correct, then Munch cannot have returned to this plate to make the second state until at least seventeen years after the initial concept, an interesting example of the enduring freshness of the graphic material for him. Clearly Munch was interested in experimenting with this image and the Straus impression, a second state printed in dark blue ink, also represents an instance of the use of color in intaglio prints.

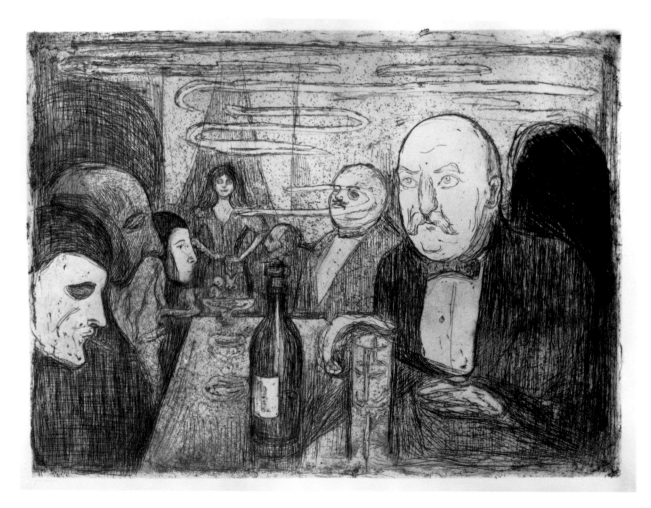

Pl. 12. *Christiania-Bohême II*, 1895.
S. 11 III/b; W. 10. Etching, drypoint, aquatint; cream wove paper. 29.5 x 39.6 (11⅝ x 15½).
Signed, graphite, lower right: "Edv Munch". Inscribed, graphite, lower left, by the printer: "O Felsing Berlin gdr."

Very different is the etching *The Dead Mother and Child*, made in 1901, in which Munch experimented with a blotchy background of uncertain origin. It seems independent of the aquatint tone which lies over other parts of the picture, and may have been made by forceful stippling on the metal. There are velvety drypoint accents on the headboard, around the mother's chin, and markings on the bodice of the child's dress. This motif owes much of its force to its size. Substantially larger than the images in the Meier-Graefe portfolio for example, it could be accommodated only on a large zinc plate.[15]

This impression, printed by Felsing in brownish black ink, stands out luridly against the tan paper. The lines, prominent above the surface in

Pl. 13. *Two Girls and a Skeleton*, 1896.
S. 44 a; W. 36. Drypoint printed in bluish black ink; buff wove paper. 31.8 x 42.2 (12½ x 16⅝).
Signed, graphite, lower right: "Edv Munch".

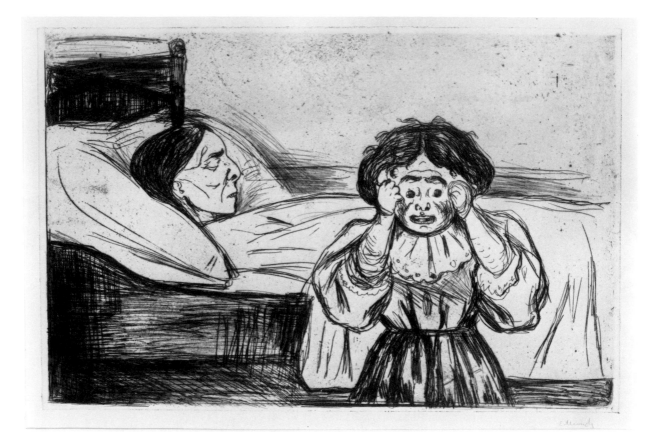

Pl. 14. *The Dead Mother and Child*, 1901.
S. 140 III; W. 59. Etching, aquatint; tan wove paper. 32.4 x 49.5 (12¾ x 19½). Signed, graphite, lower right: "E Munch". Inscribed, graphite, lower left, by the printer: "O Felsing Berlin gdr."

high relief, are as aggressively emotional as the scene itself. In 1901 (and even later) the artist still battled old memories; he was only five when his mother died. The little person depicted here, not clearly either male or female, presses tiny fists to its temples in a gesture reminiscent of *The Scream*, wailing in an agony of loss. Munch evoked a scene of pure feeling with only the barest indication of setting and circumstance. How different from Max Klinger's 1889 print of *The Dead Mother*, to which Munch's image has so often been compared. Klinger's virtuosic engraving of the same theme is so clinically detailed that the pathos of the scene has been snuffed out.

Yet another evocative use of intaglio line appears in *Puberty (By Night)* (Pl. 15), an etching made after the painting as well as after Munch's first lithograph entitled *The Young Model* (1894). Here Munch employed

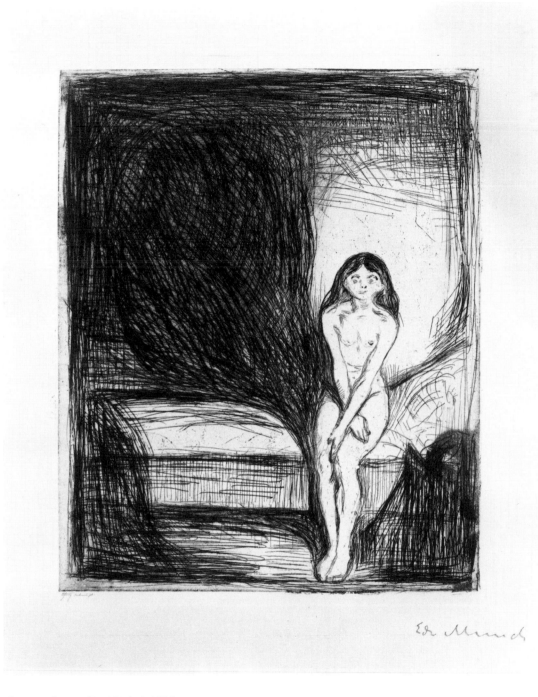

Pl. 15. *Puberty (By Night)*, 1902.
S. 164; W. 79. Etching, aquatint; cream wove paper. 19.7 x 16 (7⅞ x 6¼). Signed, graphite, lower
right: "Edv Munch". Inscribed, graphite, lower left: "O Felsing Berlin gdr."

the technique of *retroussage*, leaving enough ink on the plate during wiping to produce a blurry effect. By doing this, he captured the effect of the flickering candlelight that casts the looming shadow behind the apprehensive girl.

In *Woman*, or *Woman in Three Stages* (Pl. 16), Munch designed one of the most compelling combinations of the three techniques of drypoint, etching and aquatint. In five states Munch meticulously reworked the

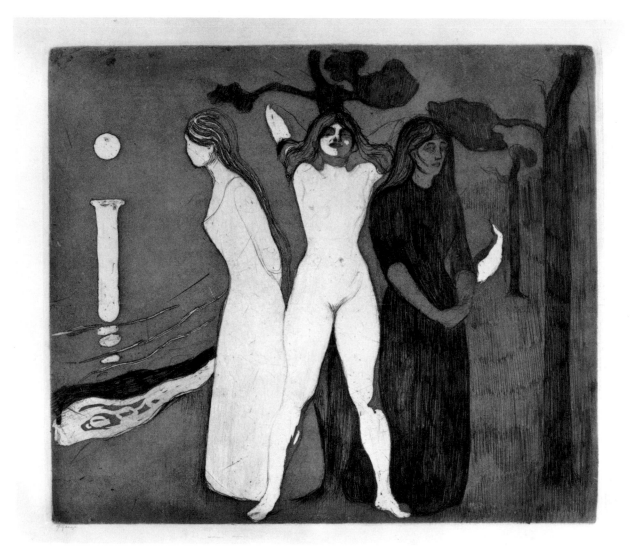

Pl. 16. *Woman (Woman in Three Stages, The Sphinx)*, 1895.
S. 21 V B v/vi; W. 21 VI. Etching, drypoint, aquatint; buff wove paper. 30.2 x 34.6 (11⅞ x 13⅝).
Inscribed graphite, lower right, by the printer: "O Felsing Berlin gdr." Verso: stamped with the seal of Munch-museet.

subject from a simple linear drypoint and etching to a richly tonal image. On an impression of the first state in the Munch Museum (Fig. 17), Munch experimented with pencil marks to test for lines he would later etch, and with ink for a subsequent application of aquatint. He sensitively evoked a nocturnal scene, biting the plate overall with aquatint except for areas carefully stopped out: the moon and path, the woman in white and the central nude, and the shoreline. The extraordinary technical skill of the artist may be seen in the delicacy with which he applied the stopping-out varnish to depict the action of the light source, the moon, whose beams play over the figures and the water. In the hair of the woman at left, for example, narrow white strands lie next to dark ones; in the water, rays gleam on the crests of the wavelets. And on the woman in the middle, aquatint and the stopping-out create the modelling shadows that lend volume to her form. The Straus impression was printed by Felsing in the brown ink characteristic of the shop, and in this color especially it conveys the velvety warmth of a summer night in which the desires of the three women can no longer be smothered.

Fig. 17. *Woman.*
OKK t20–8. Heavy white wove paper, hand colored with graphite and light black wash. 28.9 x 33.6 (11⅜ x 13¼).

MEZZOTINT

In Paris in 1896, Munch discovered the mezzotint. In this technique, the plate surface, pitted overall, is worked with the burnisher to create tones ranging from black to gray to white; and the image, often touched up with drypoint or etching, emerges. The mechanically beveled edges, present on all of Munch's mezzotints, suggest his use of commercially prepared plates.

Munch only made nine mezzotints, seven of which were also printed in color. *Evening Scene* (Pl. 18), one of the latter, is represented in the Straus collection by a fine monochromatic impression inked in a subtle brown. Unlike *Woman*, where the tone was created by applying aquatint, here the tonality was already present in the prepared plate; Munch then scratched in the drawing and used the burnisher for the highlights. Although the mezzotints are subtle and atmospheric, the technique apparently did not interest Munch very much, and mezzotint impressions are accordingly rare.

MUNCH CONTINUED TO MAKE intaglio prints throughout his life. Beyond the 1890s, though, the medium acquired other functions. After the initial reworking of the major themes from the "Frieze of Life" into drypoints and etchings, he never again drew images of this type on copper. Instead, he used the intaglio print specifically for portraiture, private commissions, and for certain kinds of intimate scenes.

31

Pl. 18. *Evening Scene*, 1897.
S. 84; W. 49. Mezzotint printed in brown; buff wove paper. 24.1 x 29.8 (9½ x 11¾). Signed, graphite, lower right: "E Munch". Inscribed, graphite, lower left, by the printer: "O Felsing Berlin gdr." Stamped in blue, lower right with seal of Harold H. Halvorsen.

In 1902, Max Linde commissioned a portfolio "Aus dem Haus Max Linde." The relationship between Munch and Linde provides an interesting twist on the concept of this artist as the independent genius. Their correspondence abounds with Linde's own suggestions for alteration and, according to him, improvement, of the etchings he had commissioned. In one case, he was dissatisfied with a portrait of one of his four sons and asked Munch to strengthen a line here or there. In another case, he advised

Munch to use black rather than brown ink and to abandon Japan paper for the image in question. A knowledgeable connoisseur, he proffered specific technical advice: "I think that it is better not to bathe [the copper] in acid that is too sharp, but better to etch it longer with more diluted acid. Also, I believe that the strokes on the copper will be more beautiful if you take a sharp needle and reserve the sheath knife for zinc."[16] Since Munch was creating work to order, he perhaps necessarily became less innovative. He reserved his experimentation for other media, especially the woodcut.

The other mode for intaglio after the 1890s was intimate scenes such as the series of erotic prints that Munch made around 1913. These are not images of archetypal consequence like *The Kiss*, or *Jealousy*, but glimpses into personal moments. Here, the smaller, more private scale of the intaglio medium makes sense. The central, or more universal, themes found their most powerful graphic realizations in the lithograph and the woodcut.

III

THE LITHOGRAPH

LITHOGRAPHY OFFERED Munch new freedom of execution. The means of
making the image, if not of preparing the stone, were as direct and spon-
taneous as drawing. The artist immediately recognized the potential of the
process, for lithography (and later zincography) soon replaced the intaglio
techniques as his "sketchbook" medium, the one in which his slightest
thought was quickly seized. Especially later in Munch's life, when mostly
he reworked old images, lithography remained a constant source for new
ones. Soon after his death, Willoch visited Munch's studio at Ekely, where
piles of unsorted graphics lay about. Some, Willoch noted, recorded only
the briefest, most germinal inspirations, and seem to have been unique
pulls from lithographically prepared zinc plates.

In addition to unconstrained handling, lithography provided the
chance to produce almost endless impressions, many more than allowed
by the intaglio plate (before steel facing), because the lithographic image
could be transferred to stone after stone. The technique also provided
Munch with further opportunities for innovation. But most importantly, it
may be postulated that Munch's introduction to lithography deepened his
understanding of what it meant for an image to be "graphic" and steered
him from the reproduction of his painted imagery to the creation of
original works in the graphic media. In a paradoxical way, lithographs
illustrate the issue of what is "graphic" (that is, possessing qualities unique
to reproductive methods) because they can be mistaken for drawings and,
in other cases (such as the complicated color compositions) differ com-

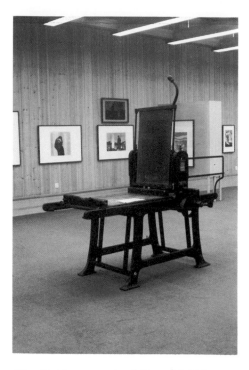

Fig. 19. Photograph of Munch's lithographic hand press.

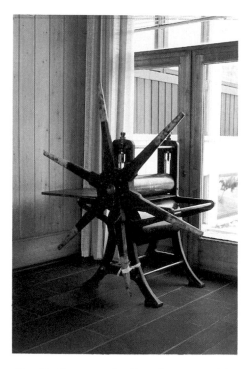

Fig. 20. Photograph of hand press used for intaglio. (Both presses manufactured by Karl Krause, Leipzig.)

pletely from drawings. From this contradiction Munch perceived a new direction for his graphic work.

The intensity and enthusiasm which Munch brought to lithography are reflected in his increased control over its materials and tools. In his booklet *La lithographie originale en couleurs* of 1898, the French critic André Mellerio deplored the case of certain artists "...ignorant of the limits of the field they are entering as well as of the resources that it contains....The craftsmanship quickly discourages them or they let themselves get caught in the net of a printer experienced in the technique. Then laziness sets in: it is so easy to hand over a bit of a study of a figure or a landscape, or a sketchy canvas which the workman will reproduce, as exactly—though never precisely—as he can."[1]

This was never Munch's practice. Even his transfer lithographs came from his own hand. In the early years, he tended to work directly on the stone, as we know from Count Kessler's diary, and later mainly produced transfer lithographs.[2]

In 1943, very soon before the artist's death, David Bergendahl visited Ekely, Munch's estate near Oslo, and wrote a short recollection of his encounter with the artist. Bergendahl relates that Munch proudly showed him his old rusty hand press (both his lithographic and intaglio presses are now in the Munch Museum, Oslo; Figs. 19 and 20) on which he had himself printed many of his lithographs and woodcuts. During the visit, the artist printed his last lithograph while discussing the technique of lithography at great length.[3] Many of the impressions Munch pulled throughout his career in fact bear the notation "Eigendruk" (self print) or "Handtryk" (hand print). Concurrently, however, images continued to be commercially pulled by professional craftsmen who came to work at Munch's various Norwegian residences, at Hvitsten and at Ekely.

Another factor that gains importance in Munch's lithographs is paper. Munch understood the impact of bare canvas in his painting better than his contemporaries, and in his lithographs exploited the effects of the blank sheet in a similar way. Since each type takes ink in a particular way, Munch was able to manipulate this aspect of an image simply by pulling impressions on a variety of supports: wove, laid, China, Japan, and so on, all of different weight, texture, and color. *The Scream*, for example, was often printed on cream colored paperboard, but there are impressions inked in black and pulled on flaming shades of red and purple. On these, the scream sounds very different to the ear. And for trial proofs, surely it was Munch himself who picked up scraps of brown wrapping paper from the floor (Fig. 21, OKK 597–2) to print a quick sample.

Whereas direct inspirations for Munch's intaglio prints may have been the Old Masters or his contact with professors of art in Berlin, in Paris he was surrounded by artists making lithographs. Although the eight lithographs made in 1895 were all printed in Berlin, these early German black and white prints nevertheless look the most "French." They recall the

works of the symbolist Odilon Redon and of Félix Vallotton, the Swiss artist then living in Paris. Vallotton's lithographs and woodcuts depend heavily on stark, simplified compositions in black and white which exploit ambiguity between figure and ground. His woodblock portrait of Dostoyevsky has been compared to Munch's *Self-Portrait with Skeleton Arm*. Vallotton commonly inserted his titles into his images, and in the lithographs he often wrote a legend on the stone below the picture, which printed like handwriting, similar to Munch's placement of his name above his self-portrait. Munch also on occasion inserted titles and he wrote an inscription to print at the bottom of *The Scream*. A biographer of Vallotton claims that Munch made his acquaintance on one of his early visits to Paris, and so the relationship between their work may be direct, although evidence is slim.[4] It is noteworthy, however, that in those of Munch's early lithographs that exist in more than one state, the first state often resembles Vallotton's ink and wash studies. And subsequent states look like the woodcuts Vallotton made from these studies. In the early years, Munch often made artistic references to other techniques in his lithographic work, and some of his early lithographs could well be mistaken for woodcuts. This was not necessarily imitation for its own sake however. Frequently, it seems to have been an important part of the artist's quest for a more congenial medium in which to render his image.

Before 1896, when Munch learned to carve in wood, he used tusche to create the flat, planar areas so prominent in many of his compositions. The early lithographs depend on tusche both to create line, as in *The Scream* and *Anxiety*, and to fill in areas that acquire almost abstract shapes, as in *Death in the Sickroom* and others. Even more than the intaglio prints, which also repeat painted motifs, these lithographs resemble the oils of the "Frieze of Life" in their patterned abstraction. At the time Munch made them, they played the ambiguous role of resembling the intaglio prints in function by disseminating the imagery, while at the same time often anticipating the woodcut stylistically.

Although lithography is a versatile medium which can approximate drawing as well as woodcut, it possesses "peculiar qualities and freedoms" of which Munch was well aware. It was these unique qualities of tone and texture that Munch developed over the years as he became increasingly proficient in the lithographic technique, and as he was able, after 1896, to leave to the woodcut effects for which that technique was better suited. Although the lithographic crayon became his primary tool, Munch did not abandon the use of tusche after the 1890s; he continued, although to a lesser degree, to exploit the areas of opaque black which form a contrast to the crayon's graininess.

As Munch matured into the lithographic technique, he assigned it a particular place in his work: the lithograph became his preferred black and white medium. The selection of lithographs in the Straus collection—nineteen are black and white, four are color, and two are a combination of

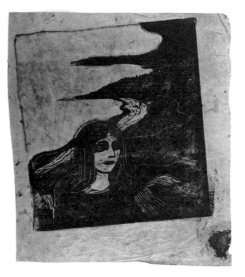

Fig. 21. *Girl's Head on the Shore.* OKK 597–2. Brown wove paper with hand coloring. 45.7 x 40.9 (18 x 16¼).

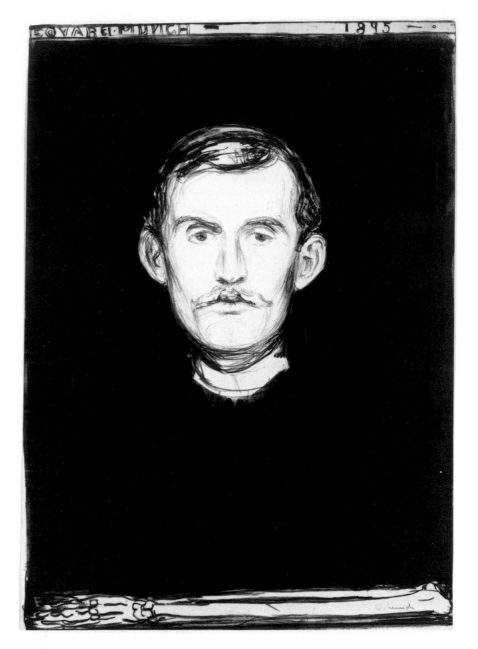

Pl. 22. *Self-Portrait with Skeleton Arm*, 1895.
S. 31. Lithograph with crayon, tusche, needle; white wove, China paper. 45.4 x 32.1 (17⅞ x 12⅝). Signed, graphite, lower right: "Edv Munch".

lithography and the woodcut—is not serendipitous, but reflects the pattern of Munch's work. Although he made significant contributions to the development of the color lithograph, as is evident in *The Sin*, he made relatively few of them. The black and white lithograph, on the other hand, permitted subtleties of tone unobtainable elsewhere and the ease of working in crayon made this medium the obvious choice for sketches, caricatures, studies of animals, and portrait drawings. So although lithography did not entirely replace the intaglio methods for these purposes, the lithographs do outnumber the drypoints and etchings.

The earliest lithograph in the Straus collection is the *Self-Portrait with Skeleton Arm* of 1895 (Pl. 22). Always self-absorbed and self-scrutinizing, Munch made portraits of himself throughout his lifetime. Three especially powerful representations date from this year: the paintings *Self-Portrait with Cigarette*, and *Self-Portrait in Hell*, and this print, one of three lithographic self-portraits in the Straus collection.

Reveling in the character of the black and white print, Munch created value contrasts as bold as the composition. Severed from the body, the artist's head emerges from the blackness, ghostly and shocking in its rigid frontality and pallor, emphasized in this impression by the choice of a very white China paper. Only the irregularity of the features offsets the uncompromising symmetry of the apparition. Drawing with crayon and tusche, as well as the needle, Munch created a spectrum of tones in which the gray modulations of the crayon hover between the inky-black background and the chalk-white of the paper.

Tonalism and delicacy of detail were not, however, important issues in all the lithographs of 1895. In *The Scream*, for example (Pl. 23), Munch returned to a purely linear design, working exclusively with tusche to brush spiraling lines onto the stone. But this linearity differs greatly from the incisions of the intaglio technique and Munch evidently sensed that the fluidity and power of the lithographic strokes could recreate his paintings in a newly evocative manner.

The Scream, represented in "The Mirror" series, reproduces the motif of one of Munch's best-known compositions. First printed in Berlin, it created a sensation when it appeared in Paris in *La Revue Blanche* of December 1, 1895. In translating the image from the expressionistically-hued painting to the stark graphic rendering, the artist faced the problem of communicating his subject, of which he had written:

"I walked along the road with two friends. The sun went down—the sky was blood red—and I felt a breath of sadness—I stood still tired unto death—over the blue-black fjord and city lay blood and tongues of fire. My friends continued on—I remained—trembling from fear. I felt the great infinite scream through nature."[5]

Munch was able to convey some of the poetry and intensity of color by printing the image on brightly hued papers, including red and purple. Some

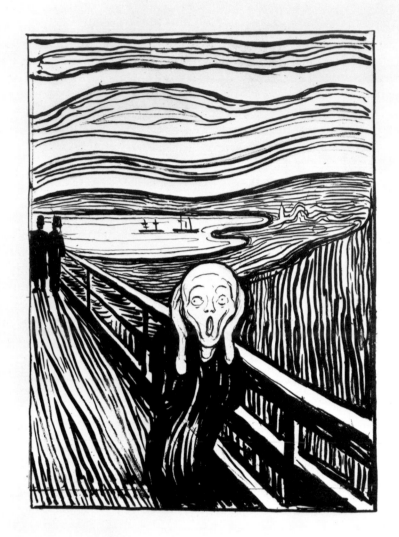

Geschrei

Ich fühlte das grosse Geschrei
durch die Natur

freundliche Erinnerung E. M.

Pl. 23. *The Scream*, 1895.
S. 32. Lithograph with tusche; buff wove paper. Image: 35.2 x 25.4 (13⅞ x 10); sheet, including printed inscription: 51.1 x 37.5 (20⅛ x 14¾). Signed, graphite, lower right: "E Munch". Inscribed, graphite, lower right: "an Frau Dr Glaser in freundliche Errinerung" (sic).

impressions were hand colored. But in evoking the enveloping terror of the experience, he emphasized the swirling sinuosity of line rather than colorism and, for this, strokes of tusche were an ideal medium. Juxtaposing the sharp, straight diagonals of the railing with the sinuous ribbons of the sky and the harbor, horizontals with verticals, the artist created a densely rhythmic, pulsing nature that mirrors the anguish of the creature in the foreground. The decorative *art nouveau* quality does not detract from the meaning, but enhances it in a curious stylization.

Yet, even though the print evinces some of the qualities peculiar to lithography, particularly the freedom of handling, it was, because of its style, mistaken for a woodcut.[6] This is not surprising; in *The Scream*, the lines have no more import than the spaces of the paper and one may easily imagine the artist carving away the white areas with his knife, leaving the raised black lines to print. Munch had not yet begun to work in wood, so the lithograph merely is a harbinger of an interest in figure and void that would find potent expression in the relief prints.

With the broad touch and almost posterlike simplicity of Toulouse-Lautrec, whose work Munch very likely saw at the printing shop of Auguste Clot in Paris, as well as the stark contrasts reminiscent of Vallotton's woodcuts, the images of *Hands* (Pl. 24) and *The Alley* (Pl. 25) stand out vividly against the otherwise blank sheet. In both prints, Munch worked loosely and lightly on the stone with both crayon and tusche, opposing the graininess of the former with the fluidity of the latter. In each, he further explored his interest in negative and positive forms, exploiting the decorative force of the juxtapositions.

In the use of materials, the lithographs of 1895 differ little from drawings made from a combination of ink and crayon. The black and white lithographs of the following year, however, when Munch moved to Paris, show the beginnings of the artist's transformation of his medium. As he began to experiment with woodcut during 1896, he concurrently became more aware of qualities unique to lithography, and a number of works from this year exhibit his new preoccupation.

Among the first of Munch's lithographs printed by the Parisian master printer Auguste Clot, described by the critic André Mellerio in 1898 as "the color printer in the forefront now" were the two versions, large and small, of the motif *Jealousy* (Pls. 26, 27); the larger version was selected for "The Mirror."[7] Although the smaller version was listed first by Schiefler in his catalogue, it was not necessarily made before the other version. The motif comes from a painting of 1894–5 where the figures in the background are seen full-length, as in the larger lithograph.[8] It seems more likely that Munch, in his first translation of the image to stone, would remain faithful to the oil, as he did with other motifs. Once the image was seen in graphic form, presumably he would feel freer to reduce its scale, and move and alter the figures. In so doing, Munch subtly altered the meaning of the image: in the small *Jealousy* the action seems to take place in the man's mind, the

41

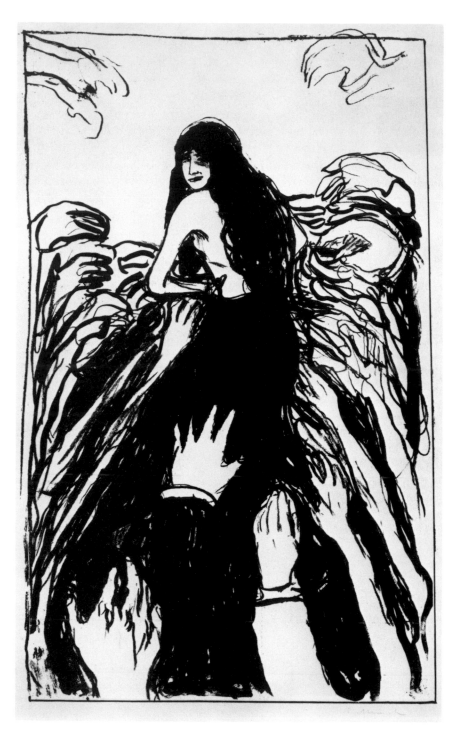

Pl. 24. *Hands*, 1895.
S. 35 II (of 2 states). Lithograph with crayon and tusche; off-white paperboard. 48.3 x 29.2 (19 x 11½). Signed, graphite, lower right: "E Munch".

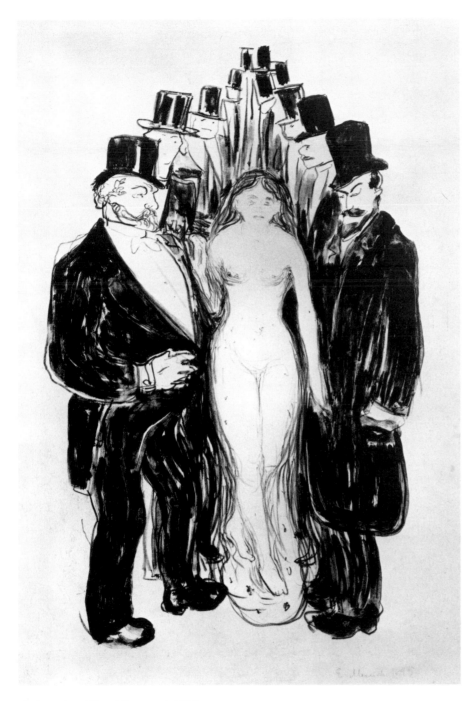

Pl. 25. *The Alley (Carmen)*, 1895.
S. 36 a (state I or II of 3). Lithograph with crayon and tusche; off-white wove paper. 49.9 x 36.5
(19⅝ x 14⅜). Signed and dated, graphite, lower right: "E Munch 1895".

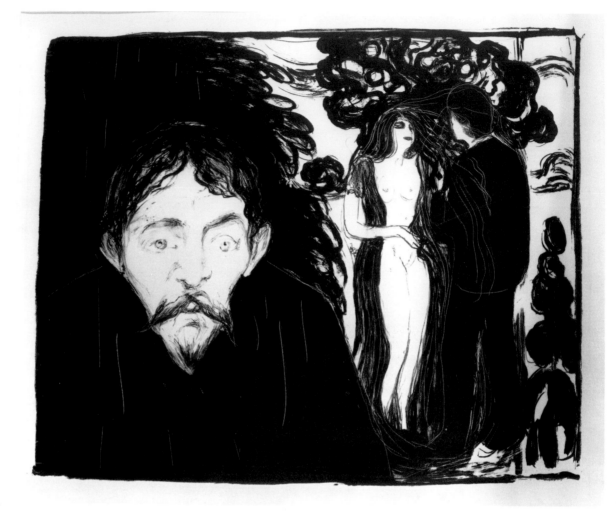

Pl. 26. *Jealousy*, 1896.
S. 58. Lithograph with crayon, tusche, needle; white wove paper. 45.7 x 57.2 (18 x 22½).

scene that torments him being an extension of his own fearful imagination. In the other version, although it retains a certain ambiguity, the composition nevertheless evokes an actual physical setting. Further, in the small version, the direct gaze of the suffering man invites, even forces, the viewer into his mind and its haunting suspicions. In the other lithograph, as well as in the oil painting, he is withdrawn; we remain as isolated from him as he is from the woman and his rival.

Munch drew both lithographic versions on the stone with crayon and tusche, and also scratched into the stone with a needle. This technique already appeared in *Self-Portrait with Skeleton Arm* where Munch modu-

lated the stark background area, but here he used it with more sophistication and variety. In the large *Jealousy*, unmodulated areas of black, such as the torso of the foreground man, have been enlivened with long scratches, and the contours of his shoulders defined. In a masterful transition of positive and negative lines, Munch drew a black moustache with crayon on the light background and extended the whiskers as white scratches against the black background; a similar effect is seen in the woman's hair where black strands blend with white scratches weaving around the man like a great web.

Along with their representational role, the needled lines add surface interest to the flattest print medium; they stand in relief on the paper as if

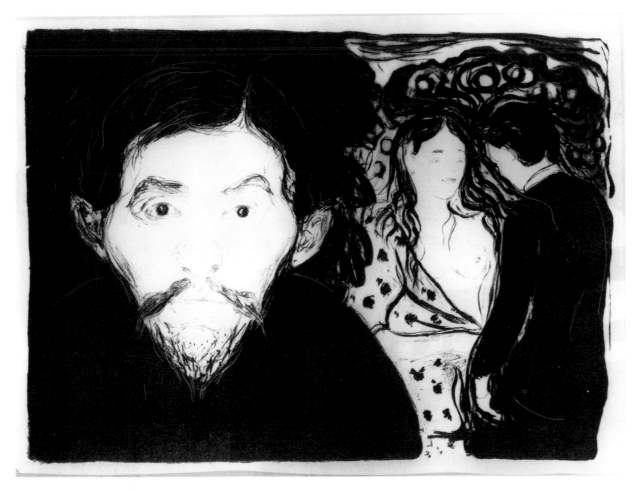

Pl. 27. *Jealousy*, 1896.
S. 57. Lithograph with crayon, tusche, needle; white laid Japan paper. 33.3 x 43.5 (13⅛ x 17⅛).

45

they were etched. In fact, the lines that extend the moustache are actually a kind of reverse intaglio, because they have been incised; but since they were not inked in order to remain white amidst the black surroundings, they also play the *role* of a relief line, in that the material has been subtracted so as not to print—a revealing example of Munch's synthesis of techniques.

Not all impressions were pulled in the stark black of the Straus print. The collection of the Munch Museum includes an impression printed in blue and hand colored in yellow and pinkish red. Unfortunately, it is undated and the year of printing cannot be determined by other factors. The impressions in the Museum, pulled on a variety of papers, from a thick cream wove to a very thin Japan are variously inscribed: "Lassally 1906–1908"; "Trykk, Berlin 1906–1908"; "No.2. Ekely/den 4/9 1916," and are good examples of Munch's practice of using stones over a period of years.[9]

Two more subjects from "The Frieze of Life" that were made for "The Mirror," *Separation II* and *Attraction I* (Pls. 28, 29) could not differ more in their techniques. Each introduces new issues into Munch's lithographic work.[10]

Separation II is an early example of a paper or transfer lithograph. In 1896, Munch drew the image with crayon on a piece of rough textured paper. Then the image was transferred to the smooth surface of a lithographic stone, retaining the grain of the face of the original sheet of paper. This grain remains constant regardless of the page upon which a given impression was pulled.

The Straus impression of *Separation II* was taken more than a decade after Munch created the image. He signed this impression, and inscribed it with the name of the Berlin printing shop, Lassally, dating it, somewhat ambiguously, "1906–9." Since it is unlikely that Munch transported the heavy lithographic stone to Berlin from Paris, where the initial printing occurred, he probably sent, or carried, the image on the special transfer paper from which it was shifted to stone. Therefore, two editions were being printed simultaneously in the two cities, a common practice of Munch's.

Separation, which exists in monochromatic impressions in black and blue, and in versions with color added by means of different stones (OKK 210–5), is obviously one of the lithographs that is most like a drawing. Although the surface qualities that would stand out in a true drawing have been smoothed away per force in printing, nevertheless one may follow each stroke of crayon, even the hesitation and alteration made in the woman's nose. For his favored device of transforming positive forms into negative ones, Munch passed the woman's hair across the man's dark torso which becomes light where the strands blow. The device also emphasizes her blondness and the lightness of the right side of the image, in contrast to the man's cap of dark hair, his shirt, and the heavily filled-in dunes behind

him. The picture lightens and opens up as she looks out to sea while the downcast male turns inward, surrounded by gloom.

Attraction I, on the other hand, beautifully printed by Clot, emphasizes blended tones. While the artist continued to use tusche, crayon and the threadlike needled scratches, he did not concentrate here on line in the sense of drawing. Instead, he used the side of the crayon to rub streaky grays into the sky, halting the hand motion abruptly to produce the stop marks which denote clouds. The marks add texture and tonal gradations so that light flickers across the sky. With the needle he nicked out tiny sparks, which occasioned an alternate title for this lithograph, used in "The Mirror": Stars. The sky fuses with the sea, separated only by the contour

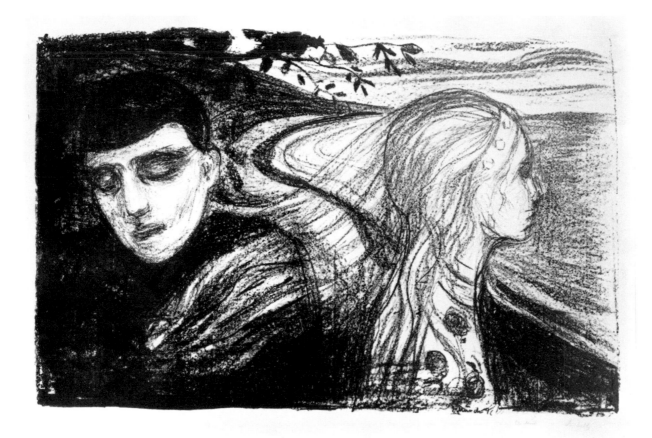

Pl. 28. Separation II, 1896.
S. 68 a. Lithograph with crayon printed in blue; white wove paper. 40.4 x 64.1 (15⅞ x 25¼).
Signed, graphite, lower right: "Edv Munch"; signed in the stone, lower right: "E Munch 96".
Inscribed, possibly by the artist, graphite, lower right: "Lassally 1906–9".

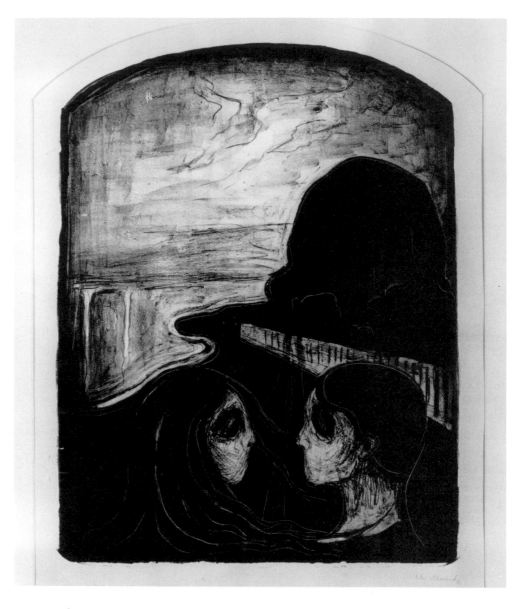

Pl. 29. *Attraction I*, 1896.
S. 65. Lithograph with crayon, tusche, needle; off-white wove paper. 41.6 x 35.7 (16⅜ x 14¹⁄₁₆).
Signed, graphite, lower right: "Edv Munch". Inscribed, graphite, lower left, by the printer:
"Ekely den 25/11 1916 No 9".

line that winds around the great clump of trees. Below, the faces emerge
from the matt tusche; only needle marks indicate the strands of hair that
float over to entangle the man. The technique in *Attraction I* represents
another case of Munch's combining of the planographic with the intaglio,
or relief: where, in the etching of the same subject the hair strands were
positive black lines, inked and printed after having been gouged into a

plate, here they are positive white lines, incised into the stone but un-inked. They shine through the planographic surface, and their relief may be seen on the surface of the paper.

One of the richest of Munch's early lithographs, and a masterpiece of tone, is *Lovers in the Waves* (Pl. 30). In this lyrical, rhythmic image Munch found a remarkable balance of the qualities of line and tone. To render the undulating motion, the artist no longer sought the crisp line of *The Scream*. Combining the same materials that he used in *Hands* and *The Alley*, yet to completely different effects, he worked with both the end and the edge of the crayon to produce the linear drawing and to rub in the shadows and modelling. Finally, he brushed on swirls of tusche. So subtle is

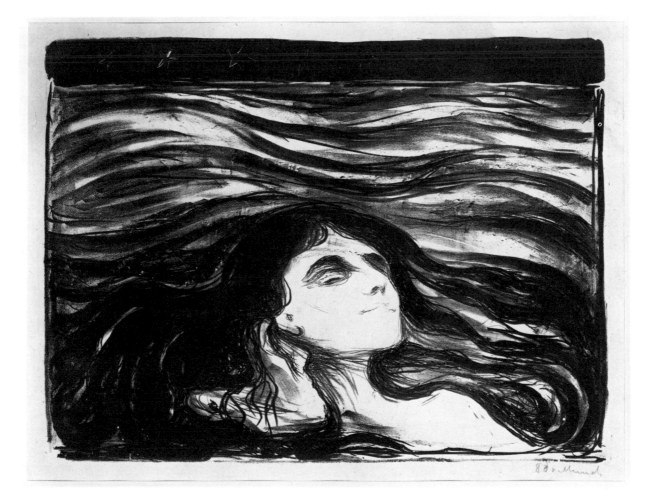

Pl. 30. *Lovers in the Waves*, 1896.
S. 71. Lithograph with crayon and tusche; white China paper. 31.1 x 41.3 (12¼ x 16¼). Signed, graphite, lower right: "Edv Munch". Verso: stamped with seal of Munch-museet.

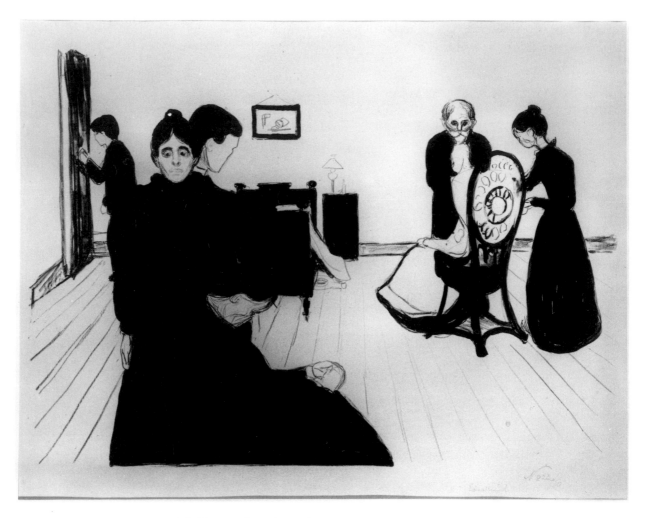

Pl. 31. *Death in the Sickroom*, 1896.
S. 73 II. Lithograph with crayon, tusche, needle; buff wove paper. 41.3 x 57.2 (16¼ x 22½).
Signed, graphite, lower right: "Edv Munch". Inscribed, graphite, lower right, by the printer:
"No 22/30".

the tonality of this print that impressions differ greatly in quality. The
Straus print captures most successfully the delicate grays in the water. The
lines blend and tangle across the surface, allowing the chalky-white sheet
to show through the layers of markings. The areas of bare paper, which
played the role of figure and void in *The Scream*, here serve to evoke a
profound sense of depth. The eye sinks through the layers of tusche to the
crayon below, and then to the paper. In reverse, the dramatic perspective of
the man's gaze up to the softly satisfied countenance of the woman, and
then to the sky, directs our perceptions into the blackness of space.
 Munch experimented with this image, double-printing one impres-

sion (OKK 213–5) to concoct an odd, atmospheric blurriness. He printed another in red, so the lovers float in waves of blood (Munch Museum, uncatalogued).

Munch's lithographic style did not, however, develop in a straight line from planar compositions, such as *Self-Portrait with Skeleton Arm* to tonal works such as *Lovers in the Waves*. As always, different interpretations of an image suggested alternate solutions. In *Death in the Sickroom* (Pl. 31), he again emphasized the abstract shapes against the background, and the startling contrast of black and white.[11]

Perhaps in no other print does the artist so hauntingly and completely appropriate the sheet of paper for the compositional purposes of the image. To indicate spatial relationships in a compressed picture space, Munch arranged the figures in overlapping planes, accentuating their rigid profiles or frontal views against the expanses of bare paper. The stiff poses and bleak juxtaposition of black forms and white emptiness emphasize the sorrow of the family, frozen by shock into immobility. Although touches of crayon delineate the more delicate details that would have been difficult or impossible to render in a relief medium, the large flat areas of tusche recall the handling of a woodcut, a technique that Munch learned the same year that he made *Death in the Sickroom*. This is true also of the treatment of planes and of figure and ground; as with *The Scream*, one sees the artist thinking in terms of another medium.

Unlike the other lithographs in the Straus collection, *Funeral March* (Pl. 32) was drawn on a zinc plate, and is probably one of the earliest Munch made on zinc. The advantages of zinc are obvious: it is light, easily portable; a plate may be purchased already grained; and it is much cheaper than stone. On the other hand, the metal must be counter-etched, that is, prepared for sensitivity to the lithographic materials before it is drawn on as well as after; and the surface does not have the same warmth and subtle texture as stone.[12] Additionally, the zinc surface does not seem to hold up as well. The scratched lines in *Funeral March*, evident on the Straus impression, appear to have been short-lived, disappearing quite rapidly in printing. When a printmaking manual notes that "...many of the 'experimental' scratching techniques are not advisable in metal plate lithography," this is surely because of the delicacy of the surface.[13] In fact, *Funeral March* is fairly rare, and its scarcity suggests that the artist may have abandoned the edition relatively early when the plate no longer produced the effect he sought.

Two years later, in *Ashes II* (Pl. 33), Munch combined his interest in strong value contrasts, emphasized by the use of tusche, with crayon tonalities. The earlier version of 1896 is more directly based upon the painting; in *Ashes II*, he made alterations that affect the emotional import of the theme. He heightened the sense of hopelessness and despair by blackening the forest with heavy tusche, rendering it ominous and impenetrable. He rubbed crayon across the stone, picking up the grain to simu-

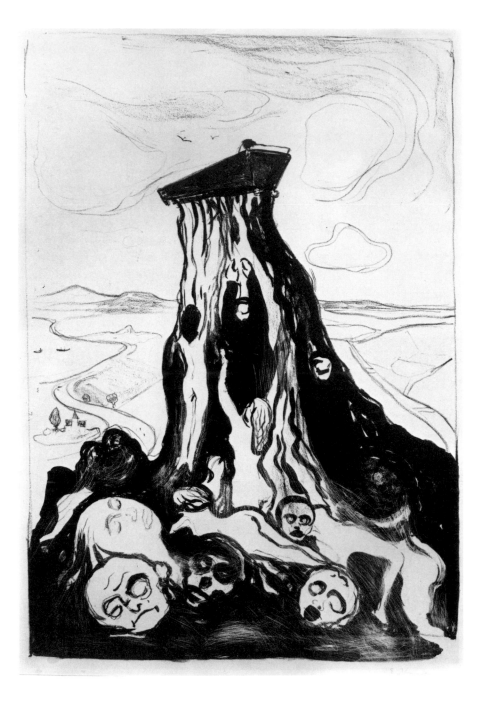

Pl. 32. *Funeral March*, 1897.
S. 94. Lithograph on zinc with crayon, tusche, needle; off-white China wove paper mounted on a cream wove sheet with watermark: "SAINTE-MARIE" (Chine collé). 55.9 x 37.5 (22 x 14¾). Signed, graphite, lower right on mount: "E Munch". Stamped in red ink on mount, lower left with mark of Heinrich Stinnes collection, L. 1376a.

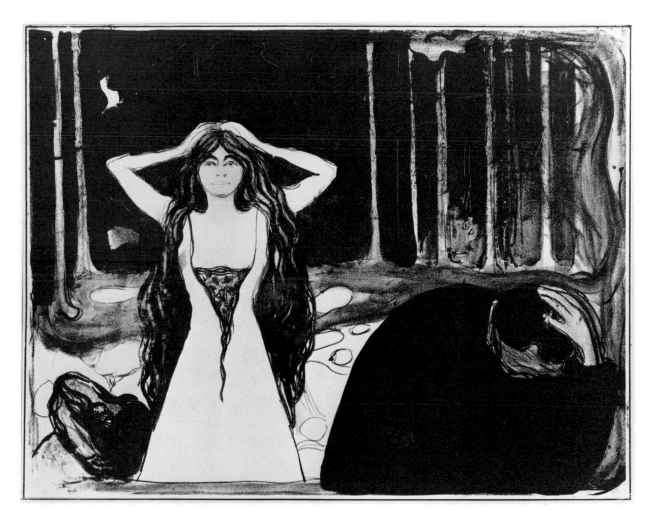

Pl. 33. *Ashes II*, 1899.
S. 120. Lithograph with tusche, crayon, needle; off-white laid paper mounted on brownish board. 35.9 x 46.6 (14⅛ x 18⁵⁄₁₆).

late acrid, ash-filled smoke which rises into the trees. It sullies the man's bowed face and hands, but leaves untouched the deceiving whiteness of the woman's skin.

The woman stands silhouetted against a square of dark background. Her configuration and stance challenge the cringing, defeated figure whose matt black rounded shape counterpoints the tree trunks that seem to crush him into the corner. The two people are completely separate; strands of hair no longer float over to her erstwhile lover as they did in the painting. Munch's simplification of the motif, his elimination of unnecessary detail and concentration of the forms intensifies the meaning of the image. Such

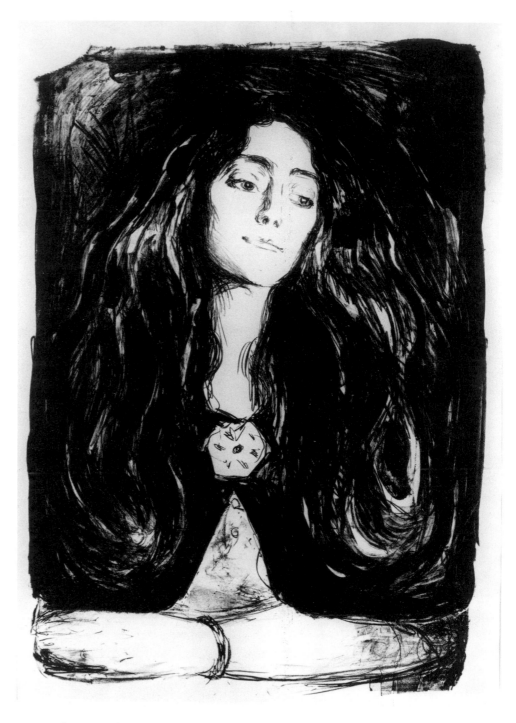

Pl. 34. *Madonna (The Brooch)*, 1903.
S. 212 III (of 4 states). Lithograph with crayon and tusche; off-white wove paper. 64.1 x 44.8 (25¼ x 17⅝). Inscribed, blue ink, by the artist's sister: "Solgt av Inger Munch 1944".

consolidation through successive workings occurs constantly, particularly in the woodcuts.

In 1903, Munch made one of his most remarkable lithographic portraits, *Madonna* or *The Brooch* (Pl. 34). The monumental crayon and tusche image of a face, veiled in locks of hair, fills the entire sheet. The special significance that it held for Munch is betrayed by the identity of the sitter, his mistress Eva Mudocci (Fig. 35), as well as by its sheer size and by its number of states.[14]

Many years later, Eva Mudocci said that Munch never succeeded in painting her, and the number of states of the lithograph suggest that drawing her likeness was not much easier. Indeed, it seems that the lithograph was never completed to his satisfaction, for in addition to the lack of visual resolution, there are transfer impressions, which suggest that Munch attempted several times to rework the composition, each time transferring the picture to a new stone to obtain a fresh start. Or perhaps he transferred it so he could make a present of the stone itself to Eva, as she suggests in an anecdote.[15]

The Straus impression represents the third state, in a sense the most interesting among them. Uncomfortable with the empty triangle below the brooch and the abrupt cropping of the loops of hair in the first state, Munch added a braceletted arm across the bottom, possibly from a piece of transfer paper, and filled in the triangular space with shading and two buttons. The arm lengthens the image by approximately four centimeters, further monumentalizing the picture. He also brushed in more locks of hair with tusche, darkening and intensifying the energetic swirls. (This may be a misperception; the amount of inking may account for the seeming strengthening of the hair.)

Munch's intention is clear. By adding the arm he sought to balance the image, to "finish" it. It almost works: a sense of a solid upper body has been achieved, and there is a base to a pyrimidal form, a resting place for the eye which, in the first state, had endlessly followed the loops of hair.

On the other hand, the arm seems almost detached, like the bones in the *Self-Portrait with Skeleton Arm*, and its presence detracts from the expressive head. Yet, once having seen this state, one returns with difficulty to the previous state, whose design now appears even more unstable.

Munch's uncertainty about the success of the arm then manifested itself in an interesting instance of transfer lithography. There is in the Munch Museum an impression based on the second state (although now with additional needle work in the hair) which is signed, and inscribed "Forsogstruk 1915," "trial proof" (OKK 255–10). Another second state impression is signed and dated "Lassally 1915" (OKK 255–35). On the former, however, there is a small white spot, a chip on the stone, in the midst of the hair at lower left. Also, the print has a dull, flat quality lacking the lively surface of the Lassally print. Further, the chip also appears on a subsequent state, with an equally lackluster surface, on which Munch also

Fig. 35. Photograph of Eva Mudocci.

5 5

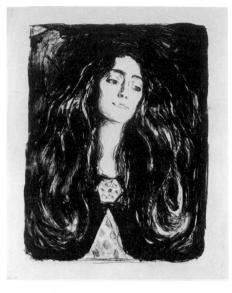

Fig. 36. *Madonna (The Brooch)*.
OKK 255–16. Off-white laid Japan paper. 59.7 x
45.8 (23½ x 18).

filled in the half moon at the upper left hand corner, sketched a design into the triangle and brooch, and scratched long regular cuts into the hair.

What seems to have happened is that the artist took a transfer of the second state of the stone, shifted it to the stone with the chip, added the scratch work, and proceeded to make yet another state on the flawed surface (Fig. 36). At the same time, another edition was being printed in Berlin at the shop of Lassally, to which Munch finally added the arm, no earlier than 1915.

This interpretation of available evidence on *The Brooch* underscores the involved technical issues relating to the lithographs and the problem of transfers that remain to be explored. Often it is a clue such as "trial proof," noted on a print with a date much later than the original conception, that betrays some new direction in printing. Consequently, each impression of a motif potentially adds to our understanding of Munch's working methods.[16]

Salomé (Pl. 37), the source of the "only row" between Eva Mudocci and Munch, raises no technical problems. With his powerful handling of the lithographic crayon and touches of the needle, the artist drew an image of his own head, with its dour expression, disembodied and entangled in the smothering locks of his lover, who smiles with lazy satisfaction. *Salomé* possesses the strength of a drawing. The artist has again made expressive use of the paper which plays the role not only of background, but of flesh. The Straus impression is particularly effective, printed on a thin, yellowish, glassinelike, textured paper that lends a curious mottled effect especially evocative for the faces. The print exists in only one state, although there are impressions pulled in a soft brown which tempers its negative connotations. Munch found it easier to make an image of ambivalence and pain caused by Woman, then one of beauty and love.

Two self-portraits from 1908–09, *Self-Portrait with Cigarette* (Pl. 38) and 1925–26, *Self-Portrait with Wine Bottle* (Pl. 39), are drawn exclusively in crayon, but Munch used that one instrument for two stylistically dissimilar images.

The earlier portrait is probably a paper or transfer lithograph; the strokes of the crayon bear a faint grain. The picture commemorates the artist's last smoke before giving up the habit in a desperate move to regain his health after an emotional breakdown. A moment of poignant sensuousness is reflected in the free and expansive line. Unlike the grainy effect of smoke of *Ashes II*, a lithograph made directly on stone, here Munch indicated the smoke by leaving the billows white against the background of the paper. He worked only with the end of the crayon, varying the pressure to produce darker or lighter lines, but the evocation of the rhythm and variety of line, rather than tonality, was the artist's main concern.

By contrast, *Self-Portrait with Wine Bottle* recalls the tonal richness of a print such as *Lovers in the Waves*. The lithographic portrait dates from

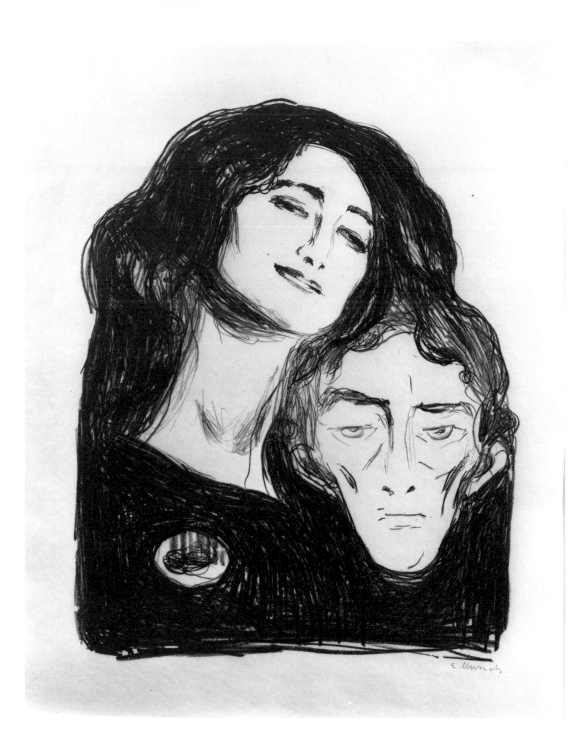

Pl. 37. *Salomé*, 1903.
S. 213. Lithograph with crayon and needle; yellowish glassine-like paper. 54.3 x 39.1 (21⅜ x 15⅜). Signed, graphite, lower right: "E Munch".

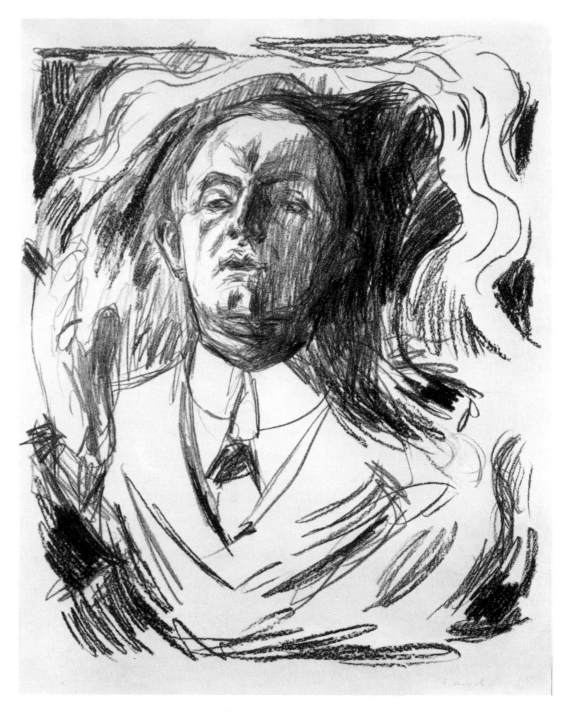

Pl. 38. *Self-Portrait with Cigarette*, 1908–9.
S. 282. Lithograph with crayon, off-white wove paper. 64.8 x 49.2 (25½ x 19⅜).

the 1920s, but its composition derives from a painting of 1906. In a dramatic transposition from the canvas, the light that had played across the painting now emerges from the blank paper in the lithograph. Where in *Self-Portrait with Skeleton Arm*, the white simply came from blank background, here the surface is modelled with such varying subtleties, that areas left bare, such as the windows and spots on the table and the right side of the artist's face, become only the "highest-lights" of an extensive scale of tones.

Again, the handling of the crayon works expressively. In *Self-Portrait*

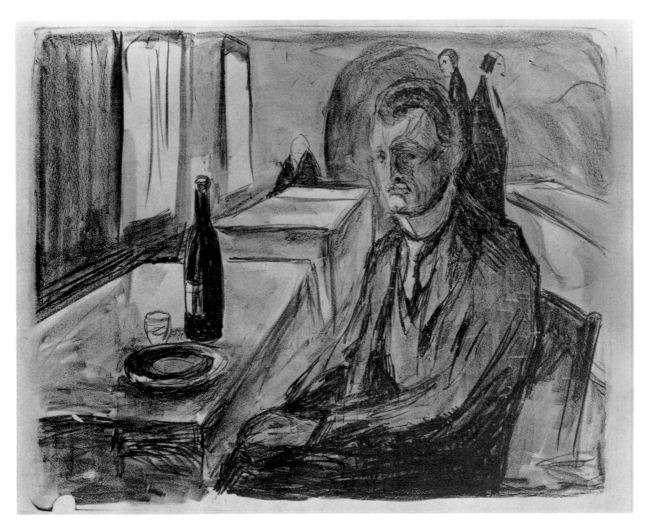

Pl. 39. *Self-Portrait with Wine Bottle*, 1925–6.
Not in Schiefler. Lithograph with crayon; off-white China paper. 41.6 x 50.8 (16⅜ x 20).

with Wine Bottle, Munch worked with both the end and the side of the crayon. He smoothed in the walls and tablecloths with its edge, accenting the surfaces of the objects as well as the grain of the stone. In drawing the figures, however, especially his own, he moved jerkily, abruptly halting the progress of the crayon and leaving stop marks on the stone. In *Attraction II* these marks suggested clouds in the starry sky, but in the portrait they create a sense of nervous agitation that causes the artist's body to vibrate with tension. This effect is even more pronounced in contrast to the rest of the drawing. Munch's touch directly affects the mood of the scene, indicating again the purposiveness of his technique.

BLACK AND WHITE LITHOGRAPHY played a special role in Munch's graphic work: he made more prints in this medium than in any other. It combined freedom of handling, unmatched in either the intaglio or the woodcut techniques, with the potential for planar forms that characterized his paintings. Further, the tonalism of lithography intrigued Munch in a way that the analogous intaglio methods, such as aquatint, never did. But this concern nonetheless represents only one aspect of his achievement. In another chapter, his techniques for printing color lithographs will be discussed at length, for, although he made truly great black and white works in this medium, it was in the printing of lithographic color that he was as innovative as he was masterful.

IV

THE WOODCUT

WHEN PUBLISHED IN Ambroise Vollard's *Album des peintres-graveurs* in
1896, the lithograph *Anxiety* (Pl. 40) was mistakenly described as a wood-
cut (bois en deux couleurs).[1] Hence, it is no surprise that Munch made his
first real woodcut the same year. Even less unexpected is his choice of
Anxiety (Pl. 41) as the first motif. As Ingrid Langaard observed: "As far as
Edvard Munch was concerned the transition from lithographs to woodcuts
was in effect merely a transfer of an expressive form, already used, to a
different and more suitable medium."[2]

Although Munch's taking up of the woodcut is itself consistent, even
obvious, the question of his training and sources of inspiration continues
to elude us. The printmaking activity in Paris in the late nineteenth
century, and the correspondence between Munch's work and contempo-
rary trends, requires consideration. Most important are the examples of
Japanese prints and the graphic works of Paul Gauguin, for these were
instrumental in shaping the work of the man who sparked the renaissance
of the woodcut in the early twentieth century.

The Japanese print gained astonishing popularity in the last decades of
the nineteenth century in France.[3] Stylistically, its unmodulated shapes
and off-key colors echoed the concerns of contemporary Western post-
impressionist painting, where artists responded to the flattening of the
picture plane, the skewed perspective and the odd angles of view.

The principle importance of the Japanese woodcut lay in its lessons for
color printing; otherwise the extent of its impact remains open to debate.

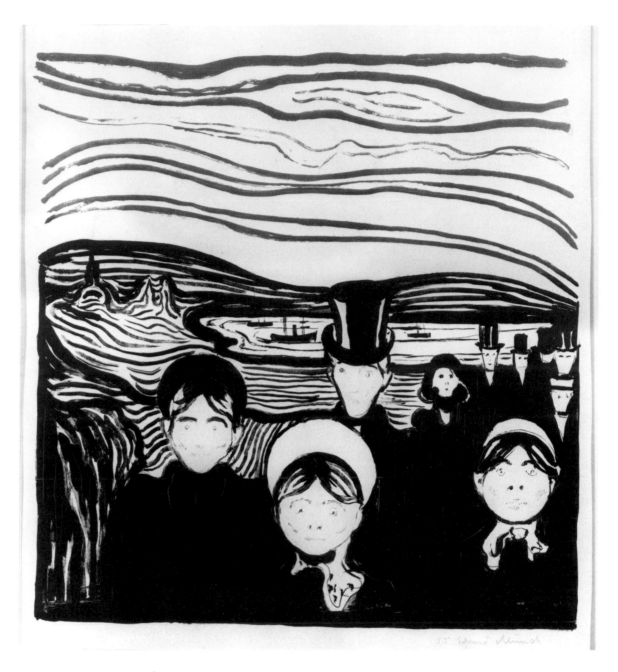

Pl. 40. *Anxiety*, 1896.

S. 61 II b. Color lithograph in tusche printed in black and red (from one stone, not two, as indicated by Schiefler); cream wove paper. 43.5 x 38.7 (17⅛ x 15¼). Signed, and inscribed, graphite, lower right: "55 Edvard Munch". Verso: stamped with seal of Staatlichen Museen Berlin, 1901; L. 1612 (1901).

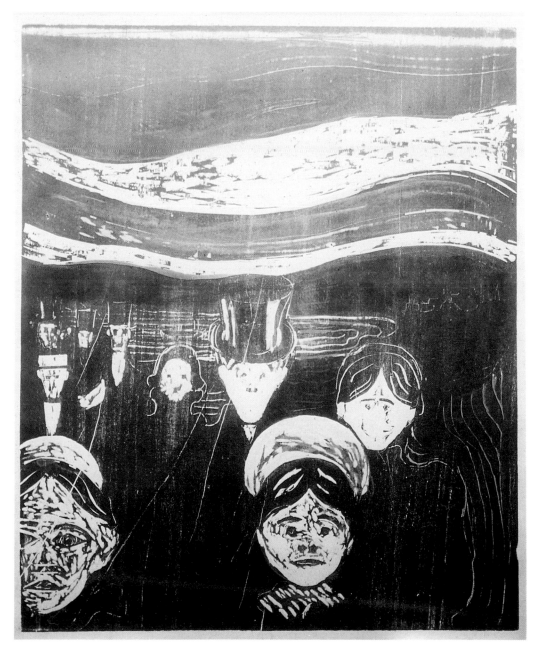

Pl. 41. *Anxiety*, 1896.
S. 62. Woodcut, handcolored in blue watercolor and in crayon in yellow, blue, green, red; white China paper. 46 x 37.7 (18⅛ x 14⅞). Signed, dated, inscribed, red pencil, lower right: "E Munch Paris 96". Verso: inscribed, brownish red pencil: "Holzschnitt gefarbt mit den Hand 60 frs."

In one of the most sensitive historical and analytical studies of the woodcut, *Das Holzschnittbuch*, the German critic Paul Westheim discussed this problem. While acknowledging the stylistic affinities between the oriental prints and contemporary trends, he maintained that the correspondence arose from a common artistic *intention*, resulting in related *forms*, rather than direct influence.[4]

Nonetheless, with the notable exception of the works of Gauguin, woodcuts in nineteenth-century Europe had been linear in style, and Westheim does credit the Japanese woodcut with the introduction of the awareness of the wood surface, an element of critical significance in Munch's work. Overall, the coincidence of a radical style change in Europe with the introduction of the Japanese prints accounts for the uncanny responsiveness on the part of Western artists to the new mode.

Bente Torjusen, in her article on "The Mirror," a series which included woodcuts as well as lithographs, examined carefully the actual relationship between Munch and Gauguin. It appears that they never in fact met, but they possessed a common friend, William Molard.[5] Embarked on his South Sea voyages, Gauguin left both a number of his blocks and impressions from them in Molard's care. It was at the house of this civil servant and understanding connoisseur that Munch was able to see an important aspect of Gauguin's graphic work.

Like Munch, Gauguin's technique, even when fluid, is controlled, sophisticated, and varied. Yet prints from the "Noa–Noa" series are far more linear than Munch's woodcuts, and Gauguin's intent in incorporating the woodgrain into the composition served very different pictorial purposes, enhancing the "primitivism" of his subject matter and somehow bringing the viewer closer to nature and the materials of the earth. In contrast, however broadly and expressionistically Munch manipulated his woodblocks, at their best they represent refinement, distillation and abstraction. They are more iconic than anecdotal, more reductive than elaborated.

Aspects of the artists' techniques are, however, similar. Both used knives, chisels, and gouges, and some kind of awl to scratch finer lines, and they shared an awareness of the particular charm of the wood surface. Gauguin, and then Munch, rejected the method of end-grain wood engraving, in use for decades as a principal reproductive technique. After the linear precision of the wood engraving the impact of these broad, abstracted works must have been startling. Softer woods were chosen. Instead of hard boxwood, Munch chose boards of soft pearwood or pine, which he may have purchased in France, and which may even have come originally from America. Due to the harshness of northern winters, the Norwegian-grown woods are too hard.[6]

In keeping with the revived interest in the intrinsic properties of materials, both artists reveled in the craftsmanship involved in making an image. Unlike relief print artists of previous centuries, who handed over

their drawings to a professional carver, Munch and Gauguin cut their own blocks, fully considering this activity to be an integral step in the genesis of the print. As Westheim observed, the handwork itself became creative. In the process, "the hand no longer only glides over the surface, it feels the resistance of the material....In the line...and then in the impression, the beholder experiences in the oscillation of a curve something of the power of the hand that guides the knife and that has mastered the resistance of the material."[7]

Unusual as it was historically to cut one's own blocks, it was entirely in character for Munch to do so. In every case, whether he was engraving a plate, drawing on a stone, or cutting a block, he considered the craft inseparable from the art.

As a hand-cutter, it is not surprising that Munch was also a hand-printer. The notation "handprint," found on many woodcut impressions by Munch is not, however, a clear indication of process. Munch owned presses and pulled impressions through the press himself. Whether the works marked "handprint" refer to Munch's own press-pulled impressions, or to impressions rubbed onto paper with a hand, is unclear. Westheim implied the latter when he compared Munch's handprinting to that done in earlier centuries or by the Orientals, as opposed to the "rough machine print."[8] However, in his discussion, he mentioned the effect of the woodgrain which also could be obtained by a press. In certain cases, no doubt, Munch did rub the impressions but not necessarily all those that bear the inscription of "handprint."

In certain cases, Munch consciously sought a rubbed effect. Traditionally, the procedure and aesthetic of the western woodcut of the late medieval period and later supposes a highly linear image, run through the press with the intention of obtaining the richest, clearest impression possible. Yet again Munch may have followed the example of Gauguin, who was as concerned with the creative aspect of printing as of cutting, and therefore intentionally softened and blurred his woodcut impressions.

Unlike any other artist, Munch exhibited his carved woodblocks as autonomous works of art, right along with the impressions pulled from them. Even Gauguin, who carved wood reliefs as sculptures, did not perceive his printing blocks in this manner. But for Munch the blocks were not merely the tools of his craft, but creative entities, and their ridged surfaces, such as those of *Man and Woman Kissing* (Fig. 42) and *The Old Sailor* (Fig. 43) demonstrate the textural richness of the material as well as the passion, sensitivity, and skill in the cutting of the image. In no other way than this simultaneous showing of block and print could the artist so clearly have expressed his esteem for his graphics, in particular for the woodcuts, and for the very process by which he gave them birth.

Munch's graphic style gradually evolved from the linear mode so evident in the intaglio prints and many of the lithographs to a planar idiom. In lithographs such as *Self-Portrait with a Skeleton Arm*, *Death in the*

Fig. 42. *Man and Woman Kissing.*
OKK P/t 612. Woodblock (birch). 39.4 x 54 x 1.3 (15½ x 21¼ x ½).

Fig. 43. *The Old Sailor.*
OKK P/t 592. Woodblock (spruce). 44.1 x 35.6 x 2 (17⅜ x 14 x ¹³⁄₁₆).

65

Sickroom, and of course *Anxiety*, massing of form, with relatively un-modulated tusche, had become central to the composition. In the medium of the woodcut Munch confronted the problem of creating such large unmodulated planes and masses essentially in reverse, for in a relief technique, the artist works from dark to light, rather than the opposite, cutting away the white areas and leaving untouched those which will be inked and printed. Such was his immediate mastery of the medium that even in his first woodcut, generally accepted to be *Anxiety*, he understood that the nature of the relief technique encouraged the conception of images in terms of masses and planes as opposed to lines. In the woodcut of *Anxiety*, one of the most striking aspects is the unity and continuity of the wood surface, a planar area which previously, in the lithographic version, had to be painted on the stone. With different kinds of cuts, Munch carved out the design but was able to retain the unique surface qualities of his material. No longer, to any degree whatsoever, does the artist merely make a reproducible drawing. Instead, his very means become an integral part of his subject.

One of the most important issues, however, which bears significance for the place of the woodcut medium in Munch's work, is color, which will be discussed below. In the woodcut medium, Munch thought in color from the moment he picked up the knife. Whereas he worked through the intaglio prints and lithographs in black and white before attempting color, he immediately printed *Anxiety* in red as well as black. For him, the most important function of the woodcut was for color compositions, and in the greatest woodcuts, Munch reworked his major motifs in endless combinations of hues.

Finally, with *Anxiety*, Munch introduced an issue of which we will constantly be aware, especially in light of the outstanding group of wood-cuts of the Straus collection. This is the new pictorial and psychological impact of the woodcut. In translating his major motifs into this medium, he crystallized them, both compositionally and affectively. The technique itself leads to this intense focus. The broad, unified planes so strongly rendered in the woodcut permit a lessening of attention to detail, with consequent emphasis on the essentials of the image. Thus, for example, as in *Anxiety*, Munch could achieve a blending of figures and sky by simply leaving untouched the wood surfaces common to both.

THE BLACK AND WHITE PRINTS in the Straus collection include some of Munch's strongest motifs. Like many of the lithographs, they depend for much of their effect upon stark value contrasts. Two of the most interesting are: *The Old Sailor* (Norwegian Fisherman) of 1899 (Pl. 44), and the so-called *Urmensch (Primitive Man)* of 1905 (Pl. 45). As Pola Gauguin, son of the artist, noted in his catalogue of some of Munch's woodcuts, the Norwegian was experimenting with the creation of monumentality through the utter simplicity possible with woodcut technique.[9] Hence,

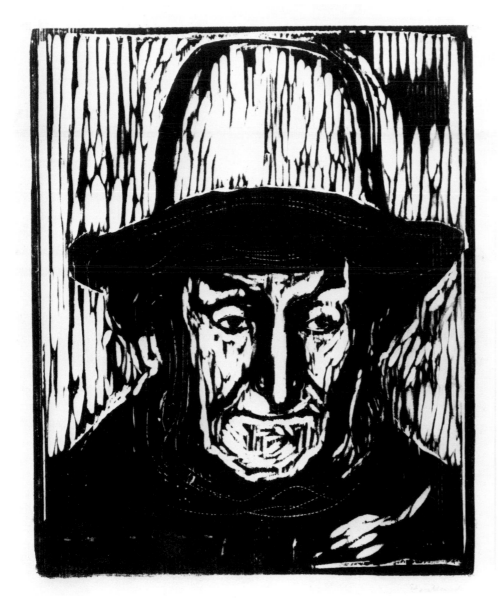

Pl. 44. *The Old Sailor*, 1899.
S. 124. Woodcut; off-white laid Japan paper. 44.5 x 35.3 (17½ x 13⅞). Signed, graphite, lower right: "Edv Munch".

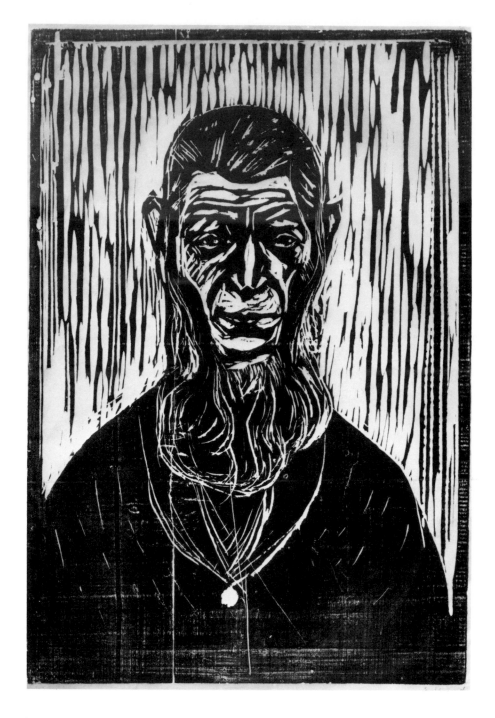

Pl. 45. *Urmensch,* 1905.
S. 237. Woodcut; off-white Japan paper. 61.5 x 46 (24⅕ x 18⅛).

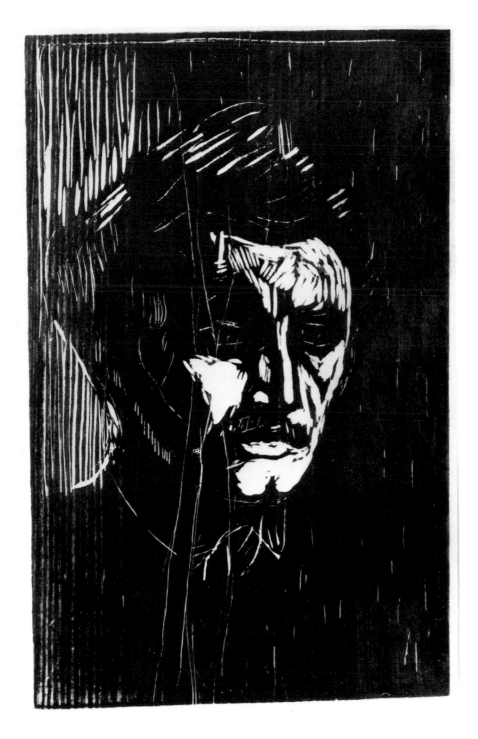

Pl. 46. *Self-Portrait*, 1911.
S. 253. Woodcut; off-white Japan paper. (22 x 13½). Signed, graphite, lower right: "E Munch".

In *Urmensch* and *The Old Sailor*, Munch worked with a gouge to scoop out the long strokes of background and the shorter modelling lines of the faces. In *The Old Sailor*, he also dragged a sharp tool around the neck and in the brim of the hat, making staccato lines over the heavily ribbed woodgrain.

As in the lithographs, here also the black and white contrast is very strong; nevertheless, the surfaces of planographic and relief prints differ significantly. The surface texture of *Self-Portrait with Skeleton Arm*, for example, is densely black and slightly shiny. In these two woodcut portraits, on the other hand, the textured materiality of the printing surface has been transferred to the impressions, an especially striking effect in the two Straus impressions, which have been pulled on lustrous sheets of Japan paper. The sheets' soft absorbency soaks up the ink and subtly yields under the pressure of the blocks in printing.

The assumption from the examples of *Urmensch* and *The Old Sailor*, that woodcut is appropriate only in the depiction of generalized, abstract types, is dismissed in the face of the artist's *Self-Portrait* from 1911 (Pl. 46). In the lithographic *Self-Portrait with Skeleton Arm*, Munch had to fill in the background with tusche to make the white face emerge from blackness. In the woodcut, however, where Munch was seeking essentially the same effect, he had only to cut away the small areas of lightness. The rest, the background, hair, the right side of his face, neck, and chest, blend together in a single plane on the surface of the block.

Not only is the likeness extraordinary, brought to life with minimal cuts of the knife, but, as the light filters across the face, the portrait communicates a quiet introspection very different from the startling value contrasts of the early lithograph and also from the nervous linearity of *Self-Portrait with Cigarette* and *Self-Portrait with a Wine Bottle*. The economy of handling in this image is unmatched among his numerous self-portraits, both painted and printed.

THE BLACK AND WHITE WOODCUTS in the Straus collection represent some of Munch's best. The others seem to vary significantly in quality as well as in subject matter and style. Some adopt themes from paintings, while others introduce subjects not rendered in canvas, like the *Snowy Landscape* (S. 118), a richly evocative wintry night scene. Still others depict the theme of the working man, of great interest to Munch around 1911 and later. There is also a series of woodcut illustrations for Henrik Ibsen's historical drama *The Pretenders* which become increasingly linear; they have a shadowy quality with insubstantial shapes and figures seeming to hover in a textured background. Although these are effective, it was in the color compositions that the language of Munch's woodcuts found its full expression.

V
COLOR PRINTING

In 1893, the year Munch painted *The Scream*, his friend the poet Sigbjørn Obstfelder observed: "Munch writes poetry with colour. He has taught himself to see the full potential of colour in art....His use of colour is above all lyrical. He feels colours and he reveals his feelings through colours; he does not see them in isolation. He does not just see yellow, red and blue and violet; he sees sorrow and screaming and melancholy and decay."[1]

Always one of Munch's greatest interests and most powerful vehicles of expression, color logically played a vital role in his graphic work from the beginning, and throughout his printmaking career. As early as 1896, Munch not only was hand coloring his work, but was actively engaged in printing color in every medium: etching, mezzotint, lithography, and the woodcut. The use of color in prints was common at this time, and many of Munch's techniques did not differ from traditional processes. His contribution to color printing lay in the innovative ways in which he could put old methods to use and in the new procedures he developed. It was in his search for the most effective and economical means for adding this central pictorial element that Munch's experimentation became as extensive as it was creative.

HAND COLORING AND COLORING À LA POUPÉE

Munch hand colored his graphic work throughout his life. In the 1930s and later, when his eyes troubled him and he did not produce many new prints, he frequently added color to old impressions to freshen them up, and then

he offered them as presents. *Fertility* (Pl. 47) is probably one of these; it has been inscribed by the artist to his friend Professor Schreiner and dated 1943, the year before the artist's death.

Experimental as always, Munch did not merely color over this picture, but, in the cases of the orange of the woman's dress and the blues and greens of the foreground grass, brushed on washes from the back of the fibrous Japan paper. It soaked through and appears, as if printed, on the

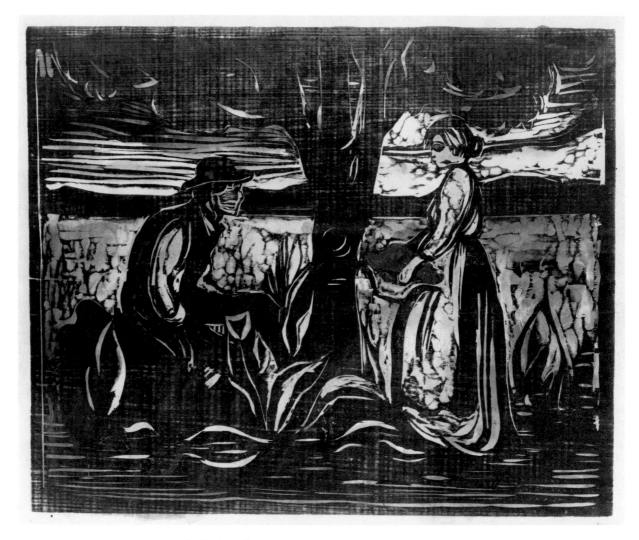

Pl. 47. *Fertility*, 1898.
S. 110. Woodcut hand colored in green, royal blue, blue-green, yellow-green, brownish orange, salmon, red washes and oil paint; cream laid Japan paper. 42.2 x 52.1 (16⅝ x 20½). Signed and inscribed, graphite, lower right: "Til professor Schreiner med hjertelig dank for god hjelper i min sykdom juli 1943 Edvard Munch".

front. The shiny oil paint of the apples he daubed right on the front of the sheet.

The Straus impression of the woodcut of *Anxiety* (see Pl. 41) has also been hand colored by the artist as attested by his inscription on the verso. With crayon and watercolor, he touched in streaks of red, yellow, and blue in the sky, an orangey hue for the faces, and green for the land at right.

In addition to coloring by hand, Munch printed color intaglio works in the traditional manner *à la poupée*, that is, rubbing different colors into the same plate and printing the complete multi-hued image all at once.[2] Although coloring *à la poupée* was a technique most often used with intaglio plates, Munch adapted the concept both to lithographs and woodcuts. For example, in the two-color printings of the lithograph and the woodcut of *Anxiety*, Munch inked the stone and block simultaneously with both colors as can be seen in the running together of the colors at the edges of the Straus lithograph (see Pl. 40). This economical step already represents a departure from the usual method of printing one color per one block or stone.

In the woodcut *Man and Woman Kissing* (Color Pl. 48) of 1905, the structure of the carving also allowed Munch to manipulate *à la poupée* coloring in the service of meaning. Since he made no dividing line between the top of the woman's hair and the man's temple, he was free either to ink that area to blend them together in intimacy, or to leave it untouched to emphasize the slight recoil on the part of the ambivalent man, probably Munch himself. In the Straus impression, the woman is red, the man and background blue. The artist left the zone between the two uninked, with a sharp delineation in the woman's hair. Additionally, carved lines in the woman's neck were not inked although the paper has been impressed by the high relief of the lines as they were cut. But even with the severance between the two, colors do overlap at certain points, such as the neck, establishing some sense of connection. Munch did not need to saw the block into pieces to communicate the estrangement; his method of coloring the block expressed the idea.

Needless to say, not every print required complicated manipulations. Some, like *Separation II*, most often inked in blue, and *In Man's Brain* (Pl. 49), inked in red, the artist simply felt were more evocative when printed in colors other than black.

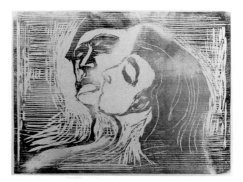

Man and Woman Kissing, 1905 (see Color Pl. 48).

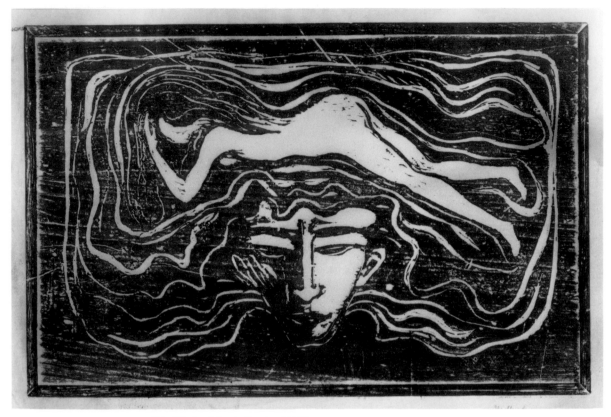

Pl. 49. *In Man's Brain*, 1897.
S. 98. Color woodcut printed in red, side pieces from another block; off-white laid Japan paper. 37.2 x 56.8 (14⅝ x 22⅜). Signed, graphite, lower right: "Edv Munch". Verso: stamped with seal of Munch-Museet.

THE COLOR LITHOGRAPH

The prints discussed above bear color of different kinds, hand applied and printed. But the issue of the color print in the sense of composition in color as opposed to printing in color introduces new problems central to Munch's graphic work. The concept of color as an active aspect of composition in pictorial art was a vital issue in the 1880s and 1890s, with Paris the center of this concern. One focus of the debate centered around the art form of the color print and the aesthetic revolution it engendered.

Color lithography had been attempted by the inventor of lithography, Alois Senefelder, in the early nineteenth century. It had not, however, been

perfected, specifically with regard to the registration of the colors, an inherent problem when each hue was printed from separate stones. Because of technical complications, color lithography as a graphic medium remained in the hands of commercial and reproductive printers. "Original" artists did not make color lithographs and even subsequent technical advances did not immediately elevate the status of the medium in their eyes or in those of the critics.

A Frenchman, Jules Chéret, creator of many of the best-known color posters of the *belle époque*, provoked a change of sentiment that finally caused the color print to be recognized as the definitive artistic mode of the age. Inspired by the expressive potential of color introduced by the Impressionists, artists easily found their way to the remarkable properties of the medium; but acceptance by critics was not initially forthcoming. As late as 1898, conservative opinion maintained, "By its essential principles, its origins and traditions, the art of the print is unquestionably the art of *Black* and *White*. This is the traditional classification to which it is attributed."[3]

André Mellerio, critic, editor of the journal *L'estampe et l'affiche*, author of *La lithographie originale en couleurs*, and great supporter of the original color print, replied to this assertion: "But the right of the color print to exist comes directly from the principle which we consider an axiom: any method or process which an artist develops to express himself is for that very reason legitimate"[4]—a remark reminiscent of Munch's own dictum: "All means are equally valid."

Both statements, against and for the color print, responded to the 1891 by-law of the Society of French Artists controlling the print section of its annual salon that "no work in color will be admitted."[5] Eight years later, thanks to intensive debate, the ban was removed and color prints, which had decorated the city and stocked dealers' shops for more than a decade, finally became part of the annual exhibition.

What exactly was this color print, object of such fierce controversy? André Mellerio defined the qualities unique to the art form:

> The picture surface [of the color lithograph] is neither as solid or sturdy as that for oil painting, just as the process does not have the same deep and bountiful richness. Neither does it have the texture or the brilliance of pastel, the penetrating light of the watercolor. Nor can it claim to have the imperceptible delicacies of an original drawing. It is a fact that mechanical printing, as perfect as it may be, takes away the tiny refinements of the brushstrokes or of the artist's touch by which he transmits his sensation directly. It seems then that for those reasons prints should avoid ambitious effects, and that a simplicity of means demanding a less active part from the printer should work in its favor.[6]

Specifically, "It is a piece of paper decorated with colors and lines which are part of it without hiding it or weighing it down. It is neither a *facsimile* of, nor a substitute for painting; it is another process, lacking

certain elements, but with its own charm, of equal artistic value and the appreciable advantage of a printing with numerous copies."[7]

The fact that this description seems to set forth only modest claims compared to the achievement of Munch's finest color lithographs underlines the richness and complexity, as well as the unique ambition of his art. Mellerio's further remark that "Lines that are too complicated, tangled composition, or elusive delicacies of atmosphere do not seem to fall within [the color print's] competence" loses credibility in the face of the fragile threads of color of *The Sick Girl* (Color Pl. 50). Sometimes subtle with melancholy overtones, other times frighteningly garish; this print is generally recognized as one of the most successful and powerful of all the lithographic images of the time. Munch himself asserted "I consider [this] lithograph my most important print."[8] It was also his first color lithograph.

Munch's friend Paul Hermann, portrayed as the tormented figure in *Jealousy*, described the magical creation of *The Sick Girl*, witnessed during a visit to Clot's shop in Paris:

> I wanted to have some printing done at Clot's when I was told: don't go, Mr. Munch's coming has been announced. The lithographic stones with the great head were already lying next to one another, neatly lined up, ready to print. Munch arrives, positions himself before the row, closes his eyes firmly and begins to direct blindly with his finger in the air: 'Go ahead and print... gray, green, blue, brown.' Opens his eyes, says to me: 'Come, drink a schnaps...' And so the printer printed until Munch came back and gave another blind order: 'Yellow, rose, red....'And so on another couple of times...[9]

Intuitively, mystically, the artist created a work of great technical subtlety and sophistication, working with one, three, or four stones.

The lithograph was made ten years after the first painted version of the theme, two years after the drypoint, and contemporaneously with the etching *Head of Sick Girl*, also printed in colors. It is not clear whether Munch made this last etching before or after he made the lithograph; both narrow the focus of the more elaborated scene of the drypoint. While the lithographic version is as concerned with line as the etching, it is in the particular treatment of color, possible with lithography but not with intaglio, that the remarkable effects emerge.

Working with Clot, Munch varied the colors and sequence of printing of stones so much that sometimes he himself became confused. On one version of *The Sick Girl* (OKK 203–14) he wrote "Krankes Mädchen Lith in 3 Farben." It is in fact printed in four, not three colors. More than once on his lithographs the inscription shows Munch forgetful about the number of colors. Probably he perceived the image as a coloristic whole, automatically registering the tonal stone which was subtle enough to be overlooked in a technical sense, although a vital accompaniment to the rest.

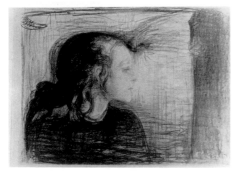

The Sick Girl, 1896 (see Color Pl. 50).

Munch often printed the three-color combination of the Straus impression, with the beige background, the drawing in red and accents in blood-red tusche. It is subdued compared to versions that approach garishness in their expressionistic use of turquoises and oranges.[10]

The layered skeins of colors and the use of the needle, touches of which can be seen in the locks of hair at left, recall the etching and the painted versions of this subject. Munch has in fact been consistent in the essentials of his working methods. In the strokes of brush, drypoint, etching needle, or lithographic crayon, plus the scraping that occurs on canvas as well as on plate and stone, his idea adapted equally to all the media with the added benefits of their idiosyncracies.

Toward the Light (Color Pl. 51) was also built up by superimposing color stones and printing them in a variety of sequences. Munch made the print as the advertisement for a 1914 exhibition of his sketches for the University of Oslo Aula decorations. In its composition of tangled lines as opposed to the simplified planes and color areas associated with advertising a decade or earlier in Paris, this poster represents a twist on the style that had so dominated both art and commerce at the moment when Munch began to make his first color lithographs.

The number of different sequences that may be seen in a large selection of these prints demonstrates Munch's anticipation of their exhibition everywhere in Oslo: variety was essential. Many impressions (Fig. 52) include the information printed in purple, yellow and red, telling when, where, and the price of admission. In all versions that have text, the tusche stones bearing drawing have been suppressed; perhaps Munch considered them too distracting in combination with the letters. And not only are there numerous color variations, there are even several renderings of the texts, with, for example, tusche used to strengthen the lettering in a second state of one stone. Although the artist intended this work as an advertisement, and most, if not all, of the impressions have been pulled on cheap poster paper, he experimented with the motif almost as extensively as he did with *The Sick Girl.*

Munch conceived both *The Sick Girl* and *Toward the Light* in terms of the traditional one color—one stone procedure. In contrast, *The Sin* (Color Pl. 53) introduces another technique that employs the principle of overlay and registration of blocks in an ingenious and new manner.

Schiefler identified only three differently colored versions of *The Sin.* There are, in fact, four different states, and Munch experimented with the combining of stones and colors to manipulate the image further.

From one stone, Munch printed the first state in one color; impressions exist in light yellow, chocolate brown, black, and possibly other colors (Fig. 54). He worked only in crayon, reserving the tusche for the following states. The single-color image looks completely different since all the details blend together, whereas they constitute accents and highlights in the later versions.

Toward the Light, 1914 (see Color Pl. 51).

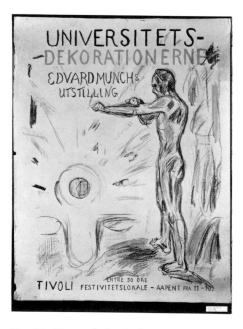

Fig. 52. *Toward the Light.*
OKK 565A–12. Off-white poster paper. 99.4 x 76.5 (39¼ x 30¼).

The Sin, 1901 (see Color Pl. 53).

The Straus lithograph is an example of the second state, in which the artist reworked the stone with tusche, possibly strengthening the contours of the woman's breasts and certainly filling out her abundant hair with curling locks. Munch also incised lines into the hair to emphasize the rhythm of the strands. Now inked in three colors, the woman's body and most of her face are beige, her hair red, eyes green.

The third state is the same as the second except for the addition of the initials "E.T." (Fig. 55) drawn in tusche between the two wide locks of hair at lower right. In the two available examples (Munch-museet and National-museum, Stockholm), they have been printed in red by the top stone. Their meaning remains obscure, with no known reference to the model (fig. 56), sometimes thought to be Munch's mistress Tulla Larsen. The letters disappear in the fourth state, in which Munch made tusche additions on the beige stone, to model the belly, and accent the hair (Fig. 57).[11]

It would be easy, on quick glance, to say that this lithograph was a two-stone creation with the body printed first, in beige, and the hair printed second, and with the eyes touched in on one or the other of the stones. Closer inspection, however, reveals that Munch has performed a *tour de force* of transfer lithography in order to achieve his effect.

The transfer occurred between the first and second states. Ignoring the tusche additions of the second state, it is clear that the drawing of the beige and brick-red stones, which were printed separately, is identical. A salient and confusing area where this may be examined in detail is the face, where tiny accents of red lie over beige ones. Also peculiar is the unusually sharp-edged contour of the red hair where it curves around the woman's left cheek. Although differently colored, both the hair and jawline are obviously parts of the same drawing. Although Munch must have used different stones to print the two main colors, both of the stones clearly carried parts of an identical drawing, with differing areas on each stone erased or blocked from printing.

This technique of superimposition recalls Munch's method of printing his woodcuts from 1896 on, but it is not directly analogous. In *Moonlight*, for example, he cut out the window on both of the blocks, causing certain lines to coincide as if they formed part of the same drawing, but they actually do not. By doing this, Munch could allow the bare paper to emerge from the printed areas to provide highlights. And, most obviously in the early version of *Melancholy*, using the two blocks, he clearly sought the counterpointing "double-exposure" effect, which he would subsequently explore in his photography, and not the continuous transfer process used in *The Sin*.[12]

Even a cursory inspection of the stone from which Munch printed *The Sin* revealed that the artist had blocked out areas of the first drawing and taken a transfer impression of the part of the image which included the border, the hair and the very small details of the face and nipples. He then transferred them to the reverse side of the same stone. In other words, both

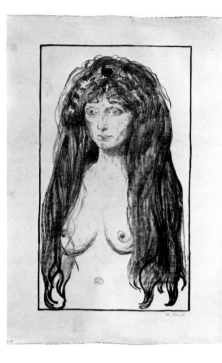

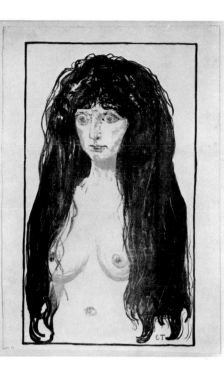

Fig. 54. *The Sin.*
OKK 241–10. Tan wove paper, printed in brown. 69.5 x 39.7 (27⅜ x 15⅝). Signed, lower right, graphite: "Edv Munch".

Fig. 55. *The Sin.*
OKK 241–7. White wove paper. 69.9 x 40.4 (27½ x 15⅞).

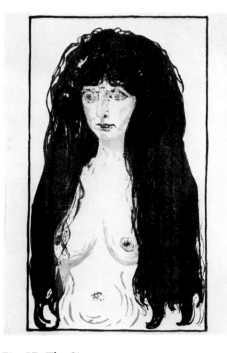

Fig. 56. Photograph of model in Munch's studio, ca. 1903.

Fig. 57. *The Sin.*
OKK 241–12. Off-white Japan paper. 69.9 x 40.4 (27½ x 15⅞).

79

sides of the same lithographic stone contain aspects of the total image and, in addition, each side of the stone has passed through two states. The "beige" stone carried the addition of the belly contour lines; the "red" stone the initials "E.T." The green eyes evidently belong to the beige side; they have been blocked out on the reverse side of the stone.

Although Munch often worked with transfer lithography, this seems to be the only print where he transferred a portion of the main image and then fused the two parts. It is a brilliant solution to the problem of blending together both the drawing and the colors of a single image. The artist also made needle scratches in the hair on the top stone, which, where superimposed over the bottom stone, allow the base color to shine through. The effect of the same drawing suddenly changing color has the impact of an optical illusion; what on the woman's left cheek is really facial contour, becomes hair when overprinted in red.

THE COLOR WOODCUT

The color lithograph can print lines, tones, and complete color areas. Carefully registered, with one color per stone, color blendings and bleedings from one shade lying on top of another can be achieved. This technique and the flat tones which resulted, hallmarks of Toulouse–Lautrec's style, reflect the impact of Japanese woodblock printing technique, still in vogue at the time Munch was working. In fact, Munch's lithographic process, with successive layers of color, more closely resembles the Japanese woodcut procedure than does his method of making woodblock prints by sawing up his blocks, where he sought, not incidentally, to expedite the elaborate Japanese process. Munch retained the concentration on line as well as color areas when he began to work with wood, but these concerns had already appeared in the color lithographs. It is another instance of the cross-fertilization of methods, as well as styles, which is one of Munch's outstanding characteristics.

In his idiosyncratic woodblock method Munch would cut the blocks into pieces with a fine jigsaw, sometimes both the block bearing most of the drawing, as well as the block mainly carrying the background color with more or less cutting. He would then ink the puzzle-like shapes in different colors, reassemble them, and print the variegated surface all at once. Given Munch's typical precocity, it is not surprising that this experimentation with sawing dates from his earliest color woodcuts, *Man's Head in Woman's Hair*, and *Moonlight*.

The implications of this device are far reaching. In a purely technical sense, it represents an important shortcut to the traditional one block–one color procedure. The "puzzle-manner" obviates the need for the painstak-

ing process of registration. While Munch certainly would have been equal to any of the challenges posed by such methods, they do not represent the intention of his woodcut style, which was to simplify and condense.

Paradoxically, some of the color woodcuts appear simple in the ordering of the planes and color areas, and only closer study raises the confusing question: into how many pieces have how many blocks been sawn? When deciphered, the cause of the uncertainty is revealed to lie in the subtlety with which Munch blended the colors. The result can be as complex and nuanced as any Japanese woodcut.

How did Munch arrive at this sawing process? Several suggestions seem plausible. For the indefatigable experimentor, the simple act of cutting into the block may have led to the cutting up of the block. The time-saving aspect of simultaneous printing in several colors which resulted was a factor that he had already recognized when he made the two-color lithograph of *Anxiety* and the impressions of the etching of the *Head of the Sick Girl* (OKK 43–6) inked *à la poupée* in three colors. In other words, the principle of simultaneous multicoloring was not new to the artist; and he also used it in woodblock prints that he never sawed, such as *Man and Woman Kissing*, in which, by not cutting the block he emphasized the essential unity of the lovers. But in compositions that stress discrete color areas, the distinct lines formed in printing by the edges of the puzzle pieces define the boundaries naturally and eloquently.

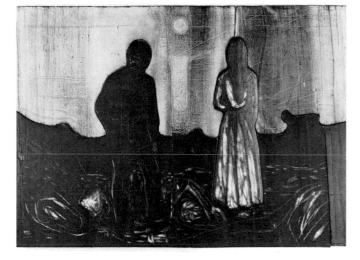

Fig. 58. *The Lonely Ones.*
OKK P/t 601. Woodblock (birch). 39.4 x 55.2 x
1.4 (15½ x 21¾ x ½).

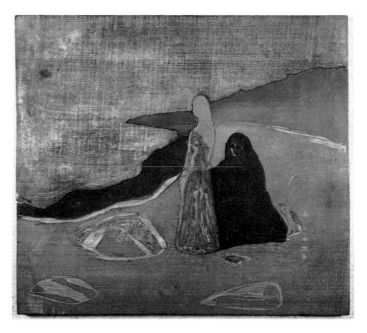

Fig. 59. *Women on the Shore.*
OKK P/t 589. Woodblock (cherry). 45.1 x 51.9 x
1.1 (17¾ x 20¼ x ⁷⁄₁₆).

81

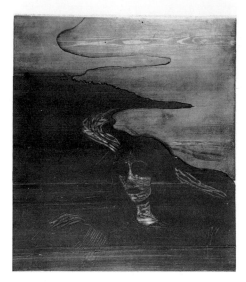

Fig. 60. *Girl's Head on the Shore.*
OKK P/t 597A. Drawing block (spruce). 48 x 41.6 (18⅞ x 16⅜).

Fig. 61. *Girl's Head on the Shore.*
OKK P/t 597B. Background block (cherry). 46 x 40.9 (18⅛ x 16¼).

Munch would manipulate these boundaries to express meaning. In *The Lonely Ones* (Fig. 58) the principal separations are that of the sea and land from each other and that of the figure of the woman from everything: she has been entirely sawn out and severed, from sea, land, and lover. The fact that Munch did not cut the man away from his surroundings, but rooted him in the earth as he had done in the drypoint, reinforces the male figure's connection to nature. Woman is the alien. In *Women on the Shore* (Fig. 59), Munch massed the two figures into one piece, inextricably binding youth and age. The shore with its distinct contour is sharply bounded from the sea. Even more complex is the shoreline in *Girl's Head on the Shore* (Figs. 60, 61), which demonstrates the delicacy of cutting which could be achieved with a fine tool and expert control.

In *Man's Head in Woman's Hair* (Color Pl. 62), also known as *The Mirror* (as the title print of "The Mirror" series), we see one of the earliest instances, if not indeed the first, of the technique. The idea seems to have occurred to him after his initial concept for the graphic use of this image. For the 1897 exhibition of "The Mirror," he printed the single drawing block; then he cut out the two figures from the paper by simply following their outline. He pasted them onto brown cardboard before hand-coloring the woman's hair in red and gold and painting the cardboard itself with red watercolor. Finally, he wrote the title of the portfolio across the top of the mount.[13] Perhaps this act of cutting out the motif and seeing it surrounded by a background from a different source may have stimulated the idea to print a background, and add color too, all at once. (See chapter on Mixed Media.)

In *Man's Head in Woman's Hair*, using a gouge and knife, Munch scooped out the faces and cut the long strings of hair that curve around the man. The block bears a pronounced grain, as does the color block printed over it. The color block has been sawn into several pieces: the background, printed in dark blue, the area of the woman's face and hair, a brownish red, and the area of the man's face. Munch never printed this latter piece, however, allowing the cream color of the paper to shine through. Clues about the wear to the top block reveal themselves in gaps on the impressions, which indicate breaks in the wood. The small rectangle under the point of the man's beard represents a loss that antedates the Straus impression. In other instances when blocks split or broke off, as in *Meeting in Space* (Color Pl. 63), or *Women on the Shore* (Pl. 64), Munch attempted to fill in the gaps either with hand coloring or with carefully shaped wood chips. This never seems to have happened with *Man's Head in Woman's Hair*. Further, it is unclear whether or not the vertical shaft to the left of the woman had ever been part of the color block, or whether it too snapped off.

What did Munch achieve in *Man's Head in Woman's Hair* by printing color in this way? The effect is similar to that of *Vampire*, although it predates that print by several years. The large areas of shaped color tend to concentrate the focus first on the man's face, which they surround, and

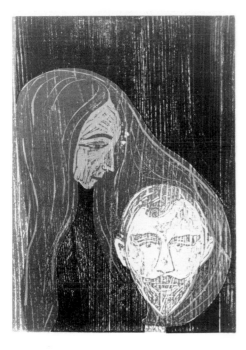

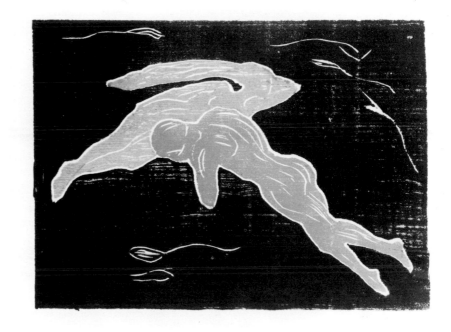

Man's Head in Woman's Hair, 1896
(see Color Pl. 62).

Meeting in Space, 1899 (see Color Pl. 63).

then on the hair of the woman. The red hair assumes the importance it would carry in *Vampire* and *Separation* where it ensnares the innocent male. After experimenting with a woodblock for the hair in *Vampire*, Munch finally chose to draw it on a lithographic stone. In *Man's Head in Woman's Hair*, however, by printing the red with a block, he could capture the color in an enveloping, graceful, and simple shape, and at the same time allow the cutting of the "snakes" of hair to show through. The kind of layered effect noted in the intaglio prints and lithographs reappears and becomes an important aspect of the woodblock compositions.

The jump in complexity from *Man's Head in Woman's Hair* to *Moonlight* (Color Pl. 65) is such that one might expect the latter to have been made much later, after much experimentation, but Munch made both in 1896, and, in fact, *Moonlight* is sometimes thought to antedate *Man's Head in Woman's Hair*. Now, no longer working simply with one block for the drawing and one for color, he cut parts of the motif into both blocks and overprinted them. Since both were inked in different colors as well, Munch counterpointed both line and color, greatly enriching the final image. In overprinting both he finally achieved, literally, the effect of layered space

83

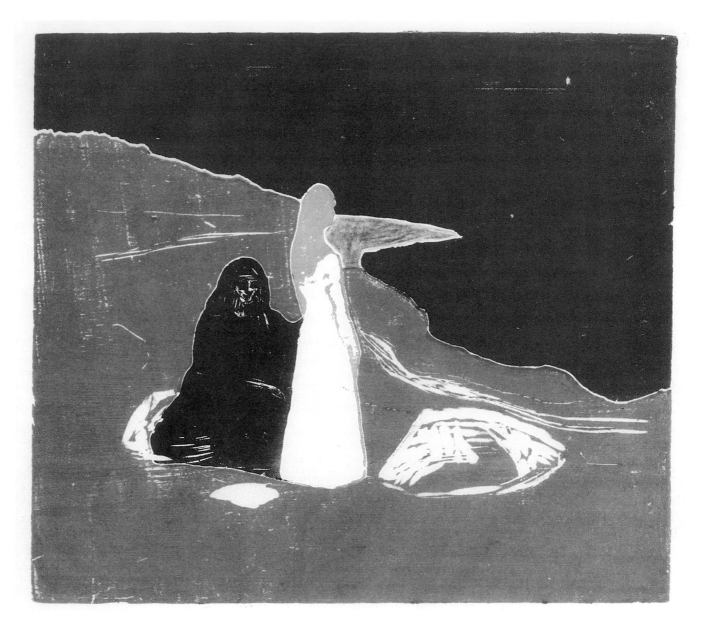

Pl. 64. *Women on the Shore*, 1898.
S. 117 I. Color woodcut from one block sawn into three pieces printed in black, dark blue, brick, light green; hand colored in light green; cream laid Japan paper. 45.7 x 51.5 (18 x 20¼). Signed, graphite, lower right: "E Munch".

that had been hinted at continually in works such as *Tête-à-Tête* and *Lovers in the Waves.*

Schiefler thought that the blocks for *Moonlight* had disappeared but, fortunately, they remain in the Munch Museum. The artist cut the drawing on both sides of the same plank. On the recto (Fig. 66) of the richly grained material, he carved out a reduced, compacted version of his painting of 1893, focusing on the face and shoulders of the woman and ignoring the rest of her body, which he had earlier painted against a white picket fence. Of the setting from the painting, there remains the window, the boards on the side of the house, the outlines of the woman's hat and shoulders, and, at left, indications of leaves. On the verso (Fig. 67) of the block he cut the face and redrew the window, adding reflections in the panes to print over those on the recto. On at least one occasion (Fig. 68) he printed just the verso, in which the ghostly, disembodied face hangs in a textured void before a floating window. The final component of *Moonlight* is the background block (Fig. 69), equally richly grained, which has been sawn into the three major divisions of tree, window, and the central area comprising the woman, her shadow, and the house. In many impressions, including the Straus example, the color blocks were printed first; then the drawing blocks, with the side with the carved face usually printed beneath the other side. Munch then reversed this printing sequence when he wanted to vary the focus of the image.

Sensitive to the potential of his materials, Munch chose a plank with a

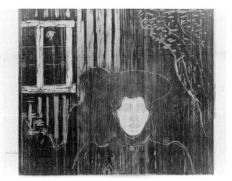

Moonlight, 1896 (see Color Pl. 65).

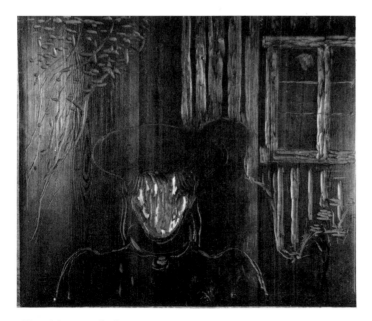

Fig. 66. *Moonlight.*
OKK P/t 570A. Woodblock (probably oak), recto. 39.3 x 46.3 (15½ x 18¼).

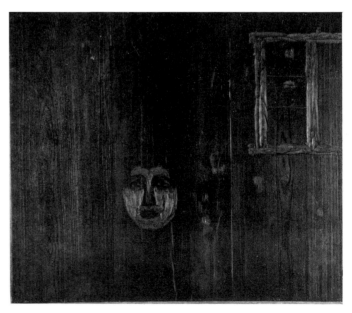

Fig. 67. *Moonlight.*
OKK P/t 570A. Verso.

85

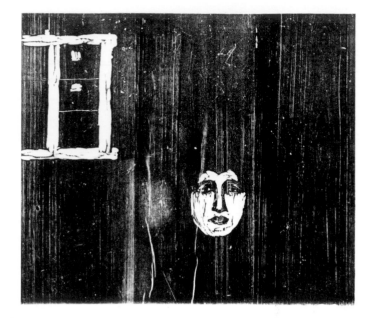

Fig. 68. *Moonlight.*
OKK 570–1. Cream wove paper mounted on
paperboard. 38.7 x 47 (15¼ x 18½).

Fig. 69. *Moonlight.*
OKK P/t 597B. Woodblock, background block
(probably oak). 40 x 45.1 x 1.5 (15¾ x 17¾ x ½).

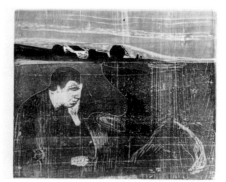

Melancholy, (see Color Pl. 70).

86

grain so pronounced that it creates its own powerful design of vertical striations which cover the woman's face like prison bars. Since both this layer of her face, as well as that of her dress and hat, comprise the background area too, the result is an overall compression of planes. The woman emerges from her surroundings, yet remains part of them; she cannot physically escape. Meanwhile, the moonlight plays over the densely printed surface, its rays filtering through from the off-white paper.

In 1901 Munch made another version of *Moonlight,* as he did also with *Melancholy.* This year and the next, he reworked *Vampire, Madonna,* and *The Kiss* into iconic color versions while simultaneously making breakthroughs in color lithography, as in *The Sin* of 1902. His achievement in these two years sums up the importance of the prints for Munch: their constant source of ideas over time, with the potential of reworking the original materials as well as making new versions. Even for the master printmaker, however, the reworkings were not always successful. In *Moonlight II* he simplified the image slightly to make it tauter, sharper, and less textured. But it is also less successful than the original version, as if it lost its spontaneity and became rigid and mannered.

Melancholy (Color Pl. 70), one of Munch's most remarkable color prints, rises from his very first year of working in the woodcut medium. It was one of his favorite motifs; he made many renditions of his friend, the

Danish art critic Jappe Nielsen, victim of an unhappy love affair, sitting sadly on the beach.

The woodblocks, cut in Munch's puzzle manner, reveal the method by which he created the complex, interwoven image. He used two planks, each of which he meticulously sawed into two pieces (Figs. 71 and 72). The first block, of which impressions exist before he sawed it, bears most of the drawing including the dejected figure, the landscape and sky. Its grain is horizontal but the artist cut vertically along the outline of the landscape and below, dividing the sea from the land with his jigaw.

For the background block (which in this case also carries parts of the drawing) Munch chose a densely patterned, vertically grained wood. Whereas Munch sawed the drawing block from top to bottom, he cut the background block along the horizon outlining the head and shoulder of the man. The artist carved out only touches of the rocks, the modelling of the boat and an area near the man's forearm; but the natural knots and grain of the wood occur so felicitously that they print as meaningfully as if the wood had been grown for this picture. The knot that appears at the upper right of the print peeks through the green clouds like a hazy sun, and the knot at lower left could pass for an elbow. However, Munch did not consistently use these elements; in impressions printed in darker colors (OKK 571) or in a different sequence, the knots are virtually invisible.

The printing variations of *Melancholy* are countless. There are impressions taken before the cutting up of the blocks, such as the print

Fig. 71. *Melancholy.*
OKK P/t 571A. Woodblock, drawing block
(ash). 37.5 x 45.4 x .5 (14¾ x 17⅞ x ⅛).

Fig. 72. *Melancholy.*
OKK P/t 571B. Color block (oak). 41.2 x 45.1 x
.8 (16¼ x 17¾ x ⁵⁄₁₆).

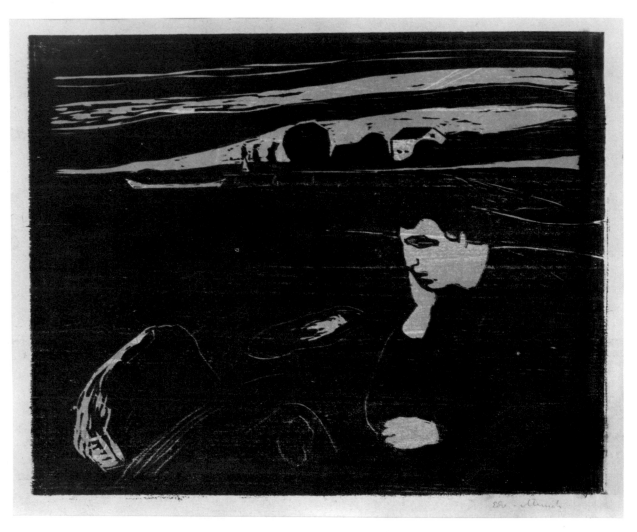

Pl. 73. *Melancholy*, 1901.
S. 144. Color woodcut from two blocks, one sawn into three pieces of which one has not been printed in this impression; printed in gray, and orange-brown, black, beige, green; brown-beige wove paper. 38.8 x 49.2 (15¼ x 19⅜). Signed, graphite, lower right: "Edv. Munch".

included in "The Mirror"; pulls made after the separation of the drawing block (OKK 571–3); and impressions of final states which incessantly vary the printing sequence of the four sections and the colors. Thus, melancholy under a peaceful blue sky could become despair under flaming red heavens.

Munch printed the Straus impression in his favorite range of colors for the motif: orange, blues, and pea-green. The tension between the hot and cool hues seems to reflect the conflicting emotions of the slumped figure.

The colors have been laid over each other alternately to produce combinations and to show through the drawing in their pure form. Munch blended them by inking and printing the blocks in a sequence not easily explained even by referring directly to the actual woodblocks.

Viewed in raking light, the Straus impression bears such deeply imprinted lines of vertical grain that the background block was surely printed last; otherwise the relief would have been flattened by the drawing block. But there is such subtle gradation of color on a single block that it is difficult to determine if the blocks were printed more than once, or if the inking was so carefully controlled that the artist could print two colors simultaneously from the same section of one block. By now we have seen enough of the sophistication of these graphic works to know that the latter could well be the case.

In the Straus impression, first, both halves of the drawing block were printed in blue, the right side (as it appears on the impression) inked in a lighter shade than the left. It is possible that the strip of trees was inked in green. Then the blue ink was rolled on further into the area of the figure. It seems clear that the blue of the land is darker than that of the sea and sky. These color modulations are so subtle however, that exactly what happened in the area of the trees remains a mystery.

The next step was the printing of the background block, the top half in pea-green, the bottom in orange. Here, the scintillating quality of the colors, as well as the strong relief of the print owe much to the paper, a fine sheet of Japan. As always, Munch's cultivation of effect extends to every aspect of the work.

In 1901, Munch cut another block of the *Melancholy* motif (Pl. 73).

Fig. 74. *Melancholy.*
OKK P/t 60A. Color block (ash). 36.9 x 47 x 1.6
(14½ x 18½ x ⅝).

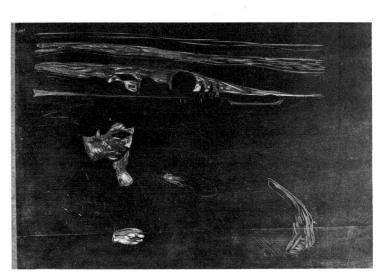

Fig. 75. *Melancholy.*
OKK P/t 606B. Drawing block (beech). 38.1 x
55.9 x 1.1 (15 x 22 x ⁷⁄₁₆).

This time, he made a mirror image and added the figures on the jetty so that it bears more resemblance to the painted versions. Again, Munch used two blocks, one for drawing, in one piece, and one exclusively for color, bearing no drawing at all, sawn into three sections (Figs. 74 and 75). Some grain is visible, more or less depending on the transparency of the colors, but the concentration on texture seen in the 1896 version has disappeared. The color schemes for this print are mostly subdued; on the majority of impressions, including the one in the Straus collection, the drawing block, inked in black, has been printed over the colors, imparting a literally black and hopeless despondency absent from the more passionate play of colors and emotions in the early rendering. Here the artist depicts melancholy as the direct consequence of jealousy: the man's reaction to the couple departing in the boat. But one cannot generalize about the color combinations and their emotional evocations: one beautiful impression[14] has no black at all, and in it the outlines of the color blocks are strong and the colors light and varied. They lend to this particular interpretation a sense of action and hope missing from the starkly conveyed misery of the Straus impression.

Girl's Head on the Shore of 1899 (Color Pl. 76) is also a genuine color composition in which the drawing and color blocks have been designed to work together for the complete image (in spite of the evidence of experimental impressions where Munch only used one or the other). Each block bears a horizontal grain which contributes to the dense texture of the final image; each is sawn in two.

Some impressions emphasize the beautiful and complicated curves of the cut blocks. In one case, for example, the artist did not print the left half of the drawing block, but allowed the jagged contour of the shore to bound the land, which is a blend of soft colors, all rolled onto one piece of wood. He then painted in a moon and a path of light. In contrast, on the Straus impression, printed in the most frequently used combination of brownish orange and turquoise, Munch teased the eye of the viewer by inking the two halves of the drawing block with the same color. The delineation between shore and sea fades away and blends with the division of the color block, so that the girl's head, color of sand and sea, emerges from the depths in a mystical watery birth. The top half of the color block has been inked so lightly that one discerns its presence mostly within the areas where the fibrous, off-white paper peeps through, as in the mass of cuts that define the central curve of the coastline.

In *To the Forest* of 1897 (Color Pl. 77), Munch combined a simple drawing block (fig. 78) with a color or background block sawn into three pieces. On the former, to which side panels of about one and a half inches were added (one panel is missing, the other barely visible in this photograph), he carved out the tops of the trees, the sky, and the woman. The man is delineated merely by scratched-in lines; otherwise he blends into the foliage. The couple's arms overlap in a witty switch between positive and

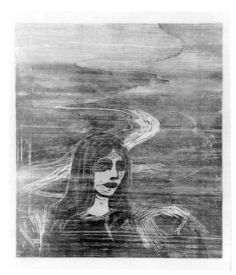

Girl's Head on the Shore, 1899 (see Color Pl. 76).

negative forms. On the color block which, in effect, constituted a trial run for his 1915 version (Fig. 79) of the same motif, Munch essentially redrew the image with the three sections of sky, the central area including the trees and background, and the ground plus the two figures. He also added details of trees and forest. The area of the figures, however, he left blank. Munch then sawed out these areas and inked the ground and figures in beige and the center area in a dark turquoise green, which subtly shifts into a lighter olive toward the lower edge of the drawing block, printed in black. The blackness lends a mysterious, sinister air to the primal growth into which the clothed man leads the naked woman. The horizontal grain negates the implied depth of the underbrush and pulls the couple to the picture surface, halting their progress and freezing them into an iconic stance.

In 1915, working with a different intent, Munch took the same color block, already sawn into three parts, and cut out a new interpretation. The woman now wears a flowing dress, the woods have thinned out, and the grain of the color block from which the new figures were cut is not visible and no longer hampers the couple. Their forms have been cut out from the background, as well as separated from each other, and now appear to be able to move of their own volition. A blue sky and bright green foliage welcome the lovers into nature, reflecting Munch's new attitude toward life— calmer and more positive than in 1897.

To the Forest, 1897 (see Color Pl. 77).

Fig. 78. *To the Forest.*
OKK P/t 575. Woodblock. 48 x 59.7 x 1.7 (18⅞ x 23½ x ¾).

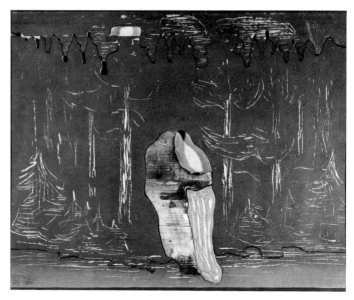

Fig. 79. *To the Forest.*
OKK P/t 644. Woodblock (probably oak). 50.8 x 64 x 1 (20 x 25⅜ x ¼).

91

In 1898 Munch designed two similar motifs, *Melancholy: Girl in Red Dress* (Pl. 80) and *Women on the Shore*. Both depict figures on the edge of a sinuously winding beach. The Straus impression of the first exhibits all the evocativeness of the hand print; the varying pressure across the block creates alternately heavily pigmented areas and spaces in which the thick, smudged tan paper shows through the sticky ink. While some sense of grain is present, the gluey texture essentially derives from the color rolled onto the block. Also, although separating the sea and sky had become standard practice for Munch, this time he cut out only the red dress, leaving the woman's arm, neck and hair on the land section.

The impressions of *Melancholy: Girl in Red Dress* appear to be essentially uniform—Munch consistently used the same colors, varying only the shade of blue in the sky to a gray-green. By contrast, he experimented extensively, in both cutting and printing, with *Women on the Shore*. Here the participation of the grain is minimal; Munch emphasized the matt surface areas of land and sea punctuated by a few rocks and modelling lines, and the two figures on the second block. Significantly, the figures are not sawn in two, but remain bound together, differentiated only by the scooping away of the young woman's dress to which her elder seems to cling with grief and intensity. The artist used the same principle of simultaneous inking which joined together the two faces in *Man and Woman Kissing*.

There are many variations on the motif of *Women on the Shore*. Munch recut the block into a second state, adding two rocks to the beach and a thick line parallel to the shoreline, and recutting the face of the old woman into a death mask. Even before the second state, however, he worked extensively with printing variations, including hand coloring, overprinting with a linoleum block, and cardboard cutouts.[15] These impressions, which often include Munch's characteristic moon and moonlit path, are monoprints, unique versions of the image. They lose the character of multiples and become closer in "status" to paintings. In fact, Munch's painted replicas of a motif resemble each other more than do the many printed versions of *Women on the Shore* where he deliberately sought variety and experimentation.

The Straus impression is considered the "classic" form of the print.[16] It is a first state pulled after the jutting point had broken off (it seems to have been missing from the start, probably broken off when Munch was sawing the wood), and after he had replaced it with a piece of cardboard (later replaced by another piece of wood). Judging from other impressions, this scheme of colors seems to have been the artist's favorite, and he emphasized the purity of matt colors and spaces by not applying the amount of pressure that sometimes picked up the modelling of the dress, which is visible on the block itself. The Straus copy possesses a stark simplicity which fully justifies the tribute "classic." With the terseness of a cipher,

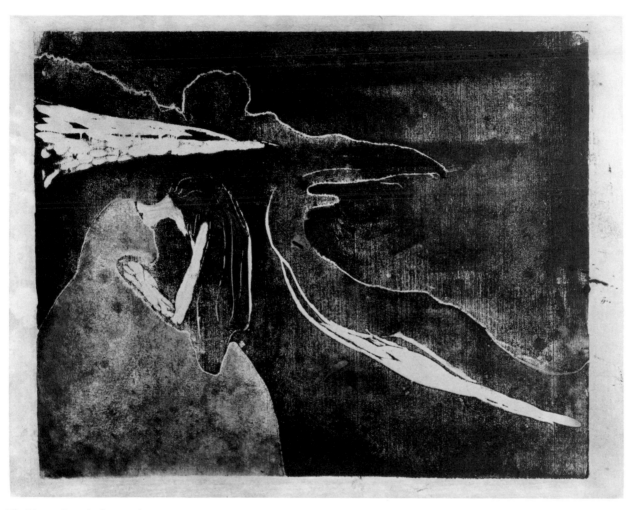

Pl. 80. *Melancholy: Girl in Red Dress*, 1898.
S. 116. Color woodcut from one block sawn into three pieces printed in black, blue, red; tan
wove paper. 33.6 x 42 (13¼ x 16½).

Pl. 81. *Fat Whore*, 1899.
S. 129. Color woodcut from two blocks, one sawn into two pieces, printed in black, yellow, green; off-white laid Japan paper. 25 x 20.2 (9⅞ x 7¹⁵/₁₆). Signed, graphite, lower right: "Edv. Munch".

the standing and crouching figures, staring out at the sea, evoke the mystery of youth and age.

Meeting in Space, 1899 (see Color Pl. 63) was also an important motif for Munch and one similar in technique to *Women on the Shore*. In a noteworthy reversal of his usual procedure, he made an intaglio print, an etching, of the subject three years after he made the woodcut. He could not further simplify the motif, but he could test other means of bringing it to form.

In the woodcut, two figures float against the grain-textured background of outer space, a despairing man and a woman who looks purposefully ahead. Spermatozoa swim around them, reminiscent of the border of *Madonna* and *Death and the Maiden*. Munch made the print from one block sawn into three pieces and inked separately: the woman, the man, the background. The white contour lines of the cut-out shapes halo the figures and define their separation, as well as create a decorative frame which echoes the strings of sperm. At the feet of both the man and woman one can see where the artist began his saw cut; two small pieces broke off and were repaired so that the grain of the piece at left runs in the opposite direction from the rest of the board. Munch then filled in the edges of the repair with black ink. This kind of wear to the block occurred time and again. It did not seem to bother Munch; he simply made the best of it.

In the *Fat Whore*, 1899 (Pl. 81) and *Prayer of the Old Man*, 1902, Munch explored the effects of layering drawing and color. These impressions from the Straus collection have also both been printed on Japan paper; the ink has soaked into the sheets and the images shimmer on the surface.

The *Fat Whore*, a memory image of the bohemian days of Berlin and Paris, consists of a drawing block and a background block sawn into two pieces (Fig. 82). Schiefler was unaware of the first version of the drawing block (Fig. 83) in which the curtain pattern was busier and more distracting, and the picture frame wider. For the second version, Munch cleaned up the curtain, widening and lengthening the cuts into a crisper organization. Then, as usual, he discovered new possibilities by printing the color blocks on top of the drawing block and vice versa. In Fig. 84 he printed the color block backwards to obtain two complementary humps of shadow behind the woman which seem to echo her generous décolletage.

In the year 1902, Munch looked to the past in many ways: he took up old motifs to rework them, and also revived old memories that led to the creation of *Prayer of the Old Man* (Pl. 85). The artist recalled glimpsing his father deep in prayer by his bedside after they had quarreled violently, and could not rest until he captured the image on paper.

Munch used the same layered overprinting as in the *Fat Whore* where the color blocks "color in" the drawn black image, as opposed to creating complex color harmonies as in *Melancholy* or *Girl's Head on the Shore* (which Mellerio would surely cite to exemplify the "true" color print as

Fig. 82A. *Fat Whore.*
OKK P/t 599B. Background block. 24.2 x 20 x .8 (9½ x 7⅞ x ⅝).

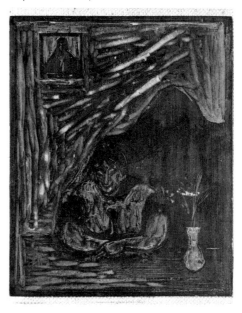

Fig. 82B. OKK P/t 499A. Drawing block (ash). 24.8 x 20 (9¾ x 7⅞).

95

Fig. 83. *Fat Whore.*
OKK 599–12. Brown paperboard. 25.1 x 20 (9⅞ x 7⅞).

Fig. 84. *Fat Whore.*
OKK 599–11. Beige paperboard. 24.1 x 21.6 (9½ x 8½).

opposed to *Prayer of the Old Man*). In this work, however, unlike the *Fat Whore*, Munch made some cuts on the yellow block allowing the creamy Japan paper to show through and creating a warm, yellow candlelight glow. In the interest of economy, perhaps, and since he did not use the jigsaw in this print (contrary to Schiefler's assertion), he printed the color from the reverse side of the drawing block. Occasionally, the artist printed the color from another, uncut woodblock, for no discernible reason, but for the most part worked from the same block, sometimes printing it upside down as the pattern of the grain reveals.

Birgitte III of 1931 (Pl. 86) is the latest work in the Straus collection and an excellent example of the artist's final woodcut style.[17] Where the late paintings became even more painterly and coloristically expressionistic, the woodcuts of the twenties and thirties are highly linear and almost exclusively black and white. Instead of the broad, clean cuts and planes of the other woodcuts, and especially of the two other black and white woodcut portraits in the Straus collection, *The Old Sailor* and *Urmensch*, Munch here constructed a spider web of lines mixed with deep woodgrain, from which a ghostly apparition emerges.

The portrait's title refers to the model Birgit Olsen Prestoe[18] who modelled for the artist toward the end of his life. He painted her and used her face in a number of woodcuts, including a series illustrating Henrik Ibsen's *The Pretenders*, which chronicled royal ambitions in thirteenth-century Norway. The portrait of Birgitte is directly related to the woodcut *Ordeal By Fire*,[19] which depicts the opening scene. Munch sensitively portrayed the spirituality of the woman in the portrait. The impact of the image lies in her facial expression, and Munch was aware of this. Although he made a second state, in which he added the Gothic arches of Christ Church in Bergen and sawed the block into two pieces, still in a number of impressions like the Straus print, he lacked interest in the other areas of the block and simply stopped inking it several inches above the bottom edge (Fig. 87).

In a discussion of this work, Frederick Deknatel, the first American scholar of Munch, wrote:

> This mature conception is expressed by a subtle use of the woodcut in which the styles of his earlier manners are integrated. The grain of the wood prints vertical white lines through the darks. The light areas of the face and neck are made by scratching away the surface of the block in vertical strokes. Light pervades the print and flows over the features which are suffused with feeling, yet the consciousness of the grain of the wood and the cutting of the block consistent with it are never lost. This integration of expressive representation with the abstract qualities inherent in making the print from wood is the final stage of what Munch began in the woodcuts of the end of the nineties.[20]

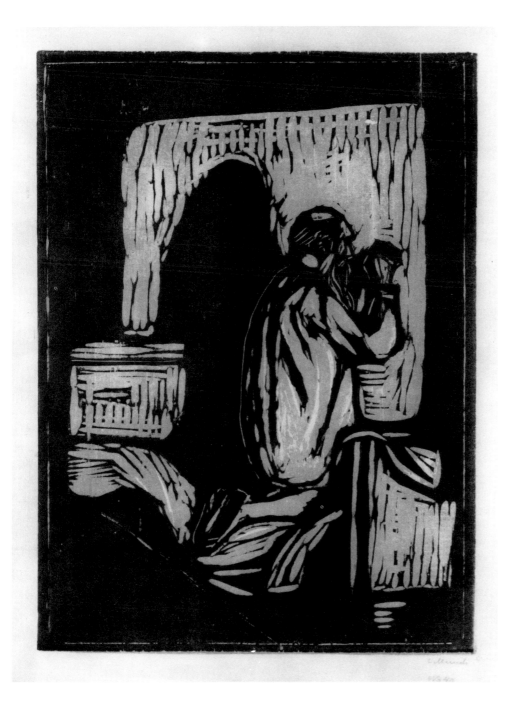

Pl. 85. *Prayer of the Old Man*, 1902.
S. 173. Color woodcut from two blocks, printed in black, orange-beige; cream laid Japan paper.
46.1 x 33 (18⅛ x 13). Signed, graphite, lower right: "E Munch".

Pl. 86. *Birgitte III*, 1931.
Not in Schiefler. Color woodcut printed in a mixture of grayish green and purple. Off-white wove paper. 44.5 x 31.7 (17½ x 12½). Signed, graphite, lower right: "Edvard Munch".

If *Birgitte III* indeed represents the "final stage" of Munch's woodcutting career, it has not been the result of a linear progression to an end. In fact, although Deknatel is right about the integration of different concerns, it seems that the intent of the monumental and complex works of the nineties, in terms both of subject matter and technique, in fact sets them far apart from these late illustrations. Issues such as counterpointed layering of sections of the picture due to the sawing of blocks and the related implications and possibilities for color, do not figure in the creation of these late compositions. In a sense, a work like *Birgitte III*, although cut into wood, instead represents a return to the linearity of the intaglio prints.

Fig. 87. *Birgitte III.*
OKK P/t 703. Woodblock (ash). 59.3 x 31.7 x .6
(23⅜ x 12½ x ¼).

VI
MIXED MEDIA

TWO OF MUNCH'S most important and interesting color prints were, in their earlier, painted renditions, intended as pendants, to be hung together as a pair. *Madonna* (Pl. 88 and Color Pl. 89) and *Vampire* (Color Pls. 90 and 91) were exhibited together in Berlin in 1893 as part of a six-painting series called "Love." Two years later, Munch made a drypoint of *Madonna*, and a black and white lithograph of each motif. Then, in 1902, in one of his most intriguing printmaking experiments, he added woodblocks to the lithographic versions, creating his first combination prints.

The lithograph of *Madonna* was pulled at the studio of Lassally in Berlin; *Vampire* at Clot in Paris. Both, printed in black and white, were conceived as "pure" lithographs, drawn on stone with crayon and tusche and accented with scratches of the needle. The black and white version of *Madonna* illustrates Munch's intention: to restate the painted image in the starkest, most austere manner, stripping it of the lush colors of the canvas. Lithography provided an excellent means of emphasizing value contrast, and so forceful was the black and white version of *Madonna* that the 1902 color print appears extravagantly sensual in comparison.

Yet, even in the earliest impressions of the black and white versions, there can be no doubt that, effective as they are, the artist did not cease to imagine them in color. Many of the earliest impressions of both *Madonna* and *Vampire* bear extensive hand coloring, although its precise date of application is not always evident. It was clearly obvious to Munch from the start that *Vampire* was intellectually incomplete without color. In this

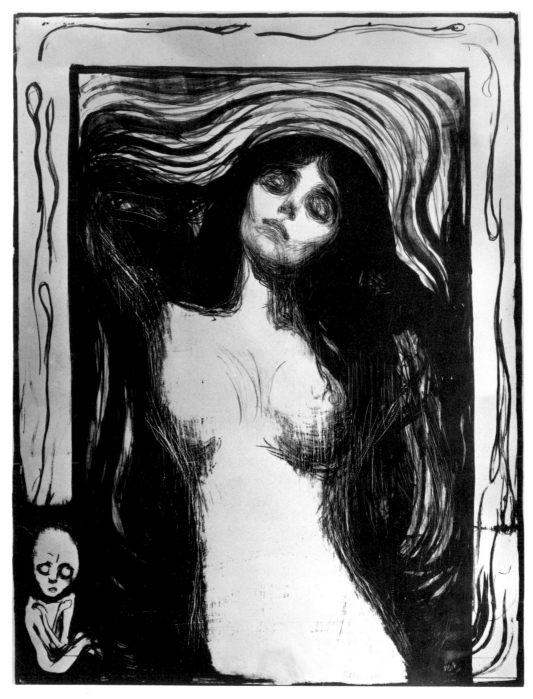

Pl. 88. *Madonna*, 1895.
S. 33 A/a/I. Lithograph with tusche and crayon; white wove paper mounted on an off-white wove sheet. 60 x 44.1 (23⅝ x 17⅜). Signed, graphite, lower right: "EMunch"; also scratched in the stone, lower right: "E Munch". Verso: stamped with seal of Munch-museet.

image, Munch used hand coloring to test the potential of color printing; in one representative impression (see Color Pl. 91), he stroked in with wash the bloody hair so central to the meaning of the image. Lacking that color, the impact of *Vampire* would be greatly diminished. And when he finally did print the colors rather than apply them by hand, he introduced the remarkable innovation of combining the lithograph with woodblocks.

What could have inspired Munch to do this and when exactly did he print combinations of media for the first time? Although he designed *Vampire* and *Madonna* in 1895, the year before he began experimenting extensively with color, nevertheless it is commonly understood that he did not reprint them as color compositions until 1902. The fact that only hand-tinted impressions were included in "The Mirror" exhibition of 1897 strongly indicates that either he had not yet made the innovation of combining the two media, or at least that he had not yet carried it through, in spite of the other color experiments of 1896. However, in an undated letter to Julius Meier-Graefe, supposed to date from late 1897, he wrote: "I am at work on various woodcuts—and will—soon send you some of them—If you're to have colored woodcuts they will have to be printed here—as I am having the color printed with lithographic stones."[1] As Torjusen notes in her article on "The Mirror," this introduces the "startling information that as early as 1897" the artist was working with the combination of lithography and woodcut. "What prints were involved, however, is unclear."[2] *Man's Head in Woman's Hair* (or *The Mirror*) may be the image that inspired the combination print. One of his earliest relief works and central to "The Mirror," it possessed a unique importance for Munch and logically became a sure choice for color experiments.

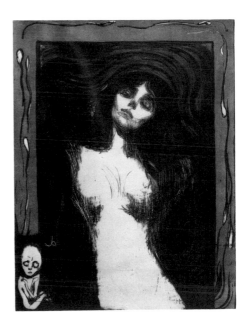

Madonna, 1895 (see Color Pl. 89).

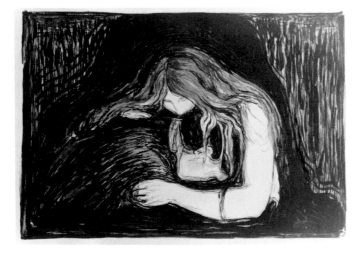

Vampire, 1895 (see Color Pl. 90).

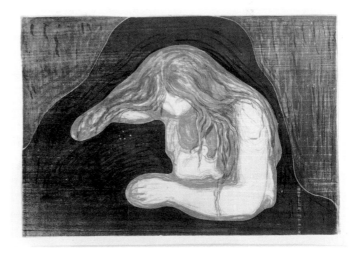

Vampire, 1895 (1902) (see Color Pl. 91).

103

The combination print referred to in the letter to Meier-Graefe would not, however, be the woodblock version of *Man's Head in Woman's Hair* but possibly a fascinating variant: that is the poster made for the 1897 exhibition of "The Mirror" at the Diorama in Christiania (Pl. 92). On the poster the image has been reversed. By a complicated transferral procedure, the woodcut image, while retaining all the characteristics of the woodgrain and cutting, was literally transformed into a lithograph for the purposes of easy reproduction and quantity. In the poster, printed in red, green, black and gold, the lithographically printed matt color frames and encloses the woodcut drawing in a manner similar to a combination print such as *Vampire*; although in the latter, the color has been printed separately from separate woodblocks, around a lithographic drawing. The principle remains the same, and Munch seems to have realized the advantages of printing the color from woodblocks rather than stones, at least in certain cases: he could simultaneously achieve the valued effect of texture from the grain. Nevertheless, the example of the lithographic poster could have sparked these ideas for further experimentation.

This is speculative, but we do know that by the time he reprinted *Vampire* and *Madonna* in color, Munch had perfected the technique of printing "pure" color lithographs such as *The Sick Girl* and *The Sin*, as well as "pure" color woodcuts such as *Man's Head in Woman's Hair* and the highly sophisticated *Melancholy*. In other words, by 1902 the artist was conversant with the various means of printing in color, having experimented extensively since 1896. So if, as his letter says, he had been printing color on woodcuts with stones, he also had understood the possibilities of the reverse method.

The early black and white impressions of *Vampire* were printed by Clot in Paris, the later color ones by Lassally in Berlin. In both versions, it is one of Munch's most exploratory and inventive graphic works. In translating the motif from painting to graphics, he initially conceived it as a lithograph and made a first version, erroneously called a first state by Schiefler. In fact, this so-called first state differs from the "second" and is several inches smaller in size. Also, in the second version (see Pl. 90) there is no trace of the window, which the artist evidently realized was a distraction from the major focus of the picture. In the second version, executed almost immediately after the first, Munch elongated the format and eliminated all but the central motif. Energetic lines of tusche streak the background and reinforce the looming shadow, the woman's hair, the man's back. The artist also used a needle, most strikingly around the woman's bowed head, so that the matt black areas acquire a certain airiness and texture which counterpoint, but complement, the rhythm of the black lines.

Munch hand colored many impressions such as the Straus impression (see Pl. 91), whose signature and date, "E Munch 1896," and inscription, may have been written when he applied the washes. This suggests that,

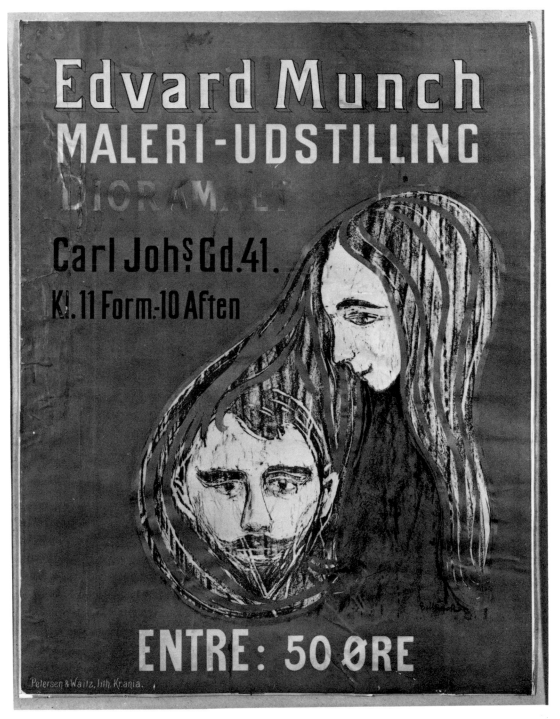

Pl. 92. *Man's Head in Woman's Hair*, 1897.
(Not in Schiefler). Lithographic poster printed in red, green, black, and gold. 63.5 x 47 (25 x 18½).

from the earliest printings, Munch was concerned with the chromatic potential of *Vampire*. On this impression, the artist, working with watercolor or possibly colored inks, brushed in strands of bloody red hair which creep over the woman's shoulders and the man's head. Red background accents echo the hair. A light green wash models the man's face; there is a royal blue wash in his hair and on his coat. The woman's prominent arm has been touched in with faint pinkish wash. Dark blue marks curve around her mouth as she sucks the neck of the man, highlighting the locus of contact in the exact center of the image. These colors, and the rich black of the printed drawing, stand out sharply from the grayish green paperboard, contributing to a ghostly atmosphere.

If at the present time we do not know when Munch started to print color on *Vampire*, we do know how. Preserved in the Munch Museum is the set of patterns and woodblocks that document the entire development of his pictorial idea.

The red hair, so prominent in the first, painted version of the image, seems to have absorbed the artist immediately. His first experiment in printing the color was to make a red "wig" cut out of a rough-grained woodblock (Fig. 93). In a rare impression (Fig. 94) we see the result of the red woodblock printed under the lithographic drawing. While the effect is interesting, it is not successful. The horizontal grain of the wood counteracts the streaming black strands and, as is especially evident in the hair falling over the woman's forearm, possesses nothing of the elastic sinuosity of the lithographic lines. Indeed, the block of wood retains little

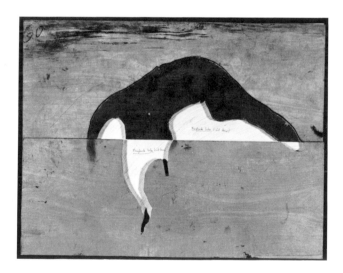

Fig. 93. *Vampire.*
OKK P/t 567D. Red wig. 38.1 x 49.5 (15 x 19½).

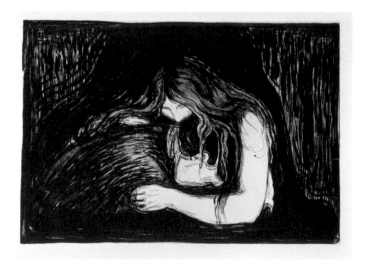

Fig. 94. *Vampire.*
OKK 567–31. White china paper, mounted on cream wove paper. 38.7 x 52.7 (15¼ x 21¾).

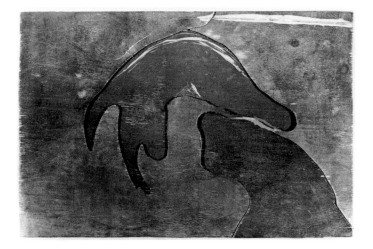

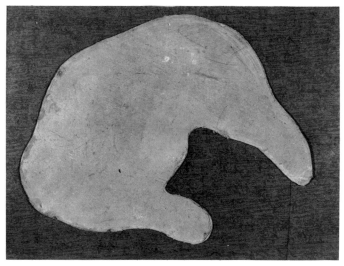

Fig. 95. *Vampire.*
OKK P/t 567B. Plywood. 37.5 x 55.3 x .5 (14¾ x
21¾ x ⅛).

Fig. 96. *Vampire.*
OKK P/t 567. Cardboard. 35.6 across (14
inches).

color, suggesting that it was inked up only a few times. Munch clearly
realized that a much more powerful effect could be obtained by adding
another lithographic stone, which carries additional strands of hair printed
in red. Probably before he thought of that option, Munch sawed another
woodblock into four pieces (Fig. 95), making another red wig, a back-
ground, and the area of the man's shoulder. The combination of shapes is
awkward, however, and it seems that only after deciding upon lithography
for the red hair did he perceive a new way of adding purple shapes to the
composition.

Experimenting further with color and simplifications of form, the
artist cut out a piece of cardboard (Fig. 96) in the shape of the area of the
figures. Its mottled beige surface corresponds directly in shape, color, and
texture to the printing on an impression (Fig. 97) which represents an early
trial proof. There is no doubt that, on this impression, the areas of green
(background) and blue (the man's coat) were printed from other cardboard
pieces which have since been lost; their means of application can be
deduced from the embossed edge of color around their contours.

From these trial cardboard pattern pieces, Munch made up two blocks,
each sawn into four pieces. The first block (Fig. 98) has a rough texture and
a horizontal grain; the center piece covers the woman and man's head,
printed in beige; another comprises the area surrounding the figures, the
looming shadow and the coat of the man, printed in dark blue; and the
third and fourth make up two background areas at left and right, printed in
blue and green. Examples of impressions taken with this woodblock exist

in the Munch Museum. In one version (OKK 567–33), Munch printed the green and blue background pieces first, then the beige-orange center piece, then the two lithographic stones (the black drawing and the red hair stone), and, finally, the dark blue woodblock areas surrounding the figures. This innovative variation in the printing sequence, using color blocks and lithographic drawing stones, became a common practice of the artist. The result was a constantly changing emphasis on different aspects of the image: in one example the strands of red hair from the stone stand out; in another, the dominance of the abstract pattern of color creates a suffocating enclosure.

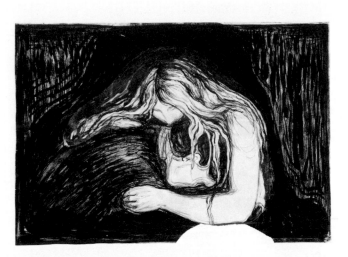

Fig. 97. *Vampire.*
OKK 567–30. White china paper mounted on cream wove. 38.7 x 55 (15¼ x 21⅝) (irregular).

Fig. 98. *Vampire.*
OKK P/t 567C. Plywood, sawn into four pieces. 55.9 x 38.2 x .5 (22 x 15¼ x ⅛).

Fig. 99. *Vampire.*
OKK P/t 567A. 38.4 x 54.9 x 1.7 (15⅛ x 21⅝ x ¾).

Munch simplified the image even further in its final version, with another woodblock (Fig. 99) for which, possibly, the rough-grained set had merely been a trial. This block, which bears a finer, smoother grain, was also sawn into four pieces, comprising the same areas, and was inked with the same selection of colors. In the Straus impression, the lithographic stone with the drawing on it was printed in gray. The beige color block was printed under the stone, and the blue and green blocks were printed over it. In what sequence the stone with the red hair and background streaks was added is less obvious. Here, the abstract color patterns predominate because the woodblocks were printed on top; in other impressions, Munch printed them underneath the drawing stones, emphasizing the motif rather than the cocoonlike background. And yet in every case, the stark simplicity of the shaped color pieces, juxtaposed with the complexity of the drawing and the pattern of the wood grain, create a remarkably rich and varied image.

The experimental nature of *Vampire* consists, therefore, in its development in printing, rather than in reworking of the drawn image. Moreover, in addition to the evolution of complex color schemes, Munch developed *Vampire* in abstract forms, seeking to reduce the color composition to its most essential elements. Then, by manipulating color patterns and sequence of printing, he varied the attention given to each element, creating a spectrum of impressions to serve different interpretations of a woman bending over the neck of a man. The understanding of the precise nature of her activity changes from impression to impression. Where the hand-colored lithograph versions tend to emphasize the individuality and differentiation of the man and the woman, the impressions printed with the woodblocks bind the two together with color and form, abstracting and universalizing the theme. The later version has become iconic, frozen into a symbol that escapes rigidity thanks to the graceful contours of the woodblocks and the serpentine red hair.

Madonna also ranks among Munch's most experimental color prints. In addition to the mixing of media, Munch made different states of the stone and different printing versions. Unusual in Munch's graphic work is his retention of the orientation of the painting: in other words, he drew the image in reverse on the stone. The artist's notes about the importance of this motif find expression in the care with which he transferred it into the graphic media:

> The pause as all the world stops in its path. Moonlight glides over your face filled with all the earth's beauty and pain. Your lips are like two ruby-red serpents and filled with blood, like your crimson red fruit. They glide from one another as if in pain. The smile of a corpse. Thus now life reaches out its hand to death. The chain is forged that binds the thousands of generations that have died to the thousands of generations yet to come.[3]

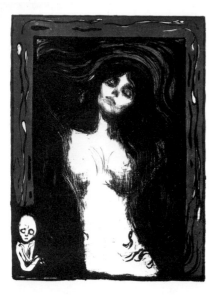

Fig. 100. *Madonna.*
OKK 194–22. White wove paper. 60.3 x 43.8
(23¾ x 17¼).

Madonna is printed in a multitude of variant impressions. Schiefler divided them into categories: single color, multicolored, two states of the stone, printings from three stones, printing from four (of which one is really a piece of wood), and, finally, the lithograph printed in full-length and half-length. Schiefler does not even mention those impressions that lack the border all around, nor a third state of the drawing block or additional versions with drawing added on other stones. In the process of designing the lush, baroque color versions, Munch made further revisions to the drawing, but probably on additional stones rather than on the stone with the image. The line between states and versions therefore becomes somewhat blurred. Since, except for the introduction of a woodblock in the background, *Madonna* is a conventional color print, composed from registered, superimposed stones, it was easy for the artist to add another stone and paint on elements such as the strands of hair and more spermatozoa in the border areas (Fig. 100).

The black and white version of the Straus print represents, it seems, a third state of the main drawing stone, based on the degree to which the strands of hair over the arm have been scratched away. The impact of this impression, pulled on a sheet of thick off-white wove paper, stuns with its spectral power and sensuality. A poem of stark value oppositions, the image is also tonal, although without the silvery transparency of the rubbed crayon seen in lithographs such as *Lovers in the Waves.* Munch made the middle tones by scratching away certain areas to mitigate the darks, as well as to model the forms, especially the breasts.

The Straus color impression on the other hand, was made in four colors: beige from an overall tone stone; blue in the center, from a woodblock printing surface discernable in the horizontal grain left among the waves of hair; brick-red from a stone for the border, halo, and touches in the hair; and finally black, the drawing stone printed over the rest. Lying on her back, at the exact moment of impregnation, the woman seems to float in blue water and blood. This impression on Japan paper is particularly vibrant; the inks are imbued with the luster of the fibers. This surface greatly differs from the subdued matt color of *Vampire,* where Munch was more concerned with the grain of the wood, that is, the printed texture, than with the paper texture.

The reason for the addition of the woodblock to *Madonna* is less clear than the combination was in *Vampire.* An obvious factor is texture, which adds interest to the blue area, as opposed to the uniform smoothness of the lithographed sections. But whereas in *Vampire* Munch used the combination of techniques to create meanings, in *Madonna* he manipulated the actual image, through states and versions such as the half-length, to make new interpretations. It was, however, important enough to Munch to render this motif as pictorially rich as possible to emphasize its sensuality; for this reason he integrated a woodblock whose grain contributes to a sense of space and watery translucence.

According to Schiefler, Munch made only four combination prints.[4] Given their special effectiveness, it is surprising that he did not make more. But since the artist did not experiment without specific intent, perhaps he did not feel that other images required the combination; their pictorial needs could be fulfilled in other ways. That these unusual prints, which figure among his most successful, represent anomalies, only underscores the wealth of experimental means that Munch had at his disposal.

THE COLOR PRINTS are distinguished by their invention, evocation, and beauty. The printing variations render many impressions unique as well as monumental, reflecting the importance that Munch assigned to them as individual works of art, not merely as multiples. These works were to be displayed on the wall, not hidden away in a portfolio for the private delectation of collectors. Their size, as well as color, demand the consideration previously accorded only to oil on canvas. Perhaps it was for that reason that Max Linde urged him to frame the prints properly.[5] A photograph of a 1917 gallery exhibition (Fig. 101) reveals that often Munch had shown his graphic works matted, without frames. Linde insisted on better presentation to emphasize their impact.

The role of the color prints in Munch's work is complicated to describe. As color works, they most closely resemble painting, but on the other hand, their bold and unmistakable "graphicness" is their most striking characteristic. Impossible, or irrelevant, in painting, is the composite effect obtained from layered configurations of blocks and stones, reminiscent of Munch's later work with double-exposure photography. In combining his two interests, color, and the discovery of new procedures to create it graphically, Munch moved beyond the confines of either medium, selecting only the qualities he needed and fusing them into a novel vision.

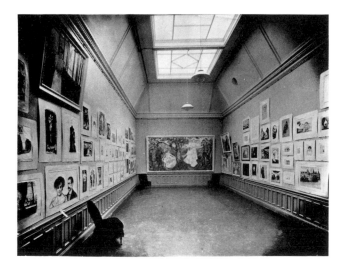

Fig. 101. Exhibition, Liljevachs Kousthall, Stockholm, 1917.

111

VII

IMAGES REWORKED

MUNCH'S LIFELONG TENDENCY to realize his most important themes in more than one medium is the key to the expressive link that he forged between subject and material. A study of the transformation of images such as *The Kiss* and *The Lonely Ones* into successive incarnations, demonstrates Munch's consolidation of pictorial concepts to achieve an economy, range, and profundity of expression that represent the zenith of his efforts.

Gustav Schiefler asserted of Munch that "The sign of a great artist (not just a second-rate one striving to prove himself) is that he can deal with the technical craft problems with careless ease or simply make light of them, because the great artist's guardian angel will always place the right expressive medium in his hands."[1]

This statement represents Schiefler's romantic and naive formulation of the relationship between idea and form. By removing, even rhetorically, the responsibility for the connection between the two from the artist to some mythical exterior force, he denied the vital issue of intent and process that Westheim described in his discussion of the woodcuts when he wrote:

> Munch does not work from the example of one technique to turn it into another and merely create suitable presuppositions from the earlier one—rather, the particular expressive possibilities of the picture planes of etching, lithography or the woodblocks themselves define and form the image.... That does

not mean that with Munch the artistic intention submits to the structure of a technique, more is it that it seems to become a part of the intention, as E.L. Kirchner once expressed it: 'Only when the unconscious works instinctively with the technical means, does pure sensation come to the picture and the technical limitations become aids rather than limitations.'[2]

We have already observed the ways in which an image and its realization evolved together within a medium, for example in the states or color variations of a print. But nowhere is the problem of the balance of the two more saliently illustrated than in the case of the motifs that Munch reworked in entirely different media. In the face of Munch's expanded experimentation, the notion of a "guardian angel" becomes even more trivial. The "right" expressive medium, in Schiefler's sense, was by no means vouchsafed the artist, but was developed in a process that did not culminate exclusively in one solution.

Munch's search for forms appropriate to the subjects and meanings he wanted to express occurred within one medium, in another way from different states, and between media. Clearly, in some instances, Munch tended to conceptualize an image in several graphic media simultaneously as he searched for its appropriate form. For example, his transition from lithographs to woodcuts was, as Langaard observed, "in effect merely a transfer of an expressive form, already used, to a different and more suitable medium." Thus Schiefler, and others, had referred to images such as *Death in the Sickroom*, *The Scream*, and *Self-Portrait with Skeleton Arm* as prefiguring the woodcut technique, and the lithograph *Anxiety*, as noted earlier, actually was mistakenly identified as a woodcut.

Anxiety is one of the motifs that Munch did transfer into a woodcut, employing the properties of this medium to express the block-like massing of the composition. But the others remained in lithographic form; though elements of some images evoke the woodcut, others, such as the delicate facial details of the people in *Death in the Sickroom*, could not be so well realized in the coarse relief medium.

Does this mean that Munch in these instances did not, in fact, find the "right" expressive medium? Does a print such as *The Scream*, which predates his involvement with the woodcut procedure, represent a failed attempt to embody a composition in what might have been its most expressive form?

The case of themes transferred into different media raises other questions. Was the working out of some images in other media, and the concomitant process of simplifying and distilling the meaning, a way of "correcting" the initial result? Is the later woodcut version of a motif qualitatively more expressive—better—than the earlier drypoint of the same subject? Did Munch "progress" from one graphic interpretation to another? If he were not satisfied with an image, would he not return to it and rework it? Or may we assume that he remained content with *Death in*

114

the Sickroom, for example, even after becoming proficient in working with wood? Would a woodcut rendition have been more powerful?

In choosing particular motifs, the artist evidently perceived that their reworking in another medium would reveal fresh pictorial forms and varied interpretations. And common to all the new renderings is a simplification of form and a consequent focusing of meanings that were suggested in previous versions of the theme. Each graphic realization of a motif is complete in itself, fully expressive given the assumptions and means of the technique in question. For example, as a graphic work, the woodcut *The Kiss* is not qualitatively better than the etching. Each pursues and resolves different formal, as well as affective, goals.

However, if one may not make qualitative comparisons, it seems clear that in the process of developing his images, and after more or less experimentation, Munch found pictorial solutions that do appear to summarize his ideas in the most terse and concentrated fashion. Once he found these basic designs, he then proceeded to work with colors and textures, as well as states (as he had also done with themes that he made in only one medium). So even the subjects that occur in more than one medium were also reworked numerous times in a single one, resulting in the spectrum of images that fulfilled Munch's quest for variety of form and nuance of meaning.

Nevertheless, in some cases, the artist may in fact not have found the most congenial mode of expression, resorting instead, for example, to imitating the woodcut aesthetic in a lithograph. With regard to lithographs such as *The Scream* and *Anxiety,* their strong resemblance to woodcut suggests that these are compositions still in search of a form. However, in these works, as well as in *Self-Portrait with Skeleton Arm* and others, Munch also was sensitive enough to the qualities of the medium to render these "legitimate" as well as highly effective lithographs and be satisfied with them.

Thus, Schiefler's romanticized reference to the artist's infallible "guardian angel" cannot be sustained. Munch's images reflect a complicated process of becoming, wherein lies much of their subtlety and originality. Following the realization of themes through several media allows us to look over Munch's shoulder while his true "guardian angel," his own spirit of inquiry, investigates the problems and possibilities of form.

Of all the graphic versions of a given theme, the intaglio is the most literal. The linearity of the technique, as well as its smaller scale, encouraged attention to detail. When working with a motif that he would render in more than one medium, Munch would explore it on a "microscopic" level, detailing it in intaglio, before conceptualizing it in more universal terms. Linearity, for Munch, is often linked to narrative; he would then use planar composition to depict the more symbolic or universal interpretation of a theme, as is evident with *The Kiss.*

But an image also sometimes found its most concise form in render-

ings that were linear and in media other than the woodcut, which is generally considered to be inherently more planar.[3] With *The Sick Girl*, for example, it is the color lithograph that is considered Munch's definitive statement. In fact, the style is as "linear" as the drypoint. In the lithograph, as well as in the little etching of the *Head of the Sick Child*, Munch also simplified the image itself, removing the setting and the weeping woman. By reducing the image, he focused on the agony of the child who faces death alone. *Woman in Three Stages* (Pl. 102) has also been reworked from intaglio to a lithograph, with areas of tusche replacing the aquatint of the intaglio version.

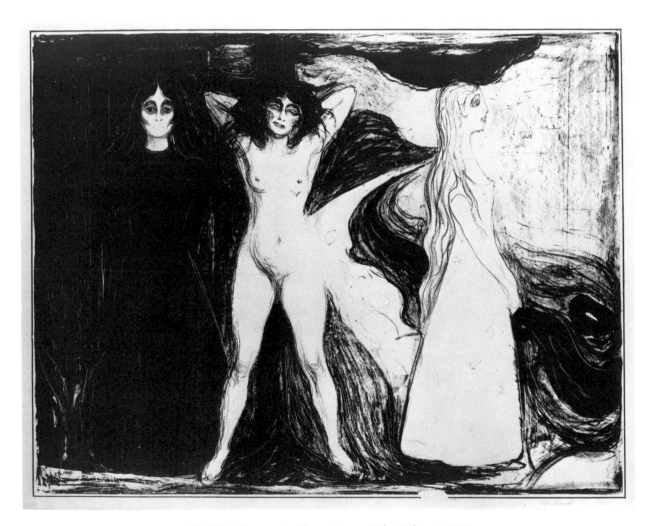

Pl. 102. *Woman in Three Stages (The Sphinx)*, 1899.
S. 122. Lithograph with crayon, tusche, needle; grayish green wove paper. 46.1 x 59.7 (18⅛ x 23½). Signed, graphite, lower right: "Edv Munch".

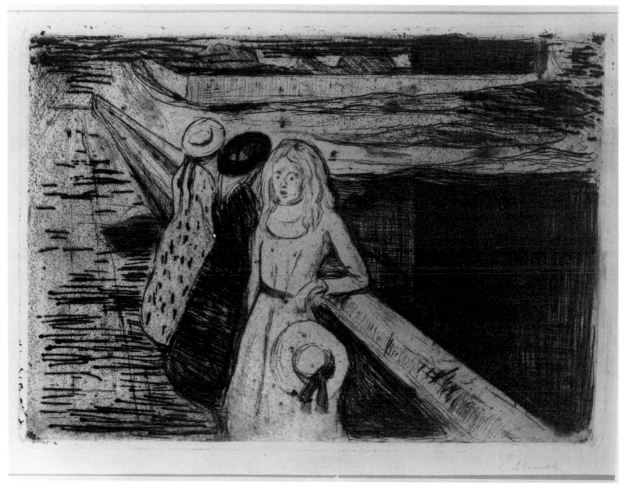

Pl. 103. *Girls on a Jetty*, 1903.
S. 200 III; W. 104. Etching, aquatint; buff wove paper. 18.6 x 26.4 (7⁵⁄₁₆ x 10³⁄₈). Signed, graphite, lower right: "E Munch".

An example of an etched motif reworked as a mixed media print is *Girls on the Jetty* (Pl. 103). In a bold and unusual reversal of the technique of *Vampire*, Munch translated the etching of *Girls on the Jetty* to a woodcut (*Girls on the Bridge*, Color Pl. 104) in which the local colors were printed from lithographically prepared zinc plates. To emphasize a sense of lightness and spontaneity in the woodcut, he used the printed colors to simulate hand drawing.

Munch worked on versions of this theme over a long period, beginning with a painting of about 1899 (National Gallery, Oslo). The scene takes place at his beloved summer retreat of Åsgårdstrand, a resort village south of Oslo. A 1922 photograph (Fig. 105) reveals the artist's faithful transcription of the familiar place with its cluster of great linden trees and the distinctive outlines and fenestration of the villa and small barn.

117

The interpretations of this scene in the etching and woodcut could not, however, resemble each other less, demonstrating how skillfully the artist manipulated technique to convey different emotional overtones. Using the freedom and robustness of the technique of etching, he built up the picture in three states, with the third becoming a forceful combination of lines, tones, and textures. After filling in the drawing, he then, according to Willoch, applied a tone (whether etched into the plate or merely wiped on it is not clear), finally working up the plate with a dotted grain (probably made by running the plate through the press with sandpaper on it) and streaks of the needle bitten so deeply with acid that they stand out in unusually high relief in this excellent impression. The dense, aggressive markings create a landscape that is overwhelming, even menacing, to the three immobile girls. It is as if their dark contemplations, projected onto their surroundings, well up and engulf them. The placid scene of the photograph has been transformed into an image taut with tension and ambiguity.

The woodcut, on the other hand, was conceived in more decorative terms. Munch removed the viewer from the scene, raising the point of view and turning the girls away from us. No longer does one of them look out, as in the etching, but all are isolated and preoccupied.

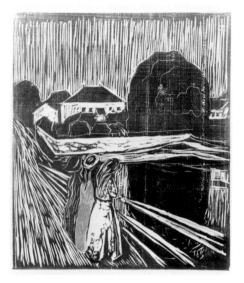

Girls on the Bridge, 1918-20 (see Color Pl. 104).

In this combination print, the main drawing lies on the woodblock, and the local colors are planographic. In the Munch Museum there are a number of impressions pulled from the several zinc plates from which Munch printed color versions, without the woodblock, printed either in single colors, or (Fig. 106) in several. Although hand-coloring gives the illusion of spontaneity on the part of the artist, in fact the mixing of the colors has been carefully planned. Munch most often printed the woodblock in blue; the strong yellow that he printed under that blue cleverly transforms the area of the trees and bushes into a textured green. Sometimes too, he printed an already mixed green directly from the zinc plate. Munch experimented with a number of different lithographically prepared zinc plates, adding red-oranges, yellows, greens, and dark blues to *Girls on the Bridge*.

The experimentation mostly remained confined to the zinc plates. The woodblock itself went through only three states, none of which involved major changes in the basic composition. In the transition from the first state to the second Munch made his essential reevaluation of the design. In the first version (Fig. 107), above the strong vertical cuts of the sky there originally floated a dramatic scene of an abduction on horseback. Delicately carved lines described two galloping horsemen, the first clasping a helpless maiden, and in the background a tree, church, the sun or moon. Like the border in *The Sick Child*, this one seems to represent the romantic summer fantasy of the three girls who stare so intently into the water. Munch realized that the little scene detracted from the taut coherence of the rest of the composition, but it possesses both suggestive

Fig. 105. View of Åsgårdstrand, 1922. Photograph, Munch Museum.

strength and lyrical charm. The omission of the dream (he did not actually saw it from the block but only left it uninked) concentrates the focus on the pattern of lines in the sky and on the bridge, which intensify the oppressive atmosphere surrounding the introspective girls. The scene itself becomes an irreal world; the quivering yellow outlines of shrubs, trees, and houses create a curious insubstantiality. Where the etching depicts a threatening environment, communicated by discontinuous lines and dots, the woodcut throbs rhythmically with waves of summer heat, the long cuts locking the girls into stultifying lethargy.

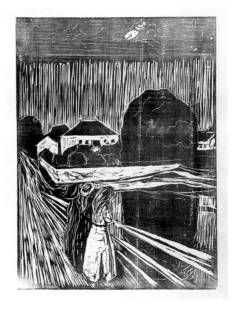

Fig. 106. *Girls on the Bridge.*
OKK 647–18. Lithograph printed from three zinc plates; cream wove paper. 48.9 x 41.9 (19¼ x 16½).

In 1902, Munch invited Schiefler to accompany him to the printing shop of Felsing in Berlin to look at some of his prints. There the artist presented his future cataloguer with an impression of *The Kiss* (Pl. 108) and observed, "Now you possess a print which, because of its alleged immorality, could not be exhibited in Christiania [Oslo]."[3]

The motif is one of Munch's best-known and most reworked. There are drawings of it, paintings, woodcuts, and a combination of etching, drypoint, and aquatint, executed in 1895.

Of all these versions, from the earliest sketch to the iconic abstract woodcut, the intaglio is the most anecdotal. Munch used the delicacy of handling possible with this technique to elaborate details that could not be rendered in a woodcut. Unlike the woodcut, and even the early painted renditions, this etching defines two individuals whose bodies intertwine but remain essentially distinct. The faces begin to blend into each other, but Munch has suggested the contour of the man's profile with tiny scratches. In contrast, the faces in the earlier paintings and later woodcuts become one. Could Munch, in the more traditional etching, have been responding to the ambivalent, or explicitly negative remarks of his friends vis-à-vis the paintings?

For in 1894, with reference to the painting of 1892 (National Gallery, Oslo) Przybyszewski wrote: "One sees two human forms whose faces have melted into each other. One cannot see any clear depiction: one sees only the area of fusion which looks like a giant ear that became deaf in the ecstasy of the blood; it looks like a puddle of fluid flesh."[4] In the famous review of Munch's Paris exhibition that appeared in *La Revue Blanche* in 1896, the Swedish author and misogynist August Strindberg described *The Kiss* as: "The fusion of two beings, the smaller of which, shaped like a carp, seems on the point of devouring the larger as is the habit of vermin, microbes, vampires, and women. Alternately: Man gives, creating the illusion that woman gives in return. Man begging the favor of giving his soul, his liberty, his repose, his eternal salvation, in exchange for what? In exchange for the happiness of giving his soul, his blood, his liberty, his repose, his eternal salvation."[5]

In 1897–8, Munch cut the first woodblock version of *The Kiss*. The evolution of the image over about a five-year period up to the final relief

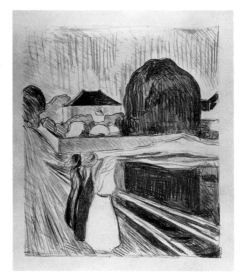

Fig. 107. *Girls on the Bridge.*
OKK 647–1. Off-white wove paper. 48.1 x 42.9 (22⅞ x 16⅞).

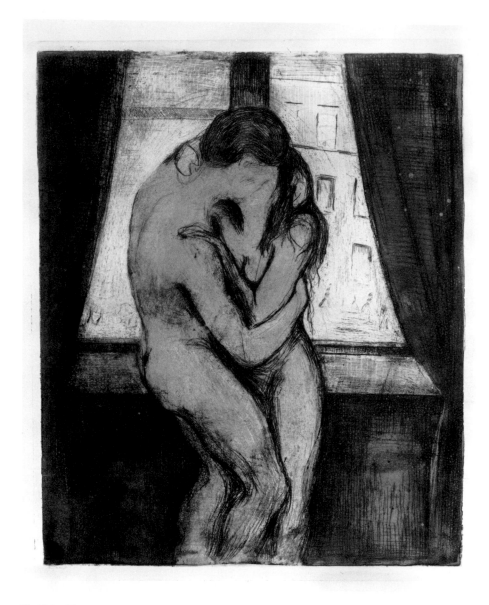

Pl. 108. *The Kiss*, 1895.
S. 22 b; W. 22. Etching, drypoint, aquatint; cream wove paper. 34.6 x 27.7 (13⅝ x 10⅞). Signed, graphite, lower right: "Edv Munch". Inscribed, graphite, lower left, by the printer: "O Felsing Berlin gdr."

print of 1902 chronicles his quest for the pictorial and thematic distillation of his idea. The resulting multiplicity of effects and meanings of all its manifestations takes us from the furtive embrace behind curtains to the kiss as symbol of immutable union.

Schiefler lists four woodcut versions, but there seem to be at least five, in addition both to variations on their printing technique and to variations

on the combinations of jigsaw pieces cut from the woodblocks. The sequence of the versions according to Schiefler is difficult to determine, and different sources do not agree.[6]

There is, however, general consensus regarding the C and D versions, of which excellent impressions are found in the Straus collection. An extraordinarily rich, velvety, and unusual impression of the so-called C version of 1898 (Pl. 109) shows that the background was printed from a plank distinguished by its beautiful grain pattern punctuated by knots. The paper, a fibrous wove sheet, was especially sensitive to the gray ink, capturing even the relief of the wood's whorls. Munch could have used his jigsaw method, and employed as background the block out of which he cut the figures (Fig. 110), and on which he cut lines that surround the figures,

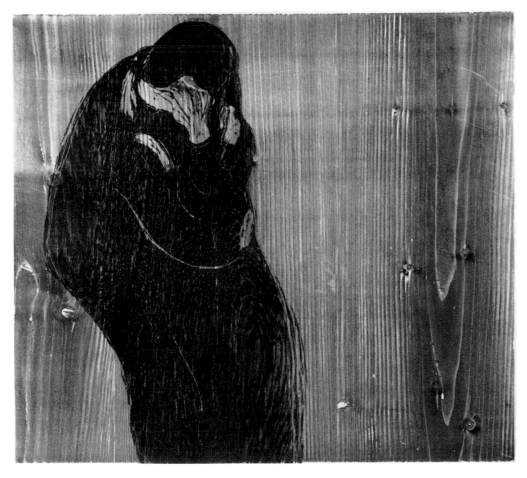

Pl. 109. *The Kiss*, 1898.
S. 102C. Color woodcut from two blocks printed in dark gray, black; off-white paper mounted on orange-beige board. 41.6 x 47.3 (16¼ x 18½). Signed, graphite, lower left on mount board: "E Munch".

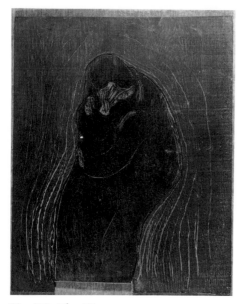

Fig. 110. *The Kiss.*
OKK P/t 577–580 (C). Woodblock sawn into two pieces (spruce). 50.2 x 40.5 x 1 (19¾ x 16 x ¼) (irregular).

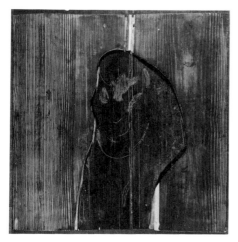

Fig. 112. *The Kiss.*
OKK P/t 580 (D). Woodblock sawn into two pieces. 46.9 x 48.6 x 1 (18½ x 19⅛ x ¼). (Irregular).

but he discarded that much less effective option; the particularly evocative grain of the actual background block is visible beneath the patterns of the figure block. The wood grain visible on the figure group block is itself wonderfully rich, with the great whorl in the area of the woman's skirt, so that in combination, the grains of the two blocks produce a magical lushness of texture that offsets the severity of the design. In addition, the unusual placement of the embracing couple towards the left, rather than in the center, establishes a tension between them and the parabola-shaped, darkly inked grain at right.

In contrast, in the D version (Pl. 111), Munch deemphasized texture although he again chose a strongly grained background block (Fig. 112). Except for the knot visible at the middle right edge of this block, the grain consists by and large of vertical lines; the figured texture seen in the C version is gone.

From his own notations on different pulls, we know that Munch printed many impressions himself: they are dated at least until 1916. The artist's interest in simplification of the image did not prevent his experimentation with both of his last versions. Two kinds of printing variations are most striking. One impression, signed and inscribed "Egenhaendig Tryk" ("Hand-printed") shows the figure group from the Straus C version printed on the background block of the Straus D version, but with the background block upside down so the telltale knot prints at the lower left edge instead of the upper right. He often mixed and matched figure and ground blocks in search of different effects, although the Straus C and D versions (except for the displacement of the figures in the C version) are representative of the artist's preferred solutions.

The D version in the Straus collection also illustrates a remarkably sophisticated technique of selective inking and carefully controlled pressure on the blocks during printing. For example, although the block with the figure group for the D version shows cutting in the faces, the artist evidently chose not to ink this area consistently. Some impressions lack modelling in the faces, creating an even more austere image, while others pick up the small flecks of black. With this version Munch had finished his experiments. It is considered to be one of his purest images.

Another of Munch's most important and experimental subjects, *The Lonely Ones*, is richly represented in the Straus collection by two drypoints, four woodcuts and the painted version of 1908 (Color Pl. 113). Meier-Graefe, in his introduction to the portfolio, described the spell of the image:

> There can be no sharper, more concise expression; the minimum of exterior substance, one does not see the faces of the two, the landscape is highly indifferent. One feels only one thing: the immeasurable loneliness of a piece of life in nature, the glaring contrast between these....One could think that suddenly, on the entire earth, there were only these two people.

It is impossible to represent more simply the relationship or rather the lack of relationship between the individual and the universe...[7]

Meier-Graefe correctly seized upon the starkness and loneliness of the scene, but the relationship between the couple and the universe seems more intertwined than the critic allowed. The figures stand monolithic, almost paralyzed in their alienation, although the man seems to make a

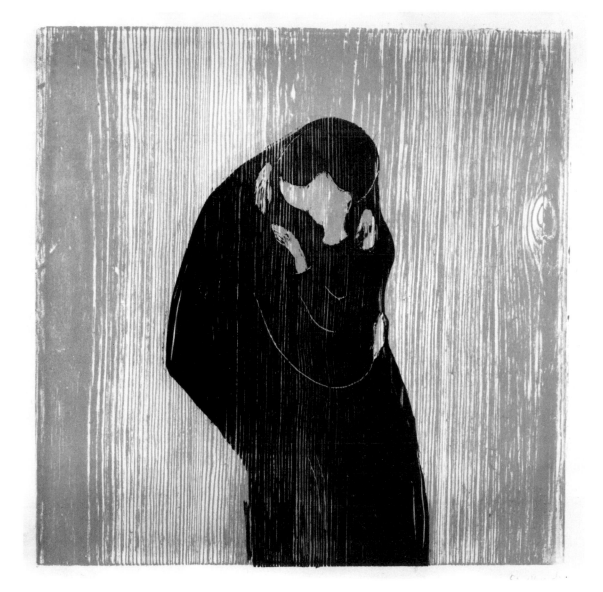

Pl. 111. *The Kiss*, 1898.
S. 102 D. Color woodcut from two blocks printed in gray and black; off-white wove paper. 47 x 47.3 (18½ x 18⅝). Signed, graphite, lower left: "Edv Munch".

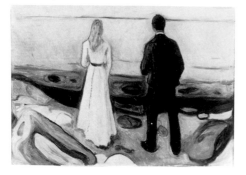

The Lonely Ones, 1908 (see Color Pl. 113).

tentative step towards the still woman. It is she who is apart. Instead of drawing in the man's feet, Munch let the ankles blend into the sand, actually unifying him with the land; but the woman has been sharply outlined so as to separate her entirely from an organic connection with her surroundings. The heavily worked black clothes further bind the man to the curving shoreline, which, contrary to what Meier-Graefe claims, is not indifferent at all. Rather, in both Straus prints, but especially in the fifth state, the artist took great care to evoke the rocky beach so characteristic of Åsgårdstrand, molding stones and shore with powerful, rhythmic contours.

Munch's intaglio interpretation of *The Lonely Ones* is shown here by a possible first state (Pl. 114) and the fifth state (Pl. 115), published in the Meier-Graefe portfolio. The most delicate drypoint scratches coexist with bold accents and robust contours. Traces of the rocker suggest texture; for

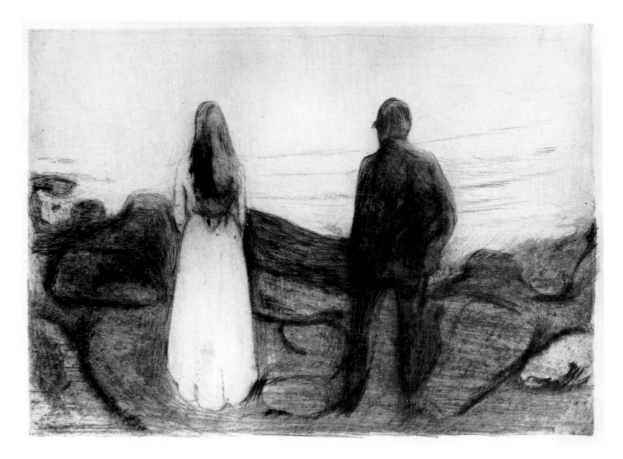

Pl. 114. *The Lonely Ones*, 1895.
S. 20I; W. 19. Drypoint, roulette; white wove paper. 23.5 x 29.4 (9¼ x 11⁹⁄₁₆). Inscribed, lower right, graphite: "an hern E. von Franquet freundlich E Munch".

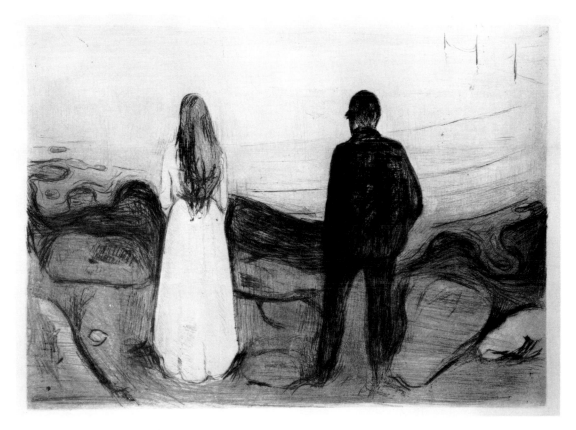

Pl. 115. *The Lonely Ones*, 1895.
S. 20 V/c; W. 19. Drypoint, roulette; buff wove paper. 16.9 x 22.6 (6⅝ x 8⅞).

instance in the woman's hair the jagged rocker marks counterpoint the
blurry, dark highlights of burr, which show more prominently in the first
state impression. A combination of many tiny scratches across the shore
area and selective plate wiping produces the grayish tones, which account
for so much of the atmosphere of the scene.

The coloristic quality of the print is essential, because the motif came
originally from a painting, and, too, because in its woodcut incarnation,
The Lonely Ones became one of Munch's most important experiments in
color printing. In his biography of Munch, Jens Thiis, first director of the
Oslo National Gallery, and friend of the artist, described one of the early
painted versions: how the stones on the beach began to speak, each with its

own color—red, green, violet.[8] The elements which Munch rendered in tonal detail in the drypoint he would later simplify into the stark, flat color areas of the woodcut.

Curiously, Schiefler not only mentions merely one version of the woodcut of *The Lonely Ones*, but only one example, which he dates to 1899. Although it seems odd that in 1907, the date of publication of the first volume of his catalogue raisonné, Schiefler would have been unaware of numerous and varied manifestations of this motif, it would seem even less likely that Munch would have waited so long to experiment with such promising material. Yet some sources[9] suggest that the reworking of the block took place as late as 1917, basing this assumption on an example of the second state in the Munch-museet, which has been inscribed (perhaps by the printer) "No 128/8–1917 Ekely." However, another example of the second state has been inscribed, perhaps in the hand of the artist, "Zwei Menschen Farbiger Holz—1899 Gedrukt und zerschnittene Platte" (Two People color woodcut—1899 printed and sawn blocks). Also, another second state in the Munch Museum (OKK 601–18), bears the date of 1899.

But although the chronology remains obscure, the progression of the artist's idea may be clearly followed. The woodblock proper exists in two states. Later Munch applied paper shapes or stencils to the block surface (similar to *Women on the Shore* with the moon and moonlit path), without altering it in the technical sense. The impression of the first state in the Straus collection (Pl. 116) is printed in the most popular colors for this state—grayish green for the sea and black for the figures and shore. The block has been sawn into two and very possibly three pieces: the sea; the man and shore; and the woman, who may form part of the latter, or be entirely separate. Although it is difficult to determine from impressions taken from the finely sawn block, it would make sense that the female figure was cut out from the beginning. Munch had so distanced her psychologically that the physical severing of the form from the rest of the image would have made perfect sense. Munch emphasized the woman's separateness by the crisp white border line enclosing her rigid form, frozen in lonely contemplation. Her lover (if that is what he is), an organic part of his surroundings, bends slightly as he steps toward her, but she is inaccessible.

Munch reworked the block (Color Pl. 117) perhaps a year later, perhaps almost twenty years later. He recut the area of the shore, mainly filling out the three rocks that punctuate the spaces between and beside the figures. In recutting, the block broke along the grain at the upper right edge, extending vertically down to the woman's head. This was by no means necessarily a consequence of finally cutting out the figure of the woman, which may have already occurred in the first state. The block in fact possessed other inherent weaknesses and as it exists now in the Munch museum, a substantial vertical section from the right side is broken off, with another piece of wood substituted. And on some second state impressions, where markings were added in the sea, a diagonal line appears on the

The Lonely Ones, 1899 (see Color Pl. 117).

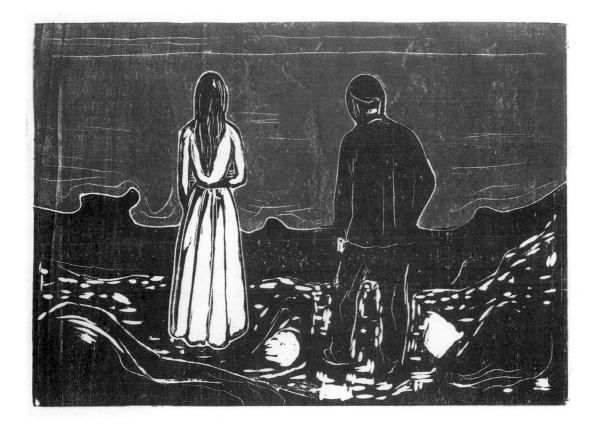

Pl. 116. *The Lonely Ones*, 1899.
S. 133 I. Color woodcut from one block sawn into three pieces, printed in black, grayish green;
off-white laid Japan paper. 39.7 x 54.9 (15⅝ x 21⅝). Signed graphite, lower right: "E Munch".

block that traverses the center of the sea area and continues through the
upper body of the man. The line itself is energetic, but it bears no obvious
formal or psychological meaning and disfigures more than it enhances.
Possibly, it is an accidental scratch that occurred during the printing of the
second state, but it is impossible to establish a chronology. In this state
also, Munch experimented with printing the woman in several colors
simultaneously. In the second state, she has been inked with complemen-
tary colors, half blue, half oranges and reds, fire and ice, freezing and
burning together.

The artist subtly controlled the inking and also the amount of pres-
sure to which he subjected his block, so that, for example, in impressions
of state two, relief lines show up that were invisible in the first state,
contradicting the subtractive method of the woodcut technique. Such

127

The Lonely Ones, 1899 (see Color Pl. 118).

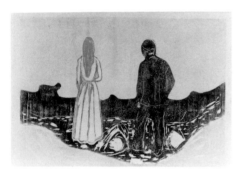

The Lonely Ones, 1899 (see Color Pl. 119).

lines appear in the two white rocks on either side of the man and in the indications of modelling in the woman's skirt and on her arms. On the woodblocks, one can see all these lines clearly, where they form part of what may be called the "second level" of cutting. Not the surfacemost relief, they lie a bit lower, and are accessible only to greater pressure that forces the paper into the block. Sometimes Munch applied less pressure and did not print the "second level" areas; other times he applied heavy pressure but had not inked them, in which cases one may, in raking light, perceive the relief of the blind lines in the paper (OKK 601–22). When he applied both ink and pressure, the nuances in the cutting, which tend to show up as modelling, become evident.

Munch's preoccupation with color and abstract form gradually supplanted his interest in further recutting. Another Straus version (Color Pl. 118), also a second state, shows the artist now differentiating the lower third of the beach from the rest of the shore by inking the block with two colors, here a lemony yellow and a brownish black. The gently slanting contours of the rocks suggest this division of color, which, beginning to displace drawing, becomes the focus of the image. The woman has also been inked in two colors; despite the title, which refers to both people, she is the keystone of the image.[10]

In further reducing his image, Munch employed a most unusual technique. In order to eliminate what now he must have found to be distracting drawing in the shore, he cut out puzzle shapes (analogous to his jigsaw cutting of the woodblock) from paper or cardboard, placed these over the block, inked and then printed them. In this version (Color Pl. 119), which is also hand-colored, the pressure in printing was strong enough to capture the relief of the carved lines from beneath the superimposed shapes. Munch used three shapes here; in others, he used six, sometimes changing their position on the block. Finally, certain experimental impressions include a moon and path of light. In the Munch Museum there is an impression where the artist worked out the idea of the moon in crayon (Fig. 120), before placing stencils of these elements over the sky. The most complex versions include six paper shapes plus the moon and its path (Fig. 121). From a more elaborated linear design (although the broad planes play an important role right from the first state) Munch reduced his scheme to bold patterns to strengthen the visual impact and the emotional message. In the end, amidst a tumble of brightly colored, unnatural shapes, two remote figures turn to the sea, where the moon and path, however suggestively shaped, only separate them more.

Munch thus transformed *The Lonely Ones* from the somber monochromatic impressionism of the drypoint, in which anecdotal detail still predominates, into one of the most forward-looking of all his graphic works. The final version heralds the age of abstraction, which would emerge in the decade to come.

128

IT IS IN WORKS such as *The Kiss* and *The Lonely Ones* that Munch came full circle from the intaglio renderings. In the process, he discovered a new dimension of printmaking, one that looks beyond the representation of draftsmanly concepts to a creation in which materials, as well as technique, play an indispensable role. The woodcuts, especially, look ahead to the appreciation of works of art as inherently material objects. They are powerful descriptions and interpretations of people or events, but, even more, these prints are very much about the artistic quest for the equation of form and idea and the process by which this is attempted. They are products of a personality whose unceasing search for the most expressive forms led him to visual communications of the greatest evocative and idiosyncratic profundity. His technical innovations are linked to such a degree to the individuality of his imagery that although other printmakers later adopted some of the same techniques, Munch's achievement essentially stands alone.

In 1934, in a letter to a friend, Munch wrote, "As I have already said, most of my graphic work, probably nearly all of it, will be burnt. It is highly unlikely that I will be able to gain more from them than I already have. They have served their purpose."[11] Fortunately, Munch did not carry out his threat, for, in their endless configurations, these graphic works continue to reveal new meanings to us, while the old do not lose their force over time.

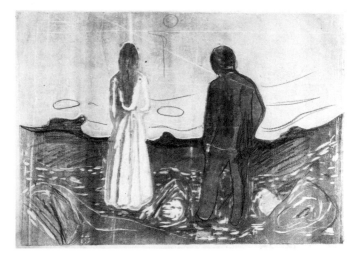

Fig. 120. *The Lonely Ones.*
OKK 601–7. Second state. Off-white wove paper. 39.9 x 55.1 (15½ x 21⅞).

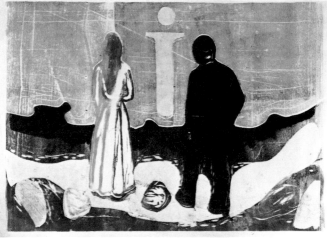

Fig. 121. *The Lonely Ones.*
OKK 601–13. Second state. Buff wove paper. 39.4 x 55 (15½ x 21⅝).

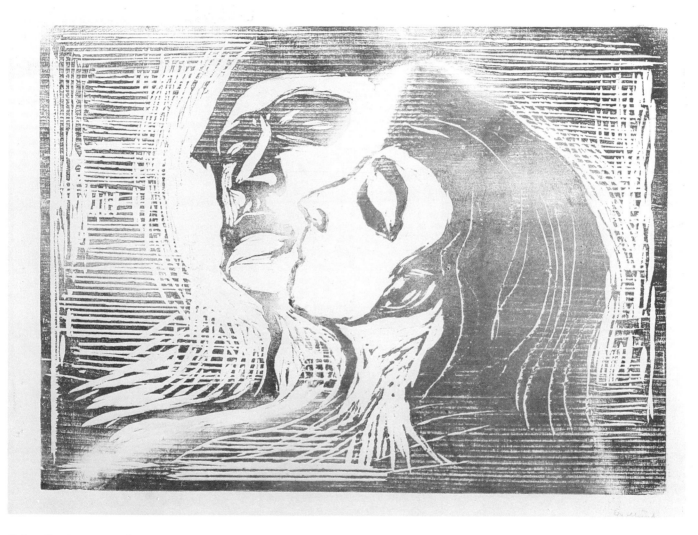

Color Pl. 48. *Man and Woman Kissing*, 1905.
S. 230. Color woodcut printed in red, blue-green; cream wove paper. 40.3 x 54 (15⅞ x 21¼).
Signed, graphite, lower left: "Edv Munch".

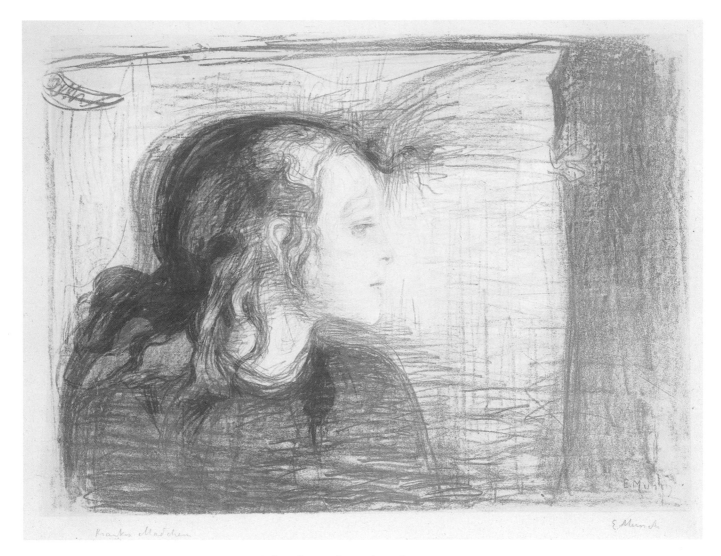

Color Pl. 50. *The Sick Girl*, 1896.
S. 59 II. Color lithograph in crayon, made from three stones, printed in beige, light red, dark red; cream wove paper. 41.9 x 56.8 (16½ x 22⅜). Signed, graphite, two superimposed signatures, lower right: "E Munch"; signed in the stone, lower right: "E. Munch". Inscribed, graphite, lower right: "Krankes Madchen".

Color Pl. 51. *Toward the Light*, 1914.
Not in Schiefler. Color lithograph with crayon and tusche from five stones printed in royal
blue, navy blue, yellow, brownish orange, purplish blue, green; cream wove paper mounted on
a sheet of Japan paper. 100.3 x 75.9 (39⅝ x 29⅞). Signed, graphite, lower right: "Edv Munch".

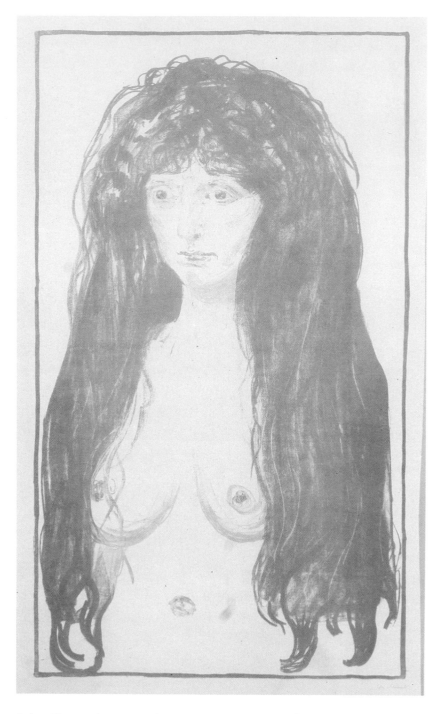

Color Pl. 53. *The Sin*, 1901.
S. 142 II (of 4 states). Color lithograph with crayon, tusche, needle from two stones (really one, recto and verso) printed in orange-beige and green, and red; buff wove paper mounted on a sheet of laid Japan paper. 70.2 x 40.3 (27⅝ x 15⅞). Signed and inscribed, graphite, lower right: "Edv Munch"; "Kvinde med rott haar og gronne oine 600".

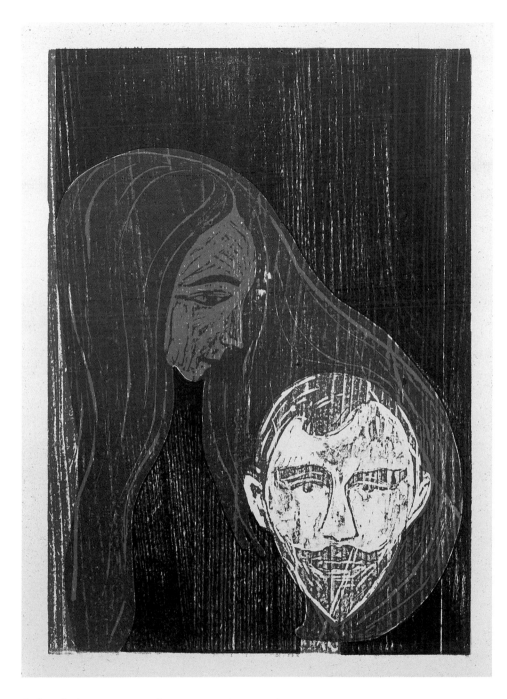

Color Pl. 62. *Man's Head in Woman's Hair (The Mirror)*, 1896.
S. 80 b. Color woodcut from two blocks, one sawn into three pieces, printed in gray, red and blue; cream wove paper. 54.6 x 38.1 (21½ x 15). Signed, graphite, lower right: "Edv Munch".

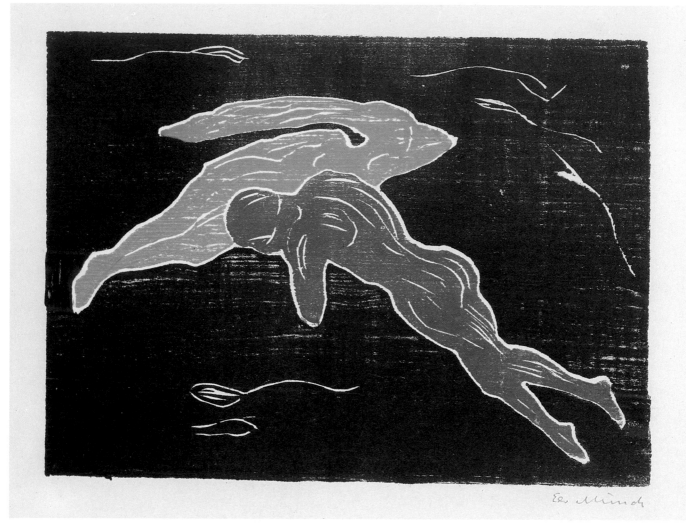

Color Pl. 63. *Meeting in Space*, 1899.
S. 135. Color woodcut from one block sawn into three pieces, printed in red, blue, black; hand colored in black; white laid China paper. 18.8 x 25.1 (7⅜ x 9⅞). Signed, graphite, lower left: "Edv Munch".

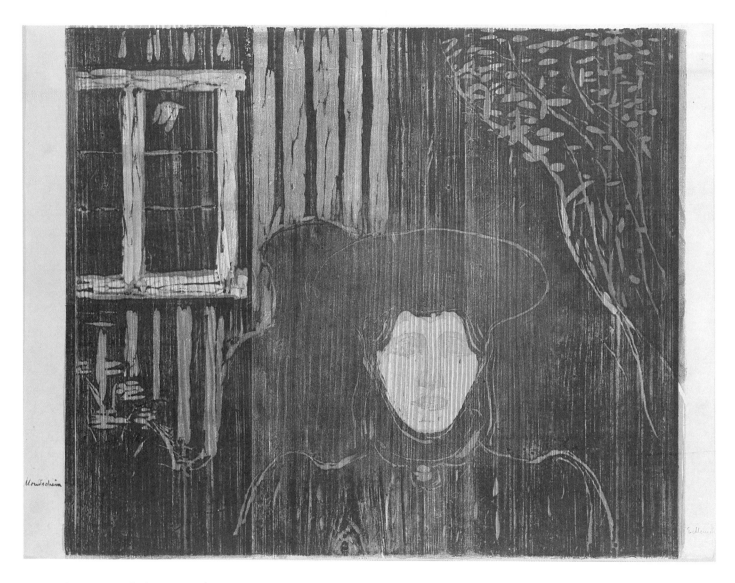

Color Pl. 65. *Moonlight*, 1896.

S. 81. Color woodcut from two blocks; the drawing of one, recto and verso; and the color block sawn into three pieces; printed in gray, black, dark blue-green, brownish orange, dark chartreuse green; off-white wove paper. 40.7 x 52.7 (16 x 20¾). Signed, graphite, lower right: "E Munch". Inscribed, graphite and brown ink, lower left: "Mondschein".

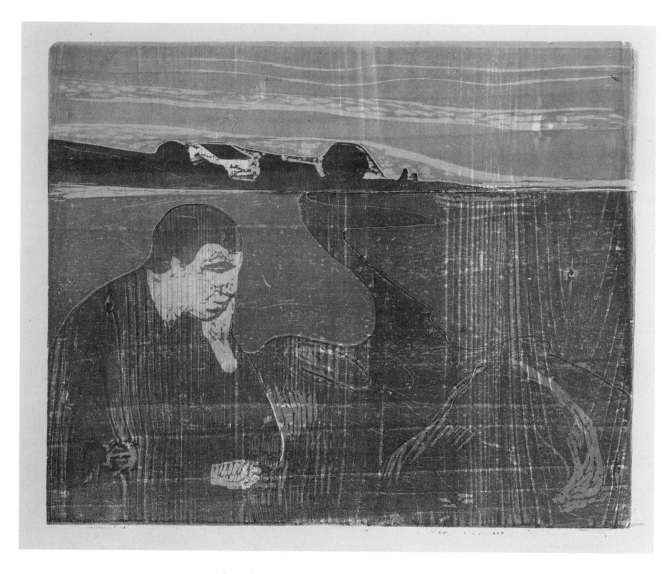

Color Pl. 70. *Melancholy*, 1896.
S. 82. Color woodcut from two blocks, each sawn into two pieces, printed in blue and brownish orange, and olive green, pea-green and blue; cream Japan paper, two pieces glued together. 37.8 x 45.7 (14⅞ x 18). Signed, graphite, lower right: "Edv Munch".

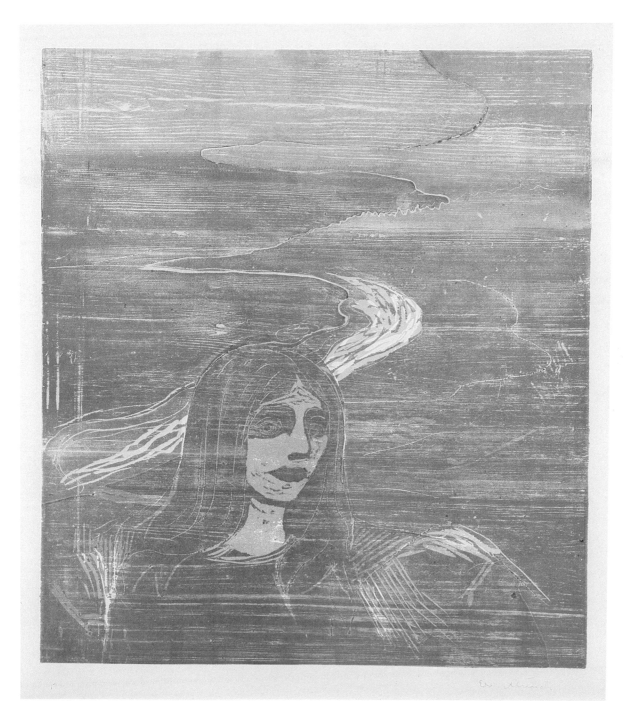

Color Pl. 76. *Girl's Head on the Shore*, 1899.
S. 129. Color woodcut from two blocks, each sawn into two pieces; printed in beige, turquoise-green, brown, orange; off-white wove Oriental paper. 46.3 x 41.2 (18¼ x 16³/₁₆). Signed, graphite, lower left: "Edv. Munch".

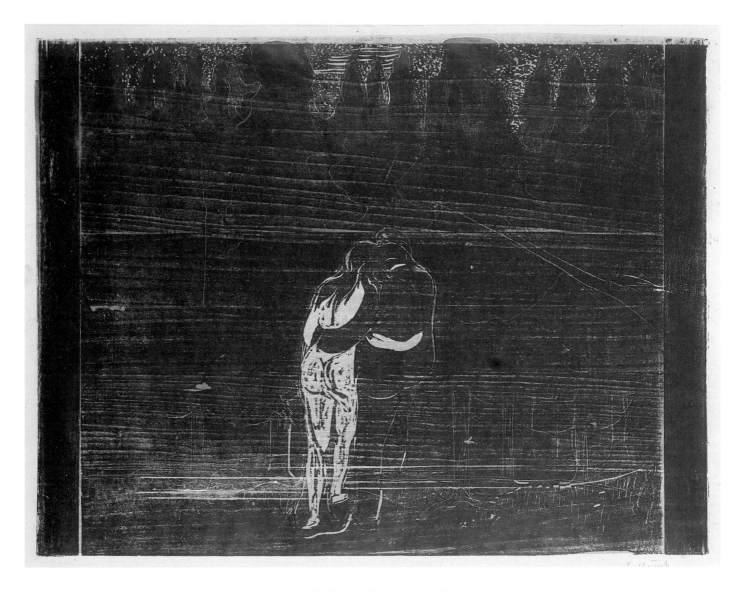

Color Pl. 77. *To the Forest*, 1897.
S. 100 b. Color woodcut from two blocks, one sawn into three pieces, side pieces from a third block, printed in black, dark turquoise-green, olive-green, beige, with dark blue hand coloring; cream wove paper. 49.8 x 65.1 (19⅝ x 25⅝). Signed and inscribed, graphite lower right: "E Munch Til Ravensberg i Erindring om de sverige karv (?) 1909 E Munch Skrivet pa Foshingen Kochs vei 21 Kobnhavn".

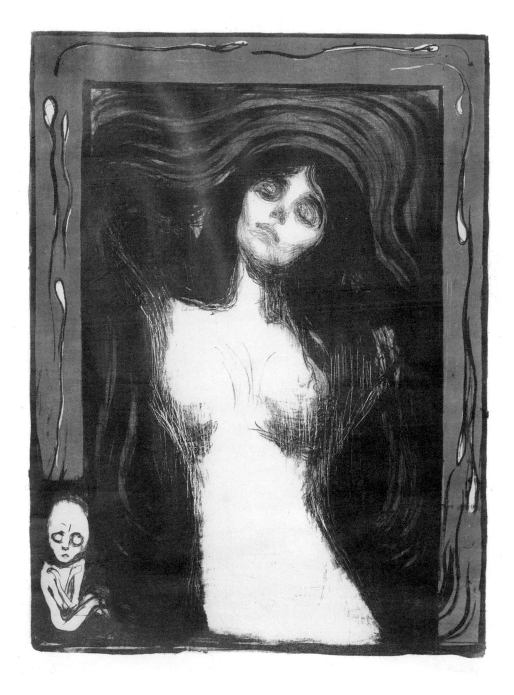

Color Pl. 89. *Madonna*, 1895.
S. 33 A/b/I or II (probably II; Schiefler did not identify the woodblock). Color lithograph with tusche and crayon with three stones printed in greenish beige, brick-red, and black and one woodblock printed in blue; 60.3 x 44.2 (23¾ x 17⅜). Signed, graphite, lower right: "Edv Munch".

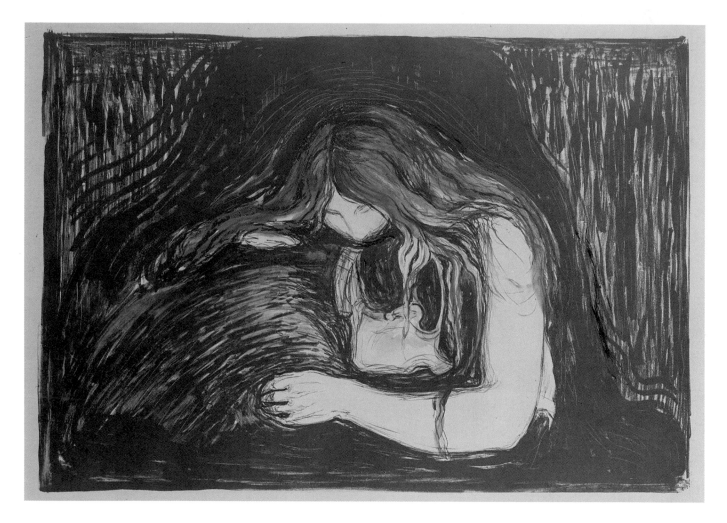

Color Pl. 90. *Vampire*, 1895.
S. 34 a (Schiefler's state II; really a different version). Lithograph with tusche, crayon, needle;
hand colored in blue, red, beige, light-green washes; grayish green paperboard. 38.8 x 55.3 (15¼
x 21¾). Signed and dated, graphite, lower right: "E Munch 1896". Stamped, black ink, lower
left, with the mark of Heinrich Stinnes Collection, L. 1376a.

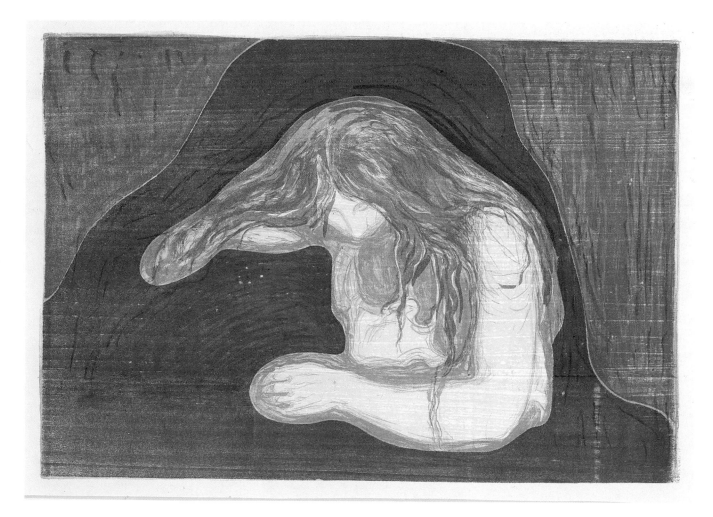

Color Pl. 91. *Vampire*, 1895 (1902).
S. 34 II/b (again, Schiefler's state II, but really only one state of the principle stone). Combination lithograph and woodcut printed from two stones in gray and red; and one woodblock sawn into four pieces printed in blue, green, beige; white wove paper. 38.7 x 55.9 (15¼ x 22).
Verso: stamped with seal of Munch-museet.

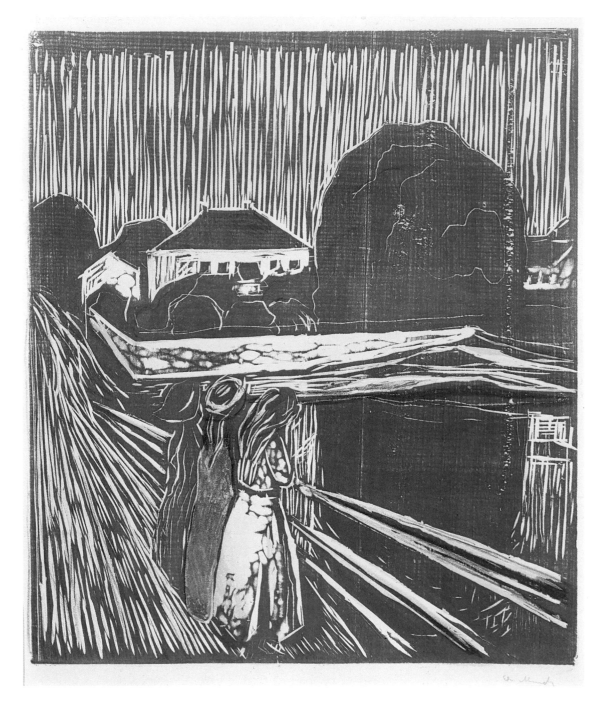

Color Pl. 104. *Girls on the Bridge*, 1918-20.
S. 488. Combination woodcut and lithograph, printed in blue, red, yellow, and dark blue; buff wove paper. 49.8 x 43.2 (19⅝ x 17). Signed, graphite, lower right: "Edv Munch".

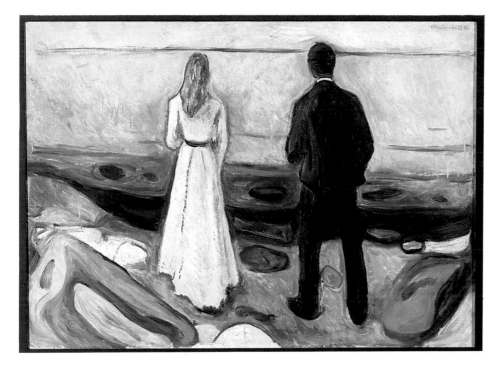

Color Pl. 113. *The Lonely Ones*, 1908.
Oil on canvas. 81 x 110 (31⅞ x 43⁵⁄₁₆).

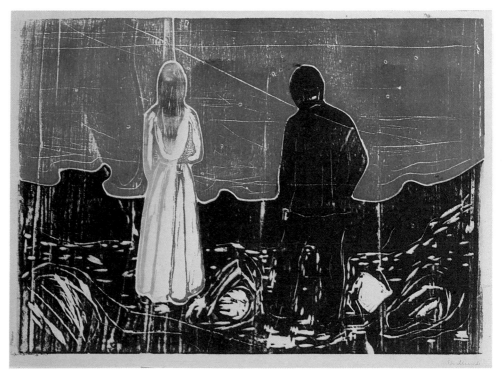

Color Pl. 117. *The Lonely Ones*, 1899.
S. 133 II. Color woodcut from one block sawn into three pieces, printed in black, yellow,
orange-red, dark turquoise; tan wove paper. 39.7 x 55.2 (15⅝ x 21¾). Signed, graphite, lower
right: "Edv Munch". Inscribed, verso: "Zwei Menschen Farbiger Holz—1899 Gedrukt and
zerschnittene Platte".

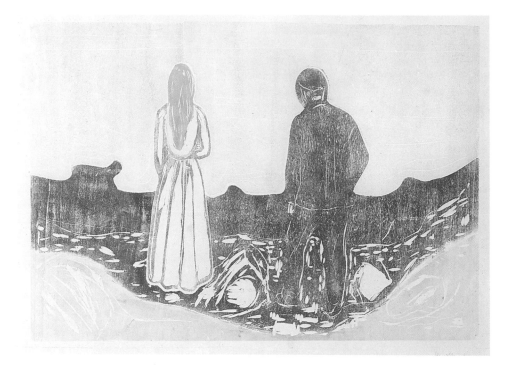

Color Pl. 118. *The Lonely Ones*, 1899.
S. 133 II. Color woodcut from one block sawn into three pieces, printed in chartreuse, lavender, red, yellow, dark brown; off-white wove paper. 39.7 x 55.7 (15⅝ x 21¾). Signed, graphite, lower right: "Edv Munch".

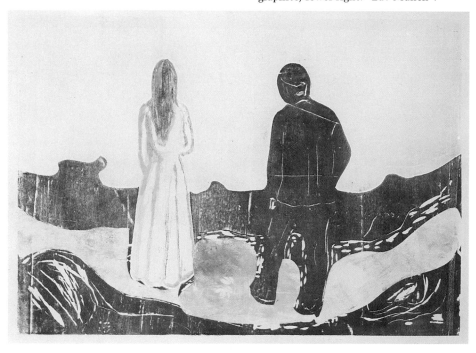

Color Pl. 119. *The Lonely Ones*, 1899.
S. 133 II. Color woodcut from one block sawn into three pieces, printed in turquoise, black, yellow, yellow-orange, red-orange; three shapes printed over the block and hand colored in orange, yellow, red washes which also appear elsewhere on the impression; cream wove paper. 39.7 x 55.9 (15⅝ x 22). Signed, graphite, lower right: "Edv Munch".

DEFINITIONS OF TECHNIQUES & TERMS

INTAGLIO PRINTING (prints lines or marks scratched below the surface of the plate).

Drypoint The process of incising lines into an unprepared plate (usually copper, sometimes zinc) with a steel needle. Depending upon the pressure applied to the needle, the resulting lines can be very fine or rich and velvety—the latter due to the metal burr raised on the edges of the lines as the needle cuts across the plate. The plate is inked, then wiped clean so that the ink remains below the surface in the incised lines. The plate is run through the printing press under high pressure and the image transferred to an absorbent paper. The blurry quality possible with drypoint is lost after about fifteen impressions because the burr wears down rapidly in printing.

Etching An etching is made from a plate (copper or zinc) which has been coated with an acid-resistant material such as resin, wax or asphaltum. With an etching needle, less sharp than that used for a drypoint, the image is scratched into the soft ground, leaving exposed the metal surface where the lines have been drawn. The plate is then submerged in an acid bath which only

Fig. 122. Munch's intaglio plate and woodcarving tools. Photograph, Munch Museum.

bites into the areas where the ground has been scratched away. The depth (and consequently darkness) of the lines may be regulated by controlling the length of time that the plate remains in the acid bath. The

147

process of stopping-out, the application of an acid-resistant varnish to protect certain areas from exposure from biting, allows the printer to control even more carefully the tonal gradations. The etched plate is then printed like a drypoint.

Aquatint The technique of aquatint is primarily used to create tones of gray. Grains of powdered resin are shaken in the desired concentration over those parts of the image where the values are to be produced. Other areas are protected by stopping-out varnish. The plate is then heated so that the particles will adhere. Then, as in etching, the plate is placed in an acid bath which bites tiny holes into the metal around the acid-resistant particles. It is those holes which, when inked and printed, create the uniform grayness, as well as the texture, of an aquatint.

Mezzotint Like aquatint, Mezzotint is a tonal process, but here the artist works from dark to light, rubbing away the plate surface to achieve the light values. A mezzotint is usually made by working over a copper plate with a roulette, an instrument with a toothed wheel attached to a handle, or with a rocker, a tool with a curved, serrated edge, both of which create lines of dots across the entire metal surface. These tools raise a delicate, uniform texture which holds ink well and, when printed, creates a uniform black surface. The artist then scrapes or burnishes away the areas intended to print the light tones of the image. The plate is inked and printed.

The burnisher, an important tool for this technique, is a small hand tool of highly polished steel, either perfectly straight or turned up slightly at its pointed end. It is used for smoothing the rough surface of a metal plate after scraping or to lighten textured areas.

It is generally held that Munch did not prepare his own plates when he made mezzotints in Paris, but bought zinc plates with ready-made surfaces.

PLANOGRAPHY (prints everything on surface of the plate).

Lithograph A lithograph is made on a slab of special limestone from Bavaria, or, in modern times, a metal plate. The image is drawn on the highly polished surface with a greasy lithographic crayon or with tusche (lithographic ink); sometimes other tools such as a needle may be used to create additional effects. Then the stone is "etched," a process in which an acidic solution is applied to the surface, "fixing" the image onto it. The process of printing the stone depends on the incompatibility of water and grease, both of which can be absorbed by the limestone. When the stone subsequently is dampened, the water sinks into the untouched areas and repels the oily ink which is rolled over them. Only the drawn areas, which have been chemically etched into the stone, accept it and it is these that print. A sheet of paper is then laid over the stone and both are passed through a press.

The method of creating the image is easy and spontaneous, like drawing. It is the preparation of the stone and the printing of it that require time and skill to produce impressions of high quality.

Paper and Transfer Lithography An alternative to direct lithography is transfer, or paper lithography. In this process, the artist makes a drawing on rough paper with lithographic materials, which is then laid over a stone and run through the press. The greasy lithographic crayon is transferred to the stone which is then prepared as usual. These lithographs can be recognized by their grain—it is that of the original paper used, and not of the stone. The advantages to the artist are that he can produce the drawing anywhere, without the burden of the heavy stone, and that the image, which is reversed on the stone, appears the "right" way on the impression. Convenience notwithstanding, this kind of print can lack the sense of immediacy present in a direct lithograph.

Another kind of transfer is that made from one stone to another. To make a duplicate transfer impression, a special greasy transfer ink is used along with coated transfer paper. When an impression pulled on this special paper is run through the press onto a new stone (although the image can also come from another printing medium), much of the original quality can be lost.

Color lithographs have traditionally been made by overprinting an image with a series of stones, each of which carried a different part of the design and was inked in a different color. It is also possible, though much less frequent, to ink and print a stone in more than one color at the same time. This is a technique called *a la poupée*, traditionally used with intaglio printing.

RELIEF PRINTING (prints everything above the surface of the plate).

Woodcut The artist cuts with a knife or gouge into a plank of wood, removing all the areas (lines) that are to remain white in the impression. All the areas and lines on the surface are inked and a sheet of paper is then either pressed against the block in a printing press, or rubbed on by hand.

Like color lithographs, color woodcuts were traditionally printed (notably by the Japanese) from a number of superimposed blocks, each of which contributed a section of color and design to the final image. Munch invented the process of sawing his woodblocks into pieces, inking them in different colors, reassembling them, and printing the multi-hued image all at once.

Impression An individual print taken from a worked plate, block, or stone.

Proof An impression pulled as a testing of a stage in the development of a printed image.

Registration The means of accurately positioning (on the press) a plate, block, or stone and the print on it during the making of a multicolor image, when the paper must be overprinted a number of times.

State Each time an alteration is made to the plate, block, or stone, and an impression is pulled from it, that is a different state. They are numbered consecutively.

Version A new rendering of a motif. Versions may be either in the same or different media.

CHRONOLOGY

Compiled from John H. Langaard and Reidar Revold, *Edvard Munch: Era År til År, en handbok (A Year by Year Record of Edvard Munch)* (Oslo: H. Aschehoug & Co., 1961)

1864 **December 12,** Edvard Munch born to Dr. Christian Munch and Laura Cathrine, née Bjølstad, in Loyten, Norway.

1864– 1868 Family moves to Oslo. Mother dies of tuberculosis; her sister Karen Bjølstad joins the household.

1877 Sister Sophie dies of tuberculosis.

1879 Munch enters Technical College to study engineering.

1880 Leaves the college, begins studies in art history.

1881 **August,** enters School of Design.

1882 Rents a studio with six friends; work supervised by the naturalist painter Christian Krohg.

1883 Exhibits for the first time, paintings and drawings.

1884 In contact with so-called Christiania-Bohême, avant-garde painters and writers who gather at the Grand Café on Karl-Johan Street in Christiania (Oslo).

1885 **May,** three weeks stay in Paris. Studies at Louvre, Salon. Begins painting *The Sick Child, The Morning After,* and *Puberty.*

1886 Completes those three paintings.

1889 **April,** first one-man show.

July, granted first state scholarship.

Summer, rents house at Åsgårdstrand.

October, Paris. Classes at the studio of Léon Bonnat.

1890 Lives in St. Cloud with Danish poet Emanuel Goldstein.

May, returns to Norway.

September, receives second state scholarship.

November, to Le Havre where sick with rheumatic fever. Paints *Night in St. Cloud* (model for drypoint *Moonlight,* S. 13). Father dies.

1891 To Nice. End of April, Paris.

May 29, returns to Norway, wins third state scholarship. Paints *Rue de Rivoli,* Busch-Reisinger Museum, Harvard University; *Evening (The Yellow Boat)* model for woodcut *Melancholy,* S. 144.

1892 Nice, Norway, Åsgårdstrand.

November, exhibition at the Verein Berliner Künstler closed after a week of scandal. Exhibition then travels to Düsseldorf, Cologne, and another

location in Berlin. Resides in Berlin for December. Again paints themes of *Puberty, The Day After, The Kiss, Death in the Sickroom* (pastel), *Evening on Karl-Johan,* all models for prints of the same titles.

1893 Berlin. "Frieze of Life" begins to take form. Paints *Vampire, Madonna, The Scream, Moonlight, Death and the Maiden, Starry Night, Dagny Przybyszewska, Evening (Melancholy).*

1894 Begins to make first prints, one lithograph and seven intaglio, including *Death and the Maiden,* S. 3; *By the Window,* S. 5; *The Sick Child,* S. 7.

July, first book on Munch published: *Das Werk des Edvard Munch,* with essays by Julius Meier-Graefe, Franz Servaes, Stanislaw Przybyszewski, Willy Pastor.

1895 **June,** Paris. Etchings for sale at the offices of *Pan.* The Meier-Graefe portfolio with a twenty-one page essay and eight intaglio prints is published.

December, *The Scream* published in *La Revue Blanche.*

March 16–24, exhibits prints for the first time in Berlin, gallery of Ugo Barroccio, Unter den Linden, including seventeen prints, drawings, and lithographs and twenty-eight paintings from the series "Love." Paints *Death in the Sickroom, Jealousy, Self-Portrait with Cigarette.* Prints twenty-one intaglio prints, including *Christiania-Bohême I,* S. 10; *Tête-à-Tête,* S. 12; *Moonlight,* S. 13; *The Day After,* S. 15; *The Lonely Ones,* S. 20; *Christiania-Bohême II,* S. 11; *Woman,* S. 21; *The Kiss,* S. 22; *Portrait of Max Asch,* S. 27; and eight lithographs, including *Self-Portrait with Skeleton Arm,* S. 31; *The Scream,* S. 32; *Madonna,* S. 33; *Vampire,* S. 34; *Hands,* S. 35; *The Alley,* S. 36. Brother Andreas dies.

1896 To Paris. Makes first color lithographs and first woodcut; contributes lithograph *Anxiety* to Ambroise Vollard's *Album des peintres-graveurs.* Prints include five mezzotints including *Evening Scene (Street Scene at Night);* twelve other intaglio works, including *Two Girls and a Skeleton,* S. 44, and *Head of Sick Girl,* S. 60; twenty-three or four lithographs, including *Jealousy,* S. 57; *Jealousy,* S. 58; *The Sick Girl,* S. 59; *Anxiety,* S. 61; *Attraction,* S. 65; *Separation,* S. 68; *Lovers in the Waves,* S. 71; *Death in the Sickroom,* S. 73; and five woodcuts, including *Anxiety,* S. 62; *Man's Head in Woman's Hair,* S. 80; *Moonlight,* S. 81; *Melancholy,* S. 82.

1897 Many exhibitions, travels to Paris, Stockholm, Brussels, St. Petersburg, Berlin.

September 15–October 17, Oslo, "The Mirror" graphic series exhibited at the Diorama.

Paints *Separation, Paul Hermann and Paul Contard.* Prints three mezzotints, three other kinds of intaglio prints, eight lithographs, including *Funeral March,* S. 94; and five woodcuts including *In Man's Brain,* S. 98; *To the Forest,* S. 100; early version of *The Kiss,* S. 102.

1898 Norway, Copenhagen, Berlin, Paris. Exhibits in Salon des Indépendants. Prints one intaglio; five lithographs, ten woodcuts, including *Fertility,* S. 110, *Melancholy: Girl in Red Dress,* S. 116, and *Women on the Shore,* S. 117.

1899 **May,** Rome, studies Raphael. Paints *Dead Mother and Child, Girls on the Bridge.* Prints four lithographs including *Ashes,* S. 120, and *Woman in Three Stages,* S. 122; and thirteen to fourteen woodcuts including *The Old Sailor,* S. 124; *Girl's Head on the Shore,* S. 129; *The Fat Whore,* S. 131; *The Lonely Ones,* S. 133; *Meeting in Space,* S. 135.

1900 Berlin, Florence, Rome, sanitorium in Switzerland.

July, Como, Italy. Paints *Dance of Life,* and *Melancholy.* Prints one intaglio, one lithograph.

1901 Summer at Åsgårdstrand, winter in Berlin.

November–December, exhibits two paintings at the Vienna Secession. Prints three intaglio including *Dead Mother and Child,* S. 140; two lithographs including *The Sin,* S. 142; two or three woodcuts including *Melancholy,* S. 144.

1902 Winter, spring in Berlin. Friend Albert Kollmann introduces him to Dr. Max Linde of Lübeck who buys painting *Fertility,* writes book on the artist. Linde commissions series of fourteen etchings and two lithographs. Portfolio appears late autumn. Relationship with Tulla Larsen ends with violence, and he loses a finger joint on his left hand.

December, Berlin. Meets Gustav Schiefler, who buys prints and begins to catalogue all the graphic works. Prints one mezzotint, twenty-eight intaglio prints which include *Puberty,* S. 164, and numerous reprises of earlier lithographic and woodcut subjects such as *The Kiss, Madonna, Vampire;* four to five litho-

graphs; and two woodcuts, including *Prayer of the Old Man*, S. 173; reprises in color of the same subjects that were being reworked in the intaglio.

1903 Winter, Berlin. March, Paris. Sells painting of *Girls on the Jetty* to Russian collector Morozov.

April, to Lübeck to paint portrait of Dr. Linde.

Summer, Åsgårdstrand; September, Lübeck; Fall, Berlin. Meets Eva Mudocci, English violinist. Depicts her in three lithographs: *Madonna*, or *The Brooch*, S. 212; *Salomé*, S. 213; *The Violin Concert*. Paints two versions of *Women on the Bridge*. Prints ten intaglio including *Girls on the Bridge*, S. 200; nine lithographs, including the above-mentioned; one woodcut.

1904 Winter, Berlin. Contract with Bruno Cassirer in Berlin for exclusive rights to the sale of his prints in Germany. Becomes regular member of the Berlin Secession. Paints frieze for nursery in Linde House, which was refused as unsuitable for children. Prints four intaglio and one or two lithographs.

1905 Berlin, Hamburg, Copenhagen. Schiefler begins preparation for the first volume of the catalogue raisonné. Munch brings him some of the earliest prints (cf. *Meine graphik sammlung*, p. 35). Prints nine intaglio; two lithographs; eight woodcuts, including *Man and Woman Kissing*, S. 250, and *Urmensch*, S. 237.

1906 Germany. Meets Swedish banker and patron Ernest Thiel for whom he paints Nietzsche after a photograph.

Summer, makes designs for Strindberg's *Ghosts* for Max Reinhardt's theatre in Berlin. Paints *Self-Portrait with Wine Bottle*. Prints two intaglio (1905–6). Seven intaglio; seven lithographs; four hectographs; (1906–7); one lithograph.

1907 Berlin. Decorations for entrance hall at Max Reinhardt's theatre.

Stockholm, paints portrait of Thiel who buys many paintings.

December, Berlin. First volume of Schiefler's catalogue raisonné of prints appears. Prints six intaglio.

1908 Berlin, Paris. Begins to paint scenes of workers and industry.

Autumn, suffers nervous breakdown in Copenhagen, enters clinic of Dr. Daniel Jacobsen. Made a Knight the Royal Norwegian Order of St. Olav. Paints *The Lonely Ones*, Straus collection. Prints one lithograph, one hectograph.

1909 Winter, spring in Copenhagen at the clinic. Writes prose poem "Alpha and Omega" which he illustrates with transfer lithographs. Paints portrait of Dr. Jacobsen. Prints series of lithographs on zinc of zoo animals.

May, Norway, rents estate at Kragerø.

June, exhibition in Bergen, one hundred paintings, two hundred prints. Starts designs for competition for frieze decorations at Oslo University Festival Hall (Aula).

Prints six intaglio (1908–9); sixty-six lithographs, including *Self-Portrait with Cigarette*, S. 282; four woodcuts.

1910 Buys estate at Hvitsten on Oslo Fjord (prints made there are often inscribed "Hvitsten"). Prints one lithograph.

1911 **August,** wins Aula competition. Starts modelling in Clay. Prints one hectograph, five lithographs, six woodcuts, including *Self-Portrait*, S. 253.

1912 **September,** Cologne, has contact with Curt Glaser, print connoisseur and art historian. Works on Aula pictures. Shows six paintings in New York exhibition.

December 10–25, "Contemporary Scandinavian Art." Prints three intaglio, twenty-seven lithographs, one mixed lithograph/woodcut, two woodcuts.

1913 Continues to travel extensively.

February 17–March 15, eight prints exhibited in the Armory Show in New York. Exhibition travels to Boston and Chicago. Prints fifteen intaglio, nine lithographs, six woodcuts.

1914 **May 29,** University accepts the murals for the Aula. Paints *Workers Coming Home*. Prints three intaglio, six lithographs, which include *Toward the Light*.

1915 Hvitsten. Paints *Winter Landscape* (Kragerø), Straus collection. Prints three intaglio, six lithographs, seven woodcuts, including second version of *To the Forest*.

1916 **January,** buys estate of Ekely at Skøyen.

September 19, Aula murals unveiled.

Paints fourth version of *The Sick Child*. Prints six intaglio; eleven lithographs; two woodcuts.

1917 At Ekely. Curt Glaser's book on the artist appears. Prints four lithographs, 1916–17.

1918 Ekely. Publishes brochure on the "Frieze of Life."

1919 Sick with Spanish influenza, paints *Self-Portrait with Influenza*.

November 29–December 20, exhibition of fifty-seven prints in New York, Bourgeois Galleries. Prints one lithograph; 1919–20.

1920 Thirty-eight lithographs, one mixed lithograph and woodcut, *Girls on the Bridge*, S. 488; four to five woodcuts.

1922 Murals for workers' dining room at the Freia Chocolate Factory, Oslo. Buys 73 graphic works by German artists in order to support their efforts.

1923 Becomes a member of the German Academy.

1924 Paints *The Gothic Girl*.

1925 Elected honorary member of the Bavarian Academy of the Bildenden Künste, Munich. Prints lithograph *Self-Portrait with Wine Bottle* (1925–26).

1926 Sister Laura dies. Paints fifth version of *The Sick Child*.

1927 Second volume of Schiefler's catalogue raisonné of prints appears. Prints one lithograph.

1928 Works on designs for murals for Oslo City Hall. Exhibits five paintings in San Francisco. Prints: one woodcut.

1929 Builds outdoor "winter studio" at Ekely. Prints: three lithographs.

1930 Suffers from eye problems. Prints: three lithographs.

1931 Aunt Karen Bjølstad dies. Eye trouble continues. Exhibits Detroit, Pittsburgh. LR prints: two woodcuts, including *Birgitte III*.

1933 Åsgårdstrand, Hvitsten, Kragerø. Made Knight Grand Cross of the Order of St. Olav. Exhibits two paintings, Pittsburgh.

1934 Exhibits two paintings, Pittsburgh.

1935 Exhibits New York, Roerick Museum, three paintings.

1936 Abandons plans for decorating Oslo City Hall.

1937 Eighty-two works in German public collections branded "degenerate" by Nazis, confiscated. Rejects Jens Thiis's idea for a Munch Museum at Tullinlokka, Oslo. Exhibits one painting, Pittsburgh.

1938 Eye problems return.

1939 Paints *Night Wanderer*, a self-portrait.

January 23, Oslo auction of fourteen paintings, fifty-seven prints from German museum.

1940 Paints *Between the Clock and the Bed*, a self-portrait.

1942 Exhibits thirty-four prints, Brooklyn Museum.

1943 Ekely. Makes last print, a lithographic reprise of 1899 portrait of writer–friend, Hans Jaeger. Nazis bomb a quay nearby, blowing out windows at Ekely. Munch becomes ill.

1944 January 23, dies at Ekely. In will, leaves most everything to city of Oslo: approximately one thousand paintings; 15,400 prints; 4500 watercolors and drawings; sketchbooks, diaries, etc.; six sculptures. Also, 155 copper plates, 143 lithographic stones, 133 woodblocks, a library of about 6000 items.

NOTES

CHAPTER I

[1] *Edvard Munchs brev: Familien. Et utvalg av Inger Munch.* Munch–museets Skrifter, 1 (Oslo, 1949), letter no. 167, p. 147.

[2] Munch could have had the chance to see Gauguin's work at the house of a mutual friend. Cf. Bente Torjusen, "The Mirror," in *Edvard Munch: Symbols & Images, exhib. cat., (National Gallery of Art, Washington, D.C., 1978)*, pp. 185-227.

[3] Reinhold Heller, "Love as a Series of Paintings and a Matter of Life and Death," in *Edvard Munch: Symbols & Images*, pp. 101-102.

[4] Harry, Count Kessler, *Tagebücher*, entry of 9 December 1894, quoted in Heller, p. 101. Unpublished manuscript from Deutsches Literaturarchiv, Schiller-Nationalmuseum, Marbach a. N.

[5] Julius Meier-Graefe, Introduction to *Edvard Munch: Acht Radierungen* (Berlin, 1895), p. 12.

[6] Heller, p. 101.

[7] Quoted in Peter W. Guenther, *Edvard Munch*, exhib. cat., The Sarah Campbell Blaffer Gallery, The University of Houston, April 9–May 23, 1976; The New Orleans Museum of Art, June 11–July 18, 1976; The Witte Memorial Museum, San Antonio, July 28–September 12, 1976, p. 13.

[8] This lithograph, (S. 8), is the same motif as the painting *Puberty* of 1894-5, and the 1902 etching *Puberty (By Night)* S. 164.

[9] The statistics used are based on the standard catalogue raisonné of Munch's graphic work by Gustav Schiefler, published in two volumes. Although not infallible, these catalogues are indispensable to any study of Munch's prints. Also necessary for study of the intaglio prints is Sigurd Willoch's catalogue. See "Note on Captions."

[10] See Kenworth Moffett, *Meier-Graefe as art critic* (München, 1973).

[11] Bente Torjusen has reconstructed the portfolio, no small task, from the catalogue of the 1897 exhibition in Christiania (Oslo), and from the evidence of a newly discovered set of twelve prints which she proposes are the surviving fragment of the original group of twenty-five exhibited works (p. 187). The original "Mirror" seems to have included twenty lithographs and five woodcuts, some of which were hand colored. Torjusen posits that, had the series been published, the coloring would have guided actual printing in color (pp. 186-188). The twelve "Mirror" prints are now part of the Straus collection and the collection of the Fogg Art Museum, Harvard University. Additional impressions of motifs from "The Mirror" included in the Straus collection are the following: *Funeral March, Death in the Sickroom, Hands, Lovers in the Waves, Madonna, Attraction I, Jealousy* (large), *Vampire* (lithograph), *Separation II, The Alley, The Scream, Melancholy, Anxiety, The Kiss, Man's Head in Woman's Hair (The Mirror).*

[12] Gerd Woll, *Edvard Munch: The Major Graphics*, exhib. cat., exhibition organized by the Smithsonian Institution Traveling Exhibition Service, 1976–77, p. 20.

[13]Ragna Stang, *Edvard Munch, The Man and His Art* (New York, 1977), p. 264.

[14]E. L. Kirchner, "Concerning Kirchner's Prints" (from "Uber Kirchners Graphik," *Genius* (München, 1921), pp. 250-263); quoted in ed. Victor H. Miesel, *Voices of German Expressionism* (New Jersey, 1970), p. 25.

[15]Letter to Ragnar Hoppe, 1929, in Ragnar Hoppe, "Hos Edvard Munch på Ekely," *Nutida Konst*, I (1939), pp. 8-19; quoted in Stang, p. 144.

[16]Rolf Stenersen, *Edvard Munch, Close–Up of a Genius* (English edition, Oslo, 1969), p. 95.

[17]Stenersen, p. 96.

[18]Ibid., p. 119.

[19]Miesel, p. 25.

CHAPTER II

[1]Stang, p. 127, note 204. She refers to Ole Sarvig, *Edvard Munchs Grafik* (Kobenhavn, 1948), p. 16; Werner Timm, *The Graphic Art of Edvard Munch* (New York and London, 1969), p. 16; also see Willoch, Introduction to cat., p. 8.

[2]Harry, Count Kessler, quoted in Heller, op. cit., p. 102. Unpublished diary entry from Deutsches Literaturarchiv, Schiller-Nationalmuseum, Marbach a.N.

[3]Meier–Graefe, pp. 12–13.

[4]Ibid., p. 14.

[5]Hermann Struck, *Die Kunst des Radierens* (Berlin, 1908), p. 197.

[6]Schiefler, 1907, pp. 20-21.

[7]In a letter of 1905, his patron from Lübeck, Max Linde, wrote: "As regards the portrait of van de Velde, I also believe that it would be good if you first made several drypoints or etchings after his head....You can get copper plates in any case at Kayser's." Letter of 23 November 1905, in *Edvard Munchs Brev fra Dr. Med. Max Linde*, Munch–museets skrifter, 3 (Oslo, 1954), p. 49.

[8]The condition of the paper in the Straus impression produces an unusual, surely unintentional, effect. The surface of the thick wove sheet is pitted, with the result that plate tone washed over it produced an irregular, mottled pattern in the background of the print. The printer must have realized what happened, because some of the more obvious pits have been touched in with graphite, visible in raking light as shiny patches. Graphite touching may be seen in the tie, on Dr. Asch's right hand, and elsewhere. This is an interesting example of the vagaries of printing and the way in which chance occurrences may be exploited for their expressive effects.

[9]Munch's graphic works have always been designated by many alternate titles. Here they are listed by the one or two by which they are best known.

[10]The shop of L. Angerer in Berlin produced the portfolio. Both a deluxe printing and an ordinary edition were made, differing in paper quality and in quality of the impressions. Schiefler notes that an edition of only sixty–five copies was printed, ten of which were numbered, signed by the artist, and pulled on heavy Japan paper (Schiefler, 1907, p. 3). The other fifty–five editions, unnumbered, were pulled from the copper plates after they were steel–faced in order to preserve them. Some of the plates are now in the Munch Museum. The Straus portfolio is one of these later editions. Other impressions were printed by shops such as Sabo and Felsing, both of Berlin. In some cases the signature of the printer appears at the edge of a print; also Felsing impressions are signed by the printer and often printed in brown or brownish black ink.

[11]Schiefler and Willoch do not always agree on technical information or states and in certain cases Willoch benefitted from information unavailable to Schiefler. Hence the discrepancies in their numbering and descriptions. But, as Willoch notes in his introduction to his listing of Munch's intaglio works, Schiefler's cataloguing "has generally been taken as the *point de depart*." (p. 14).

[12]The model for the reflective man was Munch's friend, the Danish poet Emanuel Goldstein (1862–1921).

[13]E. L. Kirchner, in Miesel, p. 26; also L. de Marsalle, "Uber Kirchners Graphik" in Lothar Grisebach, *E. L. Kirchner's Davoser Tagebuch* (Köln, 1968), pp. 190–194.

[14]Stang, p. 46.

[15]Copper was unavailable to Munch in sizes this large so he used zinc plates fairly often. Max Linde made several references to obtaining them for the artist. a) Letter of 3 June 1903, p. 21; b) Letter of 23 November 1905, p. 49, *Lindebrev*.

[16]Letter of 15 May 1903, *Lindebrev*, p. 20.

CHAPTER III

[1]André Mellerio, "La lithographie originale en couleurs" (Paris, 1898), translated in Philip Dennis Cate and Sinclair Hamilton Hitchings, *The Color Revolution, Color Lithography in France, 1890–1900* (Santa Barbara and Salt Lake City, 1978), p. 93.

[2]Harry, Count Kessler, diary entry of 15 April 1895, quoted in Reinhold Heller, *Edvard Munch: symbols & Images*, p. 103.

[3]David Bergendahl "Edvard Munch's Siste Lithografi," in *Edvard Munch Som Vi Kjente Ham*, Vennene Forteller (Oslo, 1946), pp. 108–111.

[4]Hedy Hahnloser-Bühler, *Félix Vallotton et Ses Amis* (Paris, 1936), p. 269, note 31. Nevertheless, Hahnloser-Bühler may not be the most reliable source; Ingrid Langaard in *Edvard Munch. Modningsår* (Oslo, 1960), p. 453, notes that her contention of direct influence is based on incomplete and therefore contradictory evidence.

[5]Text written on the verso of an impression of *The Scream* (Landesgalerie, Stuttgart), quoted in Gerd Woll, "The Tree of Knowledge of Good and Evil," in *Edvard Munch: Symbols & Images*, op. cit., p. 224–225.

[6]In Vance Thompson (?), "Munch, the Norse Artist," *Mademoiselle* (January, 1896), quoted in Guenther, op. cit., p. 68.

[7]Cate and Hitchings, op. cit., p. 9.

[8]*The Epstein Collection*, Bulletin, Allen Memorial Art Museum, Vol. XXIX, no.3 (Spring, 1972) p. 146.

[9]Impressions of the small version of *Jealousy* in the Munch museum and in the National Gallery, Oslo, on which *The Urn*, (S. 63), has been printed, prove that both images were drawn on the same stone.

[10]In the previous year Munch had made two etchings of *Attraction* (S. 17, W. 16; S. 18, W. 17), both printed in Berlin. Schiefler notes that one (S. 18) had even been printed in color, which would document Munch's color experiments to a very early stage in his career.

[11]This lithograph records the death of Munch's sister Sophie in 1877. The artist depicted the family members at their ages at the time of Sophie's death, rather than contemporaneous with the making of the picture. Munch did not dwell on the agony of the dying girl, as he did in *The Sick Girl*; rather, he represented the misery of the remaining ones. (See Arne Eggum, "The Theme of Death," in *Edvard Munch: Symbols & Images*, op.cit., pp. 143–183, for a good discussion.)

[12]Jules Heller, *Printmaking Today* (New York, 1958), p. 36.
[13]Ibid., p. 36.
[14]Eva Mudocci was the stage name for the violinist Evangeline Hope Muddock (1883–1953). She met the artist in Paris in March 1903 and they maintained a relationship for a number of years, meeting for the last time in the summer of 1909 (Stang, p. 298, note 231).

[15]Munch presented Eva with the lithographic stone on which he made this portrait with a note reading, "Here is the stone that fell from my heart." Eva Mudocci to W. Stabell (Stang, p. 178, note 9).

[16]I thank Gerd Woll, Curator of Prints and Drawings, Munch Museum, Oslo for sharing her observations on this print.

CHAPTER IV

[1]Langaard, op.cit., p. 452.

[2]Ibid., p. 454.

[3]See Colta Feller Ives, *The Great Wave: The Influence of Japanese Woodcuts on French Prints* (The Metropolitan Museum of Art, 1974).

[4]Paul Westheim, *Das Holzschnittbuch* (Potsdam, 1921), p. 152.

[5]Torjusen, op.cit., esp. pp.197–201.
[6]I thank Jan Thurmann-Moe, Conservator of Paintings,
Munch–museet, for information about Munch's techniques and materials.

[7]Westheim, op.cit., p. 168.

[8]Ibid., p. 157.

[9]Pola Gauguin, *Grafikeren Edvard Munch*, 1. Tresnitt og Raderinger (Trondheim, 1946), p. 52.

CHAPTER V

[1]Sigbjørn Obstfelder, 1893, from *Edvard Munch—an Experiment*, *Samtiden*, 1896, pp. 17–22; Quoted in Stang, p. 51, note 17.

[2]"Poupée" is the "French name for the roll of paper or cloth with which the colors are rubbed into the different lines on the plate." William M. Ivins, *How Prints Look* (Boston, 1943), p. 112.

[3]Henri Lefort, 1898, quoted in Cate and Hitchings, p. 1.

[4]Ibid., p. 1.

[5]Ibid., p. 1.

[6]Mellerio, in Cate and Hitchings, p. 94.

[7]Ibid., p. 95.

[8]Langaard, p. 452.

[9]Arne Eggum, "The Theme of Death", op. cit., p. 152.

[10]It is not easy to determine states and versions with this print. Arne Eggum mentions a number of stones: color stones, a "tone" stone, and a principal one which he claims was later used "mainly for the green or bluish tones in his multicolored prints," Munch having "drawn the main motif on another stone in lithographic crayon." Eggum, "The Theme of Death," p. 150. An early impression (OKK 203–22) of the drawing block exists which is signed and dated 1896 in the stone. This inscription disappears, to be replaced later with another signature altogether, but without the date. The latter version appears by 1897, based on the evidence of another impression (OKK 203–7), signed both in the stone and in graphite, lower right, "E. Munch 1897." In these two versions, the tusche stones differ, as can be seen in the difference in the locks of hair. Sometimes the signature in the stone lies on the tusche stone; in the Straus impression it seems to lie on the drawing stone, although upon very close scrutiny the "E" and the "M" appear to be drawn in ink while the "unch" is in lithographic crayon. Therefore, both the drawing block and one of the tusche blocks seems to have existed in two states while the tonal stones remain constant.

[11]The photograph of the long-haired model (Fig. 56), taken in Munch's studio in Berlin in 1902 bears a great resemblance to the woman in *The Sin*. This would seem to contradict the identification of her as Tulla Larsen.

[12]Thanks to Sam Stebbins who remarked upon the resemblance of *Melancholy* to double-exposure photography. Arne Eggum's recent article presents an interesting discussion of Munch's photographs although it does not explore their connec-

tion to his graphic work. cf. Arne Eggum, "Munch and Photography," in *The Frozen Image: Scandinavian Photography* (Walker Art Center and New York, 1982), pp. 108–114.

[13]Torjusen, p. 224.

[14]The Epstein Collection 1901–3, p. 160, 225.

[15]See Guenther, p. 94, for a good summary.

[16]Ibid., p. 94.

[17]There are two other woodcut portraits of this model. Stang, p. 264, dates the Straus version to 1930; Frederick B. Deknatel, *Edvard Munch* (New York, 1950), p. 56, says 1931; Gauguin, op.cit., p. 60, says ca. 1927.

[18]Birgit Prestoe wrote a recollection of her friendship with Munch: "Minner om Edvard Munch," in *Edvard Munch Som Vi Kjente Ham*, op.cit., pp. 100–106.

[19]Johan H. Langaard and Reidar Revold, *Edvard Munch* (New York–Toronto, 1969), repro. No. 50.

[20]Deknatel, p. 55.

CHAPTER VI

[1]Quoted in Torjusen, p. 189.
[2]Ibid., p. 189.

[3]Edvard Munch, from Munch-museet ms. T2547, "Kunskapens trae på godt og ondt," quoted in Heller, *op. cit.*, p. 105.

[4]Also, *Girls on the Bridge*, and *The Snow Shovelers*, 1912 (S. 385).

[5]Letter from Max Linde, n.d. (January, 1903?), *Lindebrev*, p. 13.

CHAPTER VII

[1]Quoted in Stang, p. 130, note 7. Schiefler, 1927, p. 24.

[2]Westheim, op. cit., p. 164.

[3]One cannot generalize about the planar nature of the woodcut; Munch's woodcuts of the early twentieth century, notably the series of illustrations for Ibsen's *The Pretenders*, to which *Birgitte III* is related are highly linear in style.

[4]Gustav Schiefler, *Meine Graphiksammlung* (Hamburg, 1974), p. 30.

[5]Quoted in Guenther, p. 66. Hrsg. Stanislaw Przybyszewski, *Das Werk des Edvard Munch* Vier Beiträge von Stanislaw Przybyszewski, Dr. Franz Servaes, Willy Pastor, Julius Meier-Graefe (Berlin, 1894), pp. 18–19.

[6]Quoted in Guenther, p. 66; August Strindberg, "L'exposition d'Edvard Munch," *La Revue Blanche* 10, No. 76 (June 1, 1896), p. 526.

[7]Arne Eggum, in *Munch: Liebe Angst Tod*, exhib. cat. Bielefeld Kunsthalle, 1980, pp. 25, 26 versus Guenther, op. cit., pp. 92–93. They reverse the A and B versions.

[8]Meier-Graefe, Introduction to *Acht Radierungen*, p. 17.

[9]Jens Thiis, *Edvard Munch* (Berlin, 1934), p. 6.

[10]*The Epstein Collection*, op. cit., p. 158; Guenther, p. 109.

[11]This suggestion is supported by the evidence of the color mezzotint (S. 42; W. 42), 1896, that depicts exclusively the figure of the woman.

[12]Johannes Roede, "Spredte Erindringer om Edvard Munch," letter of March 10, 1934, in *Edvard Munch Som Vi Kjente Ham*, op. cit., p. 60.